HULL CO...
EVERYMAN, I will go with thee ...ATION
and be thy guide,
In thy most need to go by thy side

to ROBERT GREACEN
to revivify old interests

Pre-Raphaelite Writing

an anthology

Edited, with an introduction, by
Derek Stanford

Dent : London and Melbourne
EVERYMAN'S LIBRARY

Made in Great Britain by
Guernsey Press Co. Ltd, Guernsey, C.I., for
J. M. Dent & Sons Ltd
Aldine House, 33 Welbeck Street, London W1M 8LX
First published in 1973
Reprinted as an Everyman Classic in 1984

820 /(91)

No 33 Hardback ISBN 0 460 10033 5
No 1033 Paperback ISBN 0 460 11033 0

Contents

v

Contents vii

FICTION 101

POEMS 111

SOME PAINTINGS

CRITICISM

Illustrations

Introduction

Pre-Raphaelitism began as a small revolt in painting and ended up by becoming a nationwide influence informing current fashion and taste from wallpapers and fabrics to women's hair styles. In 1858—just ten years after the Movement started—Ruskin assured the people of Liverpool that they would find 'every Pre-Raphaelite picture gradually advance in influence and taste'. 'Since Turner's death,' he continued, 'I consider that any average work from the hand of any of the four leaders of Pre-Raphaelitism [Rossetti, Millais, Holman Hunt and John Lewis] is, singly, worth at least three of any other pictures whatever by living artists.' [1] Up to the turn of the century, Ruskin's prognosis was shown to be largely correct, but by the 1920s the bottom had fallen out of the P.R. picture-market; and none could have foreseen that two separate paintings by Burne-Jones and Millais would be sold for sums between thirty and forty thousand pounds in the seventies.

So it has proved, however, and we now find ourselves in the midst of a great Pre-Raphaelite revival. A number of books have already appeared on the visual aspects of Pre-Raphaelitism, but there is no single available volume in which the writings of the personalities associated with it may be studied. From being a small band of painters, the Pre-Raphaelite personnel increased in numbers till it included poets, critics and men of letters as well as designers, craftsmen and printers. The present anthology is intended as a record of the written word by these Pre-Raphaelite personalities, and also by their

[1] *The Liverpool Echo* (11 June 1858).

sympathizers, commentators and hostile critics. A considerable
part of this material consists of literature proper, poetry, fiction
and criticism; another portion of matter belongs to the
journalism and history of art; and a third smaller section is
made up of passages from diaries and memoirs.

Section II of this introduction presents a skeleton history of
Pre-Raphaelitism, treating of its common style and spirit,
whether in the art of painting or letters; while Section III is
specifically concerned with its literary achievement. In the
fourth, postscript, section the influence of Pre-Raphaelitism on
book design and printing as it affected the volumes in the
Everyman Library is briefly touched on.

Finally, a word on how 'Pre-Raphaelite' is to be under-
stood in this anthology. I have chosen to interpret it in its
widest possible scope. In his *Pre-Raphaelitism: A Bibliocritical
Study* (1965), William E. Freedman has observed that 'critics
and literary historians of the Victorian period have too often
been inclined to denote only those aspects of Victorian romanti-
cism centering on the Pre-Raphaelite Brotherhood. More
accurately, the term includes three stages of a congeries of
literary and artistic impulse which have been used loosely and
interchangeably as synonymous: the Pre-Raphaelite Brother-
hood, the Pre-Raphaelite Movement, and Pre-Raphaelitism.
Actually, they are not mutually exclusive but sequential terms
descriptive of a continuous, if not a unified aesthetic force.' I
have not myself employed these nouns and nounal phrases
with the sense of nice scholarship Mr Freedman proposes, but
his notion of the evolution, and broadening scope, of the Pre-
Rapahelite idea is clearly an important one. It is just such a
scope I had in mind when assembling this anthology.

II

The story of the Pre-Raphaelite Movement, from the incep-
tion of the P.R.B. (Pre-Raphaelite Brotherhood) to its
widely disseminated aftermath, is substantially related in the
following pages of this anthology. This artistic force was to

influence life, art and literature up to the turn of the century, and here it seems interesting to quote a near-contemporary account of those first far-off steps.

In *The Aesthetic Movement in England* (1882), Walter Hamilton devoted his initial chapter to the Pre-Raphaelites, maintaining quite rightly—as is seen in retrospect—that the Aesthetic cult of beauty, with its dados, its sunflowers and its arum lilies, all began with a group of art students none of whom was over twenty-one. 'In the year 1848,' he tells us in his simple précis, 'there were studying together in the art school of the Royal Academy, four very young men, namely, Holman Hunt, John Everett Millais, Dante Gabriel Rossetti, and Thomas Woolner, the first three being painters, the last a sculptor. Endowed with great originality of genius, combined with remarkable industry, they formed among themselves the daring project of introducing a revolution into the arts of painting and sculpture, as then practised. . . . In 1850, they started a Pre-Raphaelite Magazine entitled *The Germ* of which William Michael Rossetti (brother of D. G. Rossetti) was appointed editor. Then two other gentlemen joined the group, namely, G. F. Stevens [sic], the art critic, and the late Dr James Collinson, and this completed the P.R. Brotherhood, which never numbered more than seven.'

In the same chapter the author quotes from an address delivered by Sir Coutts Lindsay, founder of the famous 'greenery-yallery Grosvenor Gallery' immortalized by Gilbert and Sullivan in their comic opera *Patience*. Speaking at the Social Science Congress at Manchester, he tersely described the aims and labours of the Pre-Raphaelites. During the time of Reynolds, he told his audience, 'English painters were . . . under subjection to the Italian and Dutch Schools, the result being the abandonment of knowledge derived from nature, and a narrow dogmatism based on what are called the canons of art . . .' And then the Pre-Raphaelites came into the picture. 'Half a dozen young men set themselves to the reconsideration of art. . . . Their creed involved the denial of everything the English school had hitherto held sacred. They accepted Nature alone to be their future guide and Bible, and in it they beheld the condemnation of all art *except the earliest art of Italy*. . . . These men threw themselves into the study of the natural, and

had implicit faith in the all-teaching of Nature without assistance from the stores of past knowledge.' Sir Coutts Lindsay's statement is not without over-simplification, but it makes a clear and convenient point of departure for our critical tale.

Whatever the defects of this account, it is at least specific, which is more than can be said of one of William Michael Rossetti's many retrospective formulations of the Brotherhood's intention, making us wonder just how artistically self-knit was the group behind the sodality of its name. In the memoir affixed to *D. G. Rossetti, his Family Letters* (1895), he enumerates four objects: '(1) To have genuine ideas to express; (2) to study Nature attentively, so as to know how to express them; (3) to sympathize with what is direct and serious and heartfelt in previous art to the exclusion of what is conventional and self-parading and learned by rote; (4) to produce thoroughly good pictures and statues.' Innocence or naïveté, there is not much of what D. G. Rossetti called 'fundamental brainwork' about this manifesto. Compare it with the declared aims of most continental movements and its lack of theory and blue-print is observed.

It is probably easier to define the aims of the Brotherhood in its negative rather than affirmative aspect. 'Down with slosh!' had been the initial war-cry of these young Academy students, by which they referred to a large species of contemporary picture-making distinguished by facetiousness, imaginative slackness and sentimentality. Looking back to their early beginnings, Holman Hunt grouped together the abuse of domestic genre painting and the second-hand nature of much contemporary academic production. 'The name of our Body,' he wrote, 'was meant to keep in our minds our determination ever to do battle against the frivolous art of the day, which had for its ambition "Monkeyana" ideas [reference to a vulgar and would-be humorous depiction of animals by Landseer], "Books of Beauty", Chorister Boys, whose forms were those of melted wax with drapery of no tangible texture. The illustrations to Holy Writ were feeble enough to incline a sensible public to revulsion of sentiment. Equally shallow were the approved imitations of the Greeks, and paintings that would

ape Michael Angelo and Titian, with, as the latest innovation, through the Germans, designs that affected without sincerity the naïveté of Perugino and the early Flemings.[1]

All of the first Pre-Raphaelites would nominally have subscribed to this critique by Hunt, even if their own practice did not quite square with it throughout. From the start of the Movement, however, there were actually two points of view, two philosophies of art, and two procedures, which time was to make clearer, creating both distinction and division. Hunt, in fact, located this dichotomy (though not with the Brotherhood in mind) in an early conversation he had with Millais. 'It is,' he later reports himself as saying, '*simply* fuller nature that we want. Revivalism, whether it be of classicism or medievalism, is seeking after dry bones.' Now a revival of medieval themes and images is exactly what D. G. Rossetti and Edward Burne-Jones—the artist most influenced by him—principally achieved. That the 'dry bones' abhorred by Hunt seldom showed through their compositions is due to the powerful subjective purpose they made these objective medieval forms serve. Indeed, one might say that the Middle Ages inhabited by these painters is one of fantasy rather than history. In Burne-Jones's case, the imaginary world of his art was extended to take in the territories of Classical myth, but with a considerable diminution of feeling. Later, pan Pre-Raphaelite artists such as Albert Moore and Laurence Alma-Tadema worked in more external fashion in this field though still seeking to say something which the Greek or Roman artists, or their Renaissance enthusiasts, would hardly have had in mind. Certainly, it was through D. G. Rossetti that one wing of Pre-Rapahaelitism merged with Aestheticism and, later still, even with the Symbolism and Decadence of the nineties.

Taken as a whole, Pre-Raphaelitism might be described as a postscript to the Romantic Movement, a final manifestation of that force inhabiting the domain of visual art. D. G. Rossetti is recorded as saying that any poetic young man of his day should turn to painting rather than verse, since in poetry it had

[1] *Pre-Raphaelitism and the Pre-Raphaelite Brotherhood* (1904).

xviii																								*Introduction*

already been done. One could, then, for the sake of con-
venience, regard Rossetti as the source of the poetic side of
Pre-Raphaelite painting, and Holman Hunt as its prose
disseminator. (The position of being its great prose master is an
honour which must go to Ford Madox Brown, never a member
of the Brotherhood proper.) It is, therefore, from Holman
Hunt with the impressive backing of the older Madox Brown,
that Pre-Raphaelite realism develops.

In equating 'prose' with 'realism' in this manner, we must
be careful not to exclude certain vivid characteristics some-
times thought of as poetic. One critic, writing on Hunt, has
spoken of 'that choice of colours, blue-green, purples, violets,
which came to be one of the marks of much Pre-Raphaelite
painting; colour which, however naturalistically rendered,
was selective, aimed at producing certain emotional effects.' [1]
Then there is the almost microscopic employment of detail
that constitutes a *poetry of particulars*. Passages from Madox
Brown's *Journal* offer plenty of evidence of this. 'What wonder-
ful effects I have seen this evening in the hayfields!' he records
on 21 August 1855, 'the warmth of the uncut grass, the greeny
greyness of the unmade hay in furrows or tufts with lovely
violet shadows, and the long shades of the trees thrown athwart
all, and melting away one tint into another imperceptibly; and
one moment more a cloud passes and all the magic is gone.'

The *pleinairism* of Madox Brown and Holman Hunt helped
both to discover new detail and to paint it with a freshness and
vividness not often attainable by studio artists. This cult of
detailization called for a conscientiousness which was moral as
well as asthetic. Neither the lazy painter nor he with one eye
on the clock, mindful that time is money, could execute his
work in this ardent inch-by-inch manner. While engaged on
his picture, *The Last of England*, Madox Brown remarks in his
diary that 'the madder ribbons of the [woman's] bonnet took
me four weeks to paint'. By the late eighteen-fifties this
scrupulous vigilance was beginning to pay off in terms of a
nationwide influence. 'I see,' wrote Ruskin in 1857 that 'as
year by year, in the Royal Academy, the principles established

[1] Raymond Watkinson, *Pre-Raphaelite Art & Design* (1970).

by the [Pre-Raphaelites] are more frankly accepted, and more patiently put into practice . . . there will be [a] high . . . average of perseverance and care brought to bear on every subject.' [1] The progress of P.R. principles and practice continued apace vigorously, and the next year Ruskin was likewise observing that at the R.A. Summer Exhibition 'the rooms are filled with more or less successful work by the disciples of the Pre-Raphaelite school'.

Yet, by this time, the *realistic* or *prose* aspect of the Pre-Raphaelite painting can be seen as yielding ground to the *romantic, fantasy,* or more recognizably *poetic* side of the Movement. In 1857 D. G. Rossetti led a young band of his cronies (including Arthur Hughes and Valentine Cameron Prinsep) to paint the walls of the Oxford Union with frescoes. This caravanserai, which was joined by certain choice spirits then at the university—Burne-Jones, William Morris, A. C. Swinburne and some others—did not exactly perpetrate a deathless monument to the Pre-Raphaelite spirit in Hopkins's 'towery city and branchy between towers'. 'The distemper . . . flew off the thinly whitewashed brick surface like smoke. The vision of an age that never was disappeared almost at once.' [2] The author of this quotation describes the escapade as 'a mystic rag'. 'What fun we had in that Union! What jokes! What roars of laughter!' recalled Van Prinsep (speaking as Taffy in Du Maurier's bohemian novel *Trilby*). Yet Rossetti's expedition from London certainly achieved a good deal more than a glorious medieval 'spoof'. From the encounter of the metropolitan capital and Oxford, a powerful and younger second wave of Pre-Raphaelitism was launched.

Things had been germinating at Oxford for some time. Second-wave Pre-Raphaelites were obsessively hooked on the Middle Ages. Burne-Jones—'a lank, pale, delicate fair-haired undergraduate'—was writing home to Birmingham in 1854 of a day he had spent at Godstowe—'the burial place of Fair Rosamund'. 'I came back in a delirium of joy . . . in my mind pictures of the old days, the abbey and long processions of the faithful, gay knights and ladies by the riverbank—and all the

[1] *Notes on the Royal Academy*, III (1857).
[2] William Gaunt, *The Pre-Raphaelite Dream* (1943).

pageantry of the golden age—it made me so wild and mad I had to throw stones into the water to break my dream.[1] Recent history also seemed in the process of repeating itself. Friends of Burne-Jones at Oxford thought of themselves as the 'Birmingham Group', and there was some talk of founding a 'Brotherhood' based on High Church ideals to live a semi-monastic life and do missionary work in some large city. Just as the P.R.B. might be thought of as an artistic answer to the material ugliness of industrial urban living, so this briefly mooted Oxford sodality—'the Order of Sir Galahad' with Burne-Jones as its self-elected General—can be viewed as a religious response to the moral ignominy of Victorian megalo-politan existence. As it happened, the worthy General, along with his new Oxford friend William Morris, exchanged a call to Holy Orders for one which exacted service to the Muse.

For Burne-Jones, 1856 was 'the wonderful year'. It was then that he was introduced in London to his hero D. G. Rossetti; the same year that—financed by Morris—he and William and other congenial spirits founded and conducted that short-lived organ *The Oxford and Cambridge Magazine*. Clearly modelled upon the P.R.B. publication, even to the point of reprinting a revised version of D. G. Rossetti's poem *The Blessed Damozel*, it was referred to by that poet as 'the Oxford and Cambridge *Germ*' in which 'all the contributors write for love or spooni-ness', 'tin [being] out of the question'. For Rossetti, it was 'that miraculous piece of literature', as he wrote to his friend William Allingham, and Burne-Jones 'one of the nicest young fellows in Dreamland'. Through him, Rossetti obtained a hold on a slightly younger generation, the difference between them being about five years.

This was an influence of a kind denied to Holman Hunt, since though that painter had his admirers he failed to inspire a younger artist of the calibre of Burne-Jones. Among the P.R.B. Hunt was sometimes addressed as President, but the resonance of his personality—as distinct, in part, from that of his work—tended to diminish with the years, as that of Rossetti was augmented.

[1] Georgina Burne-Jones, *Memorials of Sir Edward Burne-Jones* (1904).

Both before and after 1857—the time of Rossetti's triumph at Oxford—realistic canvases, of a kind which Hunt might have influenced or approved, were painted by a number of minor Pre-Raphaelite artists. One thinks of Henry Alexander Bowler's *The Doubt: Can these Dry Bones Live?* (1856), of Henry Wallis's *The Stonebreaker* (1857), of John Brett's *The Stonebreaker* (1858),[1] of R. B. Martineau's *The Last Day in the Old Home* (1862), of William Dyce's *Pegwell Bay* (1859–60); but whereas all these pictures—though stamped with an authentic Pre-Raphaelite passion for detail—exhibit a variety of feeling-tone, those influenced by D. G. Rossetti, or by his first lieutenant Burne-Jones, manifest a unitive sensibility. Hunt's practice was greatly respected, but what his example was responsible for was not a school of painting but a miscellany of pictures. Rossetti, on the other hand, created a collective way of seeing, an almost uniform imaginative vision—the paradox of which lay in the fact that he had elaborated it to serve the purpose of his own subtle, elusive and unique personality. A superstitious, more-than-semi-Italian pagan masquerading as an 'art Catholic', Rossetti bequeathed his expressive formula to a wide variety of individual artists, very unlike him as men yet bewitched and captured by his own subjective fantasy. The realism of the nineties is hardly that of Hunt, whereas its aestheticism bears D. G.'s signature patently upon it. Rossetti, in fact, through Burne-Jones and Swinburne, is probably the strongest single influence on painting and poetry in the second half of the nineteenth century.

'The term Pre-Raphaelite Brotherhood would not enter into the history of English poetry,' Professor Ifor Evans has told us, 'except for two accidents: first, Rossetti was a poet, and secondly, he was fortunate in influencing forward minds in poetry as well as in painting. Yet little of Rossetti's own work, or that of his associates, conforms to the principles set out by the pre-Raphaelite Brotherhood. . . . The Pre-Raphaelite movement in poetry is little more than an inconvenient synonym for Rossetti's personal influence on English poetry.' [2] There are provisos and qualifications one might like to make

[1] See plates.
[2] *English Poetry in the Later Nineteenth Century* (1933).

here, but the gist of the statement is undeniably true: namely, that it was D. G. Rossetti who brought Pre-Raphaelitism into the domain of letters, providing the Movement with a conscious and distinguished literary wing. Certain members of the Brotherhood and its early sympathizers had written poetry without, in all cases, conscientiously practising the art of verse. William Michael Rossetti, Thomas Woolner, James Collinson, Walter H. Deverell, J. L. Tupper and Ford Madox Brown all wrote poems—sometimes, one feels, as so many relief valves or as exercises in picturesque or sentimental pastiche. The first of these names is a minor exception, and the use of clear detail in his imagery is consciously in line with the close imitation of nature demanded by P.R. principles.

Nor would it (*pace* Professor Ifor Evans) be so difficult to instance numerous examples of exact descriptive writing in the verse of D. G. Rossetti and William Morris—to mention the two leading poets of Pre-Raphaelitism. It is not only the former's *Jenny*—a sociological drama vividly documented with telling images—which applies the method of detail painting. *Jenny's* anti-type *The Blessed Damozel* is full of firmly presented material fact. So, too, are many of his love poems, where he uses natural detail in symbolic or associative manner to express states of mind and modes of feeling. William Morris's medieval poems often avoid the alienness of a remote world solely by the degree in which they employ carefully observed concrete imagery both for background and foreground purposes. Minor figures such as William Allingham, William Bell Scott and William Michael Rossetti also testify to the Pre-Raphaelite cult of particularity. Then, of course, one must not forget the single significant P.R. woman poet, that strange spirit Christina Rossetti. The only notable exception among Pre-Raphaelite supporters, in terms of devotion to detail, is Algernon Charles Swinburne who dissolved the hard-edged P.R. technique in a soft, blurring glow of alliterative word music.

All in all, one is not very far from Gerard Manley Hopkinson's notion of the *quidditas* or 'what-ness' of a thing—its essential irreducible identity—and his expression of this by means of his multi-compound images. From this there is a clear connection with James Joyce's 'epiphanies', as explained in

Stephen Hero—his fictional trial run for *Portrait of the Artist as a Young Man.* Retrospectively, these 'epiphanies' (or word pictures of revelatory moments) look back to the 'phanopoeia' or eye-poems of the Imagist Movement which Ezra Pound and his friends developed, and, beyond that, to the Impressionist poems of the eighties and nineties as pioneered by Henley and Wilde and elaborated upon by Arthur Symons, John Gray, Theodore Wratislaw and other *fin-de-siècle* aesthetes.

This précis survey, with rapid forward-and-backward look at time, does not, however, exhaust the contribution which Pre-Raphaelitism—largely under Rossetti—made to nineteenth-century culture. Out of the impact which he made on the dreamer Burne-Jones and the man of action Morris, there developed the Arts and Crafts Movement: a curious combination of aestheticism, medievalism, socialism and functionalism. And here again the P.R. cult of detail proved the strength of its hold on the new artists. For instance, in wallpapers and carpets produced by the firm of Morris, the Pre-Raphaelite descriptive image is often given a decorative interpretation without at the same time losing its botanical exactitude. In whatever direction we turn in the later nineteenth century, whatever seems new, proves, as likely as not, to have its roots in Pre-Raphaelitism.

III

The literary achievement of Pre-Raphaelitism is a considerable one. Indeed it can be argued—as did Earle Welby—that Victorian Romanticism *is* Pre-Raphaelitism pure and simple. The reasoning here is clear enough: Tennyson and Browning as Romantic poets are 'pre-Victorian. Tennyson being a poet to whom Keats is a recent discovery, Browning one who has lately discovered Shelley.' By the time Victoria came to the throne, the romanticism of the Lake School had spent itself. Nor had there been, save for Wordsworth and Coleridge, the kind of coherence among its members that there was for a good many years among the associates of Rossetti. Keats, Shelley

and Leigh Hunt were men 'very much going their own way'.

This left, as contenders for Romantic hegemony, Matthew Arnold and the Spasmodics (Sydney Dobell, Alexander Smith, John Stanyan Bigg and others), the first of whom specifically repudiated Romanticism in the famous preface to his *Poems* of 1853; while the second lacked the artistic standing to be thought of as a serious contestant body. In addition to this— as Earl Welby pointed out—Pre-Raphaelitism obtained for itself a good critical press. From the fifties to the nineties, they had the influential support of Ruskin, Pater, Wilde and Arthur Symons in that continuing order. In other words, the work of these men of genius, talent and sensibility was also interpreted and disseminated by men of sensibility and distinctive talent.

Pre-Raphaelitism's literary achievement is predominantly a poetic one; though when one comes to ask quite what is a Pre-Raphaelite poem, most answers prove to be none too applicable, the best probably having been made by James D. Merritt in the introduction to his anthology *The Pre-Raphaelite Poem* (1966):

> There are certain characteristics which may be seen as typical of all (or *almost* all) Pre-Raphaelite poetry:
> 1. A heavy use of descriptive detail.
> 2. Images that tend to be highly sensuous and full of colour.
> 3. The occasional use of an obscure symbolism, such as repeated use of the number seven, and references to the more mysterious aspects of Christianity or of 'pagan' religion.
> 4. A tendency to lend the tone (if not the form) of a ballad to the narrative.
> 5. The frequent use of subjects that have an innate poignancy or morbidity. Many of these subjects were taken from literary sources.
> 6. Deliberate 'mediaevalism', such as the use of mediaeval sounding words, or the use of settings that, though unidentified, seem Pre-Renaissance.

One could certainly find *all* these 'notes' or elements in the collected poems of D. G. Rossetti; while one, two or more of

them are to be severally discovered in the verse of Christina Rossetti, Swinburne, Morris, Watson Dixon, O'Shaughnessy and Bell Scott.

Another distinguishing mark of the Pre-Raphaelite poem is the degree to which it trafficks with the visual world. The result of this preoccupation is to be seen in two ways: in a greater degree of coloured or distinctly contoured optical imagery, or in poems written about, or inspired by, works of graphic art. In his essay on D. G. Rossetti, Pater speaks of that 'particularization' which was his 'first condition of the poetic way of seeing and presenting things' and notices 'a definiteness of sensible imagery' as 'one of the peculiarities of *The Blessed Damozel*'. This celebrated poem, of course, is full of what Pater calls 'delight in concrete definition'—

> She had three lilies in her hand
> And the stars in her hair were seven
>
> * * *
>
> And the lilies lay as if asleep
> Along her bended arm.
>
> * * *
>
> The sun was gone now; the curled moon
> Was like a little feather

—and a like power of focusing upon exact detail is a characteristic of the majority of Pre-Raphaelite poets.

Poems on pictures, or poems inspired by paintings, another characteristic Pre-Raphaelite composition, are often of high quality. D. G. Rossetti's poems contain ten *Sonnets on Pictures* and fourteen *Sonnets and Verses for* . . . [his own] *Works of Art*.[1] Swinburne wrote his famous *Before the Mirror* for Whistler's *Symphony in White No. 2. The Little White Girl* (1864), and John Payne has a section *Ut Pictura* of twelve poems on paintings by Burne-Jones, Böcklin, Delacroix and others in his volume *Vigil and Vision* (1903).

Placing Pre-Raphaelite poetry in the context of nineteenth-century literature, one may say that it purified the Victorian idiom of verse which preceded it by weeding out its unctuous

[1] *The Collected Works of Dante Gabriel Rossetti*, ed. W. M. Rossetti (1886).

wordy moralism, and substituting criteria of emotional and
atmospheric intensity for those of 'message' and 'prophecy'.
Looking forward, Pre-Raphaelite poetry strongly influenced
that of the aesthetic period and the verse of the nineties; the
first by bequeathing it a stock of images of 'the beautiful', thus
encouraging the visual expressiveness of aestheticism; the
second, by imparting to it something of its own cult of intensity
—resulting in a poetry which was often passionate, melan-
choly or morbid. Rossetti and Swinburne, between them, are
sufficient to explain most of the purely *English* element in the
subsequent poetry of the nineteenth century. Add Gautier,
and you have aestheticism; add Baudelaire, Verlaine and
Mallarmé, and the formula for the decadent and symbolist
poetry of the nineties is complete.

The case against Pre-Raphaelitism in poetry was stated by
W. W. Robson in his essay 'Pre-Raphaelite Poetry' included
in *The Pelican Guide to English Literature: 6* (1958). It proceeds to
its conclusion on Arnoldian lines, and censures the P.R. poets
for their creation of a dream-world instead of instituting 'a
criticism of life'. The charge is one which cannot be gainsaid;
but in making this judgment, Mr Robson is ignoring their
intention which most specifically was to *establish certain modes
of imaginative escape*. Burne-Jones himself was reported as saying
that the more locomotives *they* created the more *he* would paint
pictures of angels. 'The true explanation of the Pre-Raphaelite
movement,' wrote Herbert Read, 'is the Great Exhibition,'
with the 'paraded ugliness and vulgarity of every single
object.' [1] It should, however, not be forgotten that the dream
or escape-poetry of the Pre-Raphaelites only provided social
and, sometimes, historical relief. Psychologically its often
intense subjectivity heightened rather than lessened the burden
of isolation, pain and sorrow as felt by the individual.

Mr Robson may be right in judging Pre-Raphaelite poetry
harshly from Arnold's point of view; but Arnold, in his time,
was an exception; and nearly all the artistically successful
poetry from Rossetti to early Eliot *is* of a non-didactic order.
Pre-Raphaelite poetry inaugurates the search for a *pure poetry*

[1] *The Philosophy of Modern Art* (1952).

as it came to be pursued and understood, whether in England, Italy or France; and the direction which the P.R. poets took was, in fact, that of modern painters in their quest for aesthetic purity and the notion of 'significant form'.

Next to painting, then, it was poetry which represented a considerable Pre-Raphaelite achievement; and next to this comes criticism. Whether in the field of the appreciation and assessment of art or of literature, Pre-Raphaelitism helped to establish a more *apposite* response and judgment than had frequently prevailed. One of the reasons for the improvement which it brought to the critical field is the keener, clearer, more sensitive co-ordination of the eye and the mind in such matters. For the critic of art, the first prerequisite is to *see the picture* which he looks at, a truism the realization of which had evaded many a critic. When Ruskin is confronted by a painting, he not only perceives it, he re-creates it. Compare, for example, Ruskin's description of Millais's *The Blind Girl* (in 'The Three Colours of Pre-Raphaelitism', *The Old Road*, 1885) with almost any non Pre-Raphaelite critic writing before him. And nowhere is the Pre-Raphaelite turn of mind, with its returning emphasis on detail, imagery and minutiae more successfully apparent than in the writings on art by authors predominantly men of letters. Thackeray had, as we know, a style of great charm; but we have only to contrast his words on paintings and drawings as an occasional reviewer of current exhibitions with those of Pater and Arthur Symons to sense the development of visual sensibility which Pre-Raphaelitism had effected in men of literary culture.

Nor did those critics, properly called Pre-Raphaelite, leave behind, in their writings on literature and art, any unsignificant body of work. The multi-coloured surface of Swinburne's critical writing, swept by keen rhetoric of likes and dislikes, presents the reader with an animated syntax seldom to be found in this supposedly sober and judicial *genre*. Morris expatiates on Gothic architecture with warmth and naturalness and, as a polemicist or propaganding publicist, writes with straightforwardness and vigour, and a pretty general show of powerful common sense. Then there are the sane and capable journeyman-critics, F. G. Stephens and W. M. Rossetti; and—

dare one claim him?—Ruskin himself, who so often descanted upon the Pre-Raphaelites as to seem almost one of them.

With its wealth of visual imagery, Pre-Raphaelite criticism led, naturally enough, to the Impressionist criticism of the nineties. In terms of style, this is understandable since both methods of interpretation frequently employed concrete modes of speech. There is, however, a paradox in the situation: the Pre-Raphaelite and Impressionist painters were utterly opposed to one another, working with different techniques, on antithetical assumptions. It is true, none the less, that a critic such as Arthur Symons was sympathetic to both, writing with great sensibility on Whistler and the Rossettis.

Of all the forms of literature, it is fiction in which Pre-Raphaelitism is most deficient. Indeed, it is almost impossible to talk about 'the Pre-Raphaelite novel' as one can speak about 'Pre-Raphaelite poetry'. Instead, there are only odd novels by one or two Pre-Raphaelites—such as Oliver Madox Brown's *Gabriel Denver* (1873), or William de Morgan's six Dickensian fictions, written after he retired at the age of sixty-seven from making Pre-Raphaelite pottery—which cannot be said to be intrinsically Pre-Raphaelite; or a few works by Pre-Raphaelite authors which are, in their manner, Pre-Raphaelite in part. To this second category belong Swinburne's two fictions: *Love's Cross-Currents* (1877), and the unfinished *Lesbia Brandon*, published posthumously in 1952; Theodore Watts-Dunton's *Aylwin* (1898) and William de Morgan's largely autobiographical *Old Man's Youth* (1921) which was completed after his death by his wife.

This leaves us with a third group of novels which constitute something of a case on their own: the work in fiction of William Morris. Neither of the two kinds of fiction which he wrote—the romantic propaganda story (*News from Nowhere*, 1891, and *A Dream of John Ball*, 1888), or the archaic romances (*The House of the Wolfings*, 1889; *The Wood Beyond the World*, 1894; *The Well at the World's End*, 1896; and others)—bears much resemblance to the fiction of his day. Alone among the Pre-Raphaelites, Morris seems to be quite at home with fiction, writing in his own confident way, though it is clearly no one else's.

News from Nowhere, his utopian novel, may not have been without influence on the early fiction of H. G. Wells, even though the Socialism of the two men was of such a different order. It can certainly be said to reconcile the values of the Arts and Crafts Movement with a vision of Socialism active before 1930. It was without doubt the archaizing romance of Morris which most influenced subsequent novelists. Arthur Symons describes the prose of Morris, here, as 'that elaborately simple language, in which the Latin element of English is drawn on as little as possible, and the Saxon element as largely as possible, a language which it has pleased some persons to call a bastard tongue'.[1] Another pejorative term of reference for this kind of prose—especially in its over-blown aspect—is 'Wardour Street'. There is a distinct vein of middle-brow fiction deriving from these romances of Morris, running from the historical novels and idylls of Maurice Hewlett to James Branch Cabell's *Jurgen*.

IV

Had this anthology been appearing in the Everyman series some forty years ago, it would have been graced production-wise by certain fitting Pre-Raphaelite touches. Influenced by Morris and Burne-Jones, the young decorative artist Reginald J. Knowles drew the now familiar two draped ladies on the end-papers of early volumes of that series. He was also responsible for the design on the title-page and the full-depth gold and black spine. Indeed, he drew the lettering for every Everyman volume until the middle 1930s. One has only to compare the firm, well-spaced lettering of the title-pages and the richly wrought decoration in the margins with, say, the design by Burne-Jones for William Morris's *A Dream of John Ball*, published by the Kelmscott Press in 1892, to see the archetype which inspired Knowles.

Pre-Rapahelite book production was just one of the many

[1] 'William Morris's Prose' (*Studies in Prose & Verse*, 1904).

arts developed and put on a footing by Morris. Between 1889 and 1890 he made an eminently practical start by supervising the printing of three of his own titles at the Chiswick Press, the firm preceding his own Kelmscott Press with the best standards of craftsmanly work. On 4 April 1891 the printing of his romance *The Story of the Glittering Plain* was completed, and Kelmscott Press, installed in a cottage close to Morris's town abode at Kelmscott House, Upper Mall, Hammersmith, issued its first book. Fifty-three titles appeared from this press during its lifetime of six years which, as Holbrook Jackson remarked, 'stand unique among books both for honesty of purpose and beauty of accomplishment'.[1] Along with Emery, he put forward an idea on what the last authority suggestively calls 'a new ethic of good printing' in a joint essay contributed to *Arts and Crafts Essays*, 1893—thus providing this movement of revival with a simple historical basis and theory.

That J. M. Dent—founder of the Everyman series—was influenced by these new stirrings in printing and book design is evident from what his son Hugh reports in editing his father's memoirs: 'When he came to know the work of Morris and Cobden-Sanderson his admiration was at once secured, and he had a strong sympathy with the ideas and ideals at the back of the Arts and Crafts Movement . . . in arranging the binding of his own books most of the designs were based upon ideas which he put before the artists who made the actual drawings.'[2] The fruits of this enthusiasm were seen from 1906 onwards when the first titles of the Everyman series appeared. As J. C. Steinberg writes in his authoritative work, *Five Hundred Years of Printing* (revised edn 1964), 'The first application of the revival of printing to mass-produced books was made by J. M. Dent. The "Everyman's Library" . . . adopted William Morris's principles and—at least in its title-pages and end-pages—style.'

Another interesting connection between J. M. Dent and Pre-Raphaelitism was the publication by the firm, in monthly parts beginning June 1893, of the now famous two-volume

[1] 'The Revival of Printing' (*The Eighteen-Nineties*, 1913).
[2] *Memoirs of J. M. Dent* (1938).

edition of Malory's *Morte D'Arthur* profusely illustrated and decorated by Aubrey Beardsley. In his last days, this prodigious draughtsman was to repudiate the Pre-Raphaelites and all their work, but when he was commissioned by J. M. Dent to undertake the task, he was in a flush of excitement over Burne-Jones whom he had described in 1891 as 'the greatest living artist in Europe'.[1] Such an attribution of status was not, perhaps, so very surprising, since in the summer of that year Burne-Jones had assured the youthful Aubrey that 'one day you will most assuredly paint very great and beautiful pictures'.

Editorial Note

In order to encompass the widest range of material possible, I have chosen many items presented only in extract. The drawbacks to such a method of anthologizing are often compensated for by the fact that the portion actually produced is frequently the most vivid passage in the original or the only one with interest for us today. In other instances, as with excerpts from Swinburne's poems, it is the principle of correlation which has lead to their inclusion. *Dolores*, *Faustine* and *Anactoria* are well-known poems, but the mention of them by John Morley in his attack on the poet and by Swinburne in his own prose defence, as well as Arthur Clement Hilton's amusing parody of the first poem, seemed to call for some minimal reproduction of them.

DEREK STANFORD.

Seaford, 1972.

[1] *The Letters of Aubrey Beardsley*, ed. Henry Maas, J. L. Duncan and W. G. Good (1971).

Select Bibliography

This list of titles has been planned to supplement the titles of books given in the introduction, the contents pages and the prefatory notices.

INDIVIDUAL AUTHORS

WILLIAM ALLINGHAM. WORKS. Verse: *Poems*, 1850; *The Master Music*, 1855; *Songs, Ballads and Stories*, 1877; *Evil May-Day*, 1883; *Ashby Manor*, 1883; *Blackberries*, 1884; *Irish Songs and Poems*, 1887; *By the Way*, 1912. Prose: *Varieties in Prose*, 1893.

FORD MADOX BROWN. BIOGRAPHICAL AND CRITICAL: F. M. Hueffer, *Ford Madox Brown—A Record of his Life and Work*, 1896.

EDWARD BURNE-JONES. WORKS: *Letters to Katie*, introduced by W. Graham Robertson, 1925. BIOGRAPHICAL AND CRITICAL: Penelope Fitzgerald, *Edward Burne-Jones: A Biography*, 1975.

ROBERT BUCHANAN. WORKS. Verse: *Undertones*, 1863; *Idylls and Legends of Innerburn*, 1865; *London Poems*, 1866. Prose: (Novels) *The Shadow of the Sword*, 1876; *God and Man*, 1881. (Plays) *A Nine Days' Queen*, 1880; *Alone in London*, 1884. (Criticism) *David Gray and other Essays*, 1868. BIOGRAPHICAL AND CRITICAL: Archibald Stodart-Walker, *Robert Buchanan*, 1901; Henry Murray, *Robert Buchanan*, 1901.

CHARLES DICKENS. WORKS: Gadshill Edition, 1897. Autobiographical: *Letters*, 3 vols, 1880–1. BIOGRAPHICAL AND CRITICAL: John Forster, *Dickens*, 1872–4.

RICHARD WATSON DIXON. WORKS. Verse: *Christ's Company*, 1861; *Historical Odes*, 1864; *Mano*, 1883; *Odes and Eclogues*, 1884; *Songs and Odes*, 1896; *Last Poems*, 1905. Prose: *The Close of the Tenth Century*, 1858; *The Life of James Dixon, D.D.*, 1874. BIOGRAPHICAL AND CRITICAL: Robert Bridges, *Three Friends*, 1932; A. J. Sambrook, *Poet Hidden—Life of Richard Watson Dixon*, 1962.

SEBASTIAN EVANS. WORKS. Verse: *Songs and Etchings*, 1871; *In the Studio*, 1875.

WALTER HAMILTON. WORKS: *A Memoir of George Cruickshank*, 1878; *The Poets Laureate of England*, 1879.

WILLIAM HOLMAN HUNT. WORKS: 'Artistic Copyright' (*The Nineteenth Century Magazine*), March, 1879; 'The Pre-Raphaelite Brother-

hood—a Fight for Art' (*The Contemporary Review*), 1886. BIOGRAPHICAL
AND CRITICAL: John Ruskin, *Notes on the Pictures of Mr. Holman Hunt,
exhibited at the rooms of the Fine Art Society, 1886*, 1886; Mary E. Cole-
ridge, *Holman Hunt*, 1910; Diana Holman-Hunt, *My Grandfather—His
Wives and Loves*, 1969.

HENRY JAMES. WORKS. Fiction: New York Edition, 1907–9 (now
being reprinted by Scribners). Non-fiction: *The Painter's Eye*, 1956;
English Hours, 1905. Autobiographical: *A Small Boy and Others*, 1913;
Notes on a Son and Brother, 1914. BIOGRAPHICAL AND CRITICAL: Leon
Edel, *Henry James*, 5 vols, 1953–68.

PHILIP BOURKE MARSTON. WORKS. Verse: *Song-Tide*, 1871; *A Last
Harvest*, 1891; *Collected Poems*, 1892. BIOGRAPHICAL AND CRITICAL:
C. C. Osborne, *P. B. Marston*, 1926.

JOHN MORLEY. WORKS. *Critical Miscellanies*, 1871–7; *Studies in Litera-
ture*, 1890. BIOGRAPHICAL AND CRITICAL: F. W. Hirst, *John Morley—
Early Life and Letters*, 1927; J. D. MacCullum, *Lord Morley's Criticism
of English Poetry and Prose*, 1921.

WILLIAM MORRIS. WORKS. Verse: *The Defence of Guenevere*, 1858; *The
Life and Death of Jason*, 1867; *The Earthly Paradise*, 1868–70; *Love is
Enough*, 1872; *A Choice of William Morris's Verse*, selected and intro-
duced by Geoffrey Grigson, 1969. (Translation) *The Story of Sigurd the
Volsung*, 1877. Prose: (Romances) *A Dream of John Ball*, 1888; *The
Roots of the Mountains*, 1890; *The Story of the Glittering Plain*, 1891; *A
Tale of the House of the Wolfings*, 1896; *The Well at the World's End*,
1896; *The Sundering Flood*, 1897; *The Water of the Wondrous Isles*, 1897.
(Translation, individual or in collaboration) *Grettir Saga*, 1869;
Volsunga Saga, 1870; *Three Northern Love Stories*, 1875; *The Saga
Library*, 1891–5; *The Tale of Beowulf*, 1895. Critical: *The Lesser Arts*,
1878; *The Beauty of Life*, 1880; *Art and the People*, 1883; *The Aims of
Art*, 1887; *The Collected Works of William Morris*, 24 vols, introduced
by May Morris, 1910–15; *William Morris—Selected Writings and Designs*,
edited by Asa Briggs, 1962. BIBLIOGRAPHICAL AND CRITICAL:
Aymer Vallance, *William Morris—His Art, His Writings, and His
Public Life*, 1897; B. I. Evans, *William Morris and his Poetry*, 1925;
E. P. Thompson, *William Morris—Romantic to Revolutionary*, 1955.

FREDERIC WILLIAM HENRY MYERS. WORKS. Verse: *St. Paul*, 1867.
Prose: *Wordsworth*, 1881; *Essays Classical*, 1883; *Science and a Future
Life*, 1893.

ARTHUR WILLIAM EDGAR O'SHAUGHNESSY. WORKS. Verse: *An Epic of Women*, 1870; *Lays of France*, 1872. BIOGRAPHICAL AND CRITICAL: Richard Garnett, 'Arthur O'Shaughnessy' (*The Dictionary of National Biography*).

JOHN PAYNE. WORKS. Verse: *The Masque of Shadows*, 1870; *Intaglios*, 1871; *Songs of Life and Death*, 1872; *Lautrec*, 1878; *New Poems*, 1880; *Collected Poems*, 1902; *Songs of Consolation*, 1904; *Flower o' the Thorn*, 1909; *The Way of the Winepress*, 1920.

CHRISTINA ROSSETTI. WORKS. Verse: *The Prince's Progress and other Poems*, 1866; *Sing-Song*, 1872; *A Pageant and other Poems*, 1881; *Verses*, 1893; *New Poems*, 1896; *Poems*, preface by A. Meynell, 1910. Prose: (Fiction) *Commonplace, and other short stories*, 1870; *Speaking Likenesses*, 1874; *Maude*, 1897. (Devotional) *Annus Domini, a Prayer for each Day of the Year*, 1874; *Seek and Find*, 1879; *Called to be Saints*, 1881; *Letter and Spirit*, 1883; *Time Flies*, 1885; *The Face of the Deep, a Devotional Commentary on the Apocalypse*, 1892. Autobiographical: *Family Letters of Christina Rossetti*, ed. W. M. Rossetti, 1908. BIOGRAPHICAL AND CRITICAL: Ellen A. Procter, *Brief Memoir*, 1895; Edith Birkhead, *C. Rossetti and Her Poetry*, 1931; Lona Mosk Packer, *Christina Rossetti*, 1963.

DANTE GABRIEL ROSSETTI. WORKS. Verse: *The Early Italian Poets*, 1861, reissued as *Dante and his Circle*, 1874; *Poems*, 1870; *Ballads and Sonnets*, 1881. Prose and Verse: *Collected Works*, 1886. Autobiographical: *Dante Gabriel Rossetti—his family letters*, ed. William Michael Rossetti, 1895; *Letters of Dante Gabriel Rossetti*, ed. O. Doughty and J. R. Wahl, 1965-8. Art: Marina Henderson, *Dante Gabriel Rossetti*, 1973. BIOGRAPHICAL AND CRITICAL: William Sharp, *Rossetti*, 1882; T. Hall Caine, *Recollections of Dante Gabriel Rossetti*, 1882; William Michael Rossetti, *Dante Gabriel Rossetti as Designer and Writer*, 1889; O. Doughty, *A Victorian Romantic: Dante Gabriel Rossetti*, 1949, 2nd edn 1960.

WILLIAM MICHAEL ROSSETTI. WORKS. Verse: *Democratic Sonnets*, 1907. Prose: *Lives of famous poets*, 1878; *Life of Keats*, 1887; *Dante and his Convito—A Study*, 1910; (with E. Dowden and Richard Garnett) *Letters about Shelley*, 1917; *Letters concerning Whitman, Blake and Shelley to Anne Gilchrist*, 1934. Autobiographical: *The Family of Rossetti—three Rossettis*, ed. J. C. Troxell, 1937; *The Rossetti-Macmillan Letters, 1861–1889*, ed. L. M. Packer, 1963.

ROBERT ROSS. WORKS. Prose: *Aubrey Beardsley*, 1909.

JOHN RUSKIN. WORKS. *The Seven Lamps of Architecture*, 1849; *The Stones of Venice*, 1851–3; *Frondes Agrestes*, 1875; *Arrows of the Chace*, 1880; *The Works of John Ruskin*, Library Edition ed. E. T. Cook and Alexander Wedderburn, 1903–12; *Ruskin Today*, chosen and annotated by Kenneth Clark, 1964. Autobiographical: *Letters*, ed. T. J. Wise, 1894, 1895, 1896, 1897; *Ruskin in Italy: Letters to his parents, 1845*, ed. Harold I. Shapiro, 1972; *The Diaries of John Ruskin*, ed. Joan Evans and John Howard Whitehouse, 1956–9. BIOGRAPHICAL AND CRITICAL: W. J. Collingwood, *The Life and Works of John Ruskin*, 1893; R. H. Wilenski, *John Ruskin*, 1923; W. James, *The Order of Release*, 1948; Joan Evans, *John Ruskin*, 1954; John D. Rosenberg, *The Darkening Glass, A Portrait of Ruskin's Genius*, 1954.

WILLIAM BELL SCOTT. WORKS. Verse: *Hades or The Transit*, 1838; *The Year of the World*, 1846; *Poems*, 1854; *A Poet's Harvest Home*, 1882. Prose: *Half-hour lectures on the history and practice of the fine and ornamental arts*, 1867; *Albert Durer*, 1869; *The Little Masters*, 1879.

FREDERICK GEORGE STEPHENS. WORKS. Prose: *Flemish Relics*, 1866; *Dante Gabriel Rossetti*, 1894.

ALGERNON CHARLES SWINBURNE. WORKS. Verse: *The Queen Mother*, 1860; *Rosamund*, 1860; *Atalanta in Calydon*, 1865; *Chastelard*, 1865; *A Song of Italy*, 1867; *Songs before Sunrise*, 1871; *Bothwell*, 1874; *Songs of Two Nations*, 1875; *Erechteus*, 1876; *Poems and Ballads (Second Series)*, 1878; *Songs of the Springtides*, 1880; *Studies in Song*, 1880; *Mary Stuart*, 1881; *Tristram of Lyonesse*, 1882; *A Century of Rondels*, 1883; *A Mid-summer Holiday*, 1884; *Marino Faliero*, 1885; *Locrine*, 1887; *Poems and Ballads (Third Series)*, 1889; *The Sisters*, 1892; *Astrophel*, 1894; *A Channel Passage and other Poems*, 1894; *The Tale of Balen*, 1896; *Rosamund Queen of the Lombards*, 1899; *The Duke of Grandia*, 1908; *A Choice of Swinburne's Verse*, ed. and introduced by Robert Nye, 1972. Prose: (Critical) *William Blake*, 1867; *George Chapman*, 1875; *A Note on Charlotte Brontë*, 1877; *Shakespeare*, 1880; *Victor Hugo*, 1886; *Miscellanies*, 1886; *Ben Jonson*, 1889; *Studies in Prose and Poetry*, 1894. (Fiction) *Lesbia Brandon*, 1952; *The Novels of A. C. Swinburne*, introduced by Edmund Wilson, 1963. BIOGRAPHICAL AND CRITICAL: Edmund Gosse, *Life of Algernon Charles Swinburne*, N.Y., 1917; Humphrey Hare, *Swinburne—A Biographical Approach*, 1949; Jean Overton Fuller, *Swinburne—a Critical Biography*, 1968; Clyde K. Hyder (ed.), *Swinburne—the Critical Heritage*, 1970.

THEODORE WATTS-DUNTON. WORKS. Prose: *The Truth about Rossetti*, 1883; 'Poetry' (*Encyclopaedia Britannica*, Ninth Edn); *Poetry and the Renascence of Wonder*, 1903; *Studies of Shakespeare*, 1910.

WORKS OF GENERAL REFERENCE

Ernest Chesneau, *The English School of Painting*, translated from the French by Lucy N. Etherington, 1884; Richard and Samuel Redgrave, 'The Pre-Raphaelites' (*A Century of Painters of the English School*), 2nd edn, 1890; Harry Quilter, 'A Chapter on the History of Pre-Raphaelitism' (*Preferences in Art, Life and Literature*), 1892; Percy Bate, *The English Pre-Raphaelite Painters—Their Associates and Successors*, 1899; Ford Madox Hueffer, *The Pre-Raphaelite Brotherhood*, 1907; Lafcadio Hearn, *Pre-Raphaelite and other poets*, 1923; T. Earle Welby, *The Victorian Romantics, 1850–1870—The Early Work of Dante Gabriel Rossetti, William Morris, Burne-Jones, Swinburne, Simeon Solomon and their Associates*, 1929; Francis Bickley, *The Pre-Raphaelite Comedy*, 1932; William Gaunt, *The Pre-Raphaelite Tragedy*, 1942, republished in 1943 as *The Pre-Raphaelite Dream*; Graham Hough, *The Last Romantics*, 1947; Robin Ironside and John Gere, *The Pre-Raphaelite Painters*, 1948; D. H. Dickason, *Daring Young Men—The Story of the American Pre-Raphaelites*, 1953; William E. Fredeman, *Pre-Raphaelitism—A Bibliographical Study*, 1965; John Dixon Hunt, *The Pre-Raphaelite Imagination 1848–1900*, 1968; John Nicoll, *The Pre-Raphaelites*, 1970; Raymond Watkinson, *Pre-Raphaelite Art and Design*, 1970; Timothy Hilton: *The Pre-Raphaelites*, 1970; Keith Roberts, *The Pre-Raphaelites*, 1973.

Portraits and Personalities

[Unlike the Romantic Movement at the turn of the century, the Pre-Raphaelite Movement of fifty years later was a largely cohesive affair. Its members not only knew each other but were, for the most part, gathered together in one place, London, for the greater part of their working careers.

The nucleus of this aesthetic society was, of course, the original seven members of the P.R.B. 'As soon as the Pre-Raphaelite Brotherhood was formed,' its historiographer William Michael Rossetti tells us, 'it became a focus of boundless companionship.' For a while it had its own rules and prospective headquarters or common studio-domicile ('P.R.B. might be written on the bell, and stand for "please ring the bell" to the profane'); and although the close camaraderie and adhesiveness of these first members began to relax and dissolve from about 1853, new participants and sympathizers were quickly found when Dante Gabriel Rossetti descended on Oxford in 1857.

William Michael Rossetti knew both the original group and the slightly younger Oxford Pre-Raphaelites well. He describes himself as a man of 'pacific temperament', and as such was probably a good recorder of the Movement as a whole which, as he admitted, included men of 'contentious temper'. His biographical writings offer a number of portraits—from cameo to full length—of P.R. personalities; but it is in *Some Reminiscences* (1906) that the most complete gallery of them is to be found, and it is from this volume that most of the following likenesses in words have been taken.]

WILLIAM MICHAEL ROSSETTI

DANTE GABRIEL ROSSETTI

Few brothers were more constantly together, or shared one another's feelings and thoughts more intimately, in childhood, boyhood, and well on into mature manhood, than Dante Gabriel and myself. I have no idea of limning his character here at any length, but will define a few of its leading traits. He was always and essentially of a dominant turn, in intellect and in temperament a leader. He was impetuous and vehement, and necessarily therefore impatient; easily angered, easily appeased, although the embittered feelings of his later years obscured this amiable quality to some extent; constant and helpful as a friend where he perceived constancy to be reciprocated; free-handed and heedless of expenditure, whether for himself or for others; in family affection warm and equable, and (except in relation to our mother, for whom he had a fondling love) not demonstrative. Never on stilts in matters of the intellect or of aspiration, but steeped in the sense of beauty, and loving, if not always practising, the good; keenly alive also (though many people seem to discredit this now) to the laughable as well as the grave or solemn side of things; superstitious in grain, and anti-scientific to the marrow. Throughout his youth and early manhood I considered him to be markedly free from vanity, though certainly well equipped in pride; the distinction between these two tendencies was less definite in his closing years. Extremely natural and therefore totally unaffected in tone and manner, with the naturalism characteristic of Italian blood; good-natured and hearty, without being complaisant or accommodating; reserved at times, yet not haughty; desultory enough in youth, diligent and persistent in maturity; self-centred always, and brushing aside whatever traversed his purpose or his bent. He was very generally and very greatly liked by persons of extremely diverse character; indeed, I think it can be no exaggeration to say that no one ever disliked him. Of course I do not here confound the question of liking a man's personality with that of approving his conduct out-and-out.

Of his manner I can perhaps convey but a vague impression. I have said that it was natural; it was likewise eminently easy, and even of the free-and-easy kind. There was a certain British bluffness, streaking the finely poised Italian suppleness and facility. As he was thoroughly unconventional, caring not at all to fall in with the humours or prepossessions of any particular class of society, or to conciliate or approximate the socially distinguished, there was little in him of any veneer or varnish of elegance; none the less he was courteous and well-bred, meeting all sorts of persons upon equal terms—i.e. upon his own terms; and I am satisfied that those who are most exacting in such matters found in Rossetti nothing to derogate from the standard of their requirements. In habit of body he was indolent and lounging, disinclined to any prescribed or trying exertion of any sort, and very difficult to stir out of his ordinary groove, yet not wanting in active promptitude whenever it suited his liking. He often seemed totally unoccupied, especially of an evening; no doubt the brain was busy enough.

The appearance of my brother was to my eye rather Italian than English, though I have more than once heard it said that there was nothing observable to bespeak foreign blood. He was of rather low middle stature, say five feet seven and a half, like our father; and, as the years advanced, he resembled our father not a little in a characteristic way, yet with highly obvious divergences. Meagre in youth, he was at times decidedly fat in mature age. The complexion, clear and warm, was also dark, but not dusky or sombre. The hair was dark and somewhat silky; the brow grandly spacious and solid; the full-sized eyes blueish-grey; the nose shapely, decided, and rather projecting, with an aquiline tendency and large nostrils, and perhaps no detail in the face was more noticeable at a first glance than the very strong indentation at the spring of the nose below the forehead; the mouth moderately well-shaped, but with a rather thick and unmoulded underlip; the chin unremarkable; the line of the jaw, after youth was passed, full, rounded, and sweeping; the ears well-formed and rather small than large. His hips were wide, his hands and feet small; the hands very much those of the artist or author type, white, delicate, plump, and soft as a woman's. His gait was resolute

and rapid, his general aspect compact and determined, the prevailing expression of the face that of a fiery and dictatorial mind concentrated into repose. Some people regarded Rossetti as eminently handsome; few, I think, would have refused him the epithet of well-looking. It rather surprises me to find from Mr Caine's book of *Recollections* that that gentleman, when he first saw Rossetti in 1880, considered him to look full ten years older than he really was—namely to look as if sixty-two years old. To my own eye nothing of the sort was apparent. He wore moustaches from early youth, shaving his cheeks; from 1870 or thereabouts he grew whiskers and beard, moderately full and auburn-tinted, as well as moustaches. His voice was deep and harmonious; in the reading of poetry, remarkably rich, with rolling swell and musical cadence.

CHRISTINA ROSSETTI

Christina Rossetti was of an ordinary female middle height—slim in youth, but, in middle and advanced age, often rather over-plump; this had been the tendency of both her parents. Some people thought her extremely like her mother; I myself never saw this strongly—the mother's features were the more regular of the two, but not perhaps the more agreeable in combination. My sister's complexion was dark and uniform—yet much less dark than Maria's—and after early youth her cheeks were colourless. Her hair was a dark brown, with a good deal of gloss; not remarkably plenteous in youth, and only a little altered by age—to the last it was essentially brown, not grey. The same had been the case with her mother. Her eyes were originally a blueish-grey (portraits show this); but in adult years they might rather be called a greyish hazel, or a richly hazelled grey, and towards the close they may have told out to most persons as being a warm brown, of dark tint. They were always of full size; and, after the attack of exophthalmic bronchocele which began in 1871, they were over-prominent—even somewhat distressingly so at time, but by no means always. The forehead was ample, the lips not noticeably full, with a firm and also a sensitive expression, the chin rather

prolonged and pointed in girlhood, but this was little or not at all observable later on; the facial contour shapely. Her nose was not far from being straight, but taking a slight outward curve towards the tip. Her hands were delicate; and her figure might be called good, without being remarkably fine. She had a good speaking and reading voice—singing she never attempted, apart from the ordinary congregational singing in church. Indeed, I believe that her speaking voice, though not nearly so rich and impressive as Maria's, was considered in youth uncommonly fine in tone and modulation; in her later years there was a certain degree of strain and fatigue in it, but, to many persons who only knew her in those years, this may hardly have been apparent. Her utterance was clear; her delivery—as indeed her whole aspect and demeanour— marked unmistakably by sincerity, consideration for others, and a modest but not the less definite self-regard. I recollect having once told her jocularly (she was perhaps barely seventeen at the time) that 'she would soon become so polite it would be impossible to live with her'. She was one of the last persons with whom any one would feel inspirited to take a liberty, though one might, without any sort of remonstrance, treat her as the least important of womankind.

A question has sometimes been raised as to the amount of good looks with which Christina Rossetti should be credited. She was certainly not what one understands by 'a beauty'; the term handsome did not apply to her, nor yet the term pretty. Neither was she 'a fine woman'. She has sometimes been called 'lovely' in youth; and this is true, if a refined and correct mould of face, along with elevated and deep expression, is loveliness.

EDWARD BURNE-JONES

Burne-Jones was a man of fair stature, with a clear but pale complexion, deep-set eyes very serious and candid-looking, a noticeably spacious high forehead, and yellowish hair, which had thinned before he became elderly. His manner was very gentle, and utterly alien from any vaunting self-assertion. He

was never in strong health, yet to call him an invalid might be going too far. I did not find him much of a talker; but he made from time to time some very discerning and even weighty observation, and ample evidence of his thoughtful and exalted tone of mind is now on record in the admirable book written by his widow. The general tone of his conversation, as heard by myself, was however curiously boyish; and he had (in at any rate one instance within my knowledge) a boyish way of becoming fancifully fond of a person, and afterwards loathing him. I will not suggest that in this particular instance Burne-Jones was without justification; I only mention the case as symptomatic. With this juvenility of temperament and feeling, he was an easily lovable man, of fibre refined and delicate rather than tight-drawn. His nature had the musical ring of glass, not the clangour of iron.

WILLIAM MORRIS

I regard Morris as about the most remarkable man all round— the most *uncommon* man—whom I have known. He was artist, poet, romancist, antiquary, linguist, translator, lecturer, craftsman, printer, trader, socialist; and was besides, as a man to meet and talk to, a most singular personality. Among my intimates he was one of the few who had some little turn for sport: he would go out fishing, boating, and the like. His frame was cast in a large mould, but was by no means tall—not well up to middle height. His face was on the whole very handsome, though it looked as if some slight additional shade of refine-ment in one feature or other would have made it yet a good deal handsomer; the eyes were rather small. The portrait of him by George F. Watts is a decided likeness; still, I hold that it does Morris less than justice—it does not present him at his best. Dante Rossetti used to say that Morris looked like a knight of the Round Table, and this was not far from the fact. He figures as Sir Lancelot in Rossetti's design for *The Lady of Shalott*, in the illustrated Tennyson. The author of *The Earthly Paradise* was the least paradisal of men, if we regard Paradise as a scene of fruition and serene content: he was turbulent, rest-

less, noisy (with a deep and rather gruff voice), brusque in his movements, addicted to stumbling over doorsteps, breaking down solid-looking chairs the moment he took his seat in them, and doing scores of things inconsistent with the nerves of the nervous. He relished a good glass of wine, and was by no means averse from a savoury dinner, and an ample one. His nickname was Topsy, or Top—for years I seldom heard him called any other name. This pseudonym had been imposed upon him in Oxford University before my brother or myself knew him. The stories of Morris's oddities and escapades were numerous; exaggerated sometimes, yet in essence true. At the present day, and to his host of well-warranted admirers, Morris the many-gifted presents an almost heroic aspect, and well that it should be so; but to his familiars in the days of youth—who none the less most thoroughly appreciated his surprising powers—he was the object of almost constant 'chaff'. Dante Rossetti might be regarded as a leader in these skirmishings, but he was only *primus inter pares*, and the *pares* were many. If Morris had not been a genuinely 'fine fellow', and had not had a rich sense of humour which enabled him to enter into a joke against himself as against any one else, he would never have stood it; he did stand it, and on occasion gave as good as he got. He was volcanic, and would rage and swear on very small inducement; but, being very easy-natured too, and knowing that the men of his circle truly delighted in the splendour of his genius, and gave full expression to the value they set upon it whenever opportunity offered, he took the chaff (in a double sense) along with the grain. In the firm of Morris, Marshall, Faulkner & Co., he was the leading spirit, though not in early days the leading artist; that position belonged to Burne-Jones, Madox Brown, and Dante Rossetti, whom I name here in the order of their productivity of art-work for the association. Webb was also active; but, being by profession an architect, he did not so regularly contribute designs for the purposes of the firm. It may be recollected by many of my readers that Morris appeared first as a poet (*The Defence of Guenevere*, etc.), and was admired as such among his intimates before his turn for decorative art had developed to any serious extent, and long prior to his launch-

ing out upon any socialistic scheme or propaganda. In the earlier days Morris seemed to me to be alien from all political interests, and it was not on the ground of actual or surmised socialism than [that] anybody bantered him.

ALGERNON CHARLES SWINBURNE

Swinburne belongs by birth and nurture to the aristocratic class; and, though he has put forward very advanced democratic and republican views, his temperament and demeanour witness to his origin. In a certain general atmosphere of political and some other ideas he and I sympathized very warmly: in the application of them we often differed. He hated Napoleon the First; upheld the Southern against the Northern States in the American Civil War; sided with the Turks against the Russians in the war of 1878; loathed Gladstone's Home-rule policy; and believed England to be wholly in the right in the Transvaal conflict. In all these respects I belong to the opposite camp. Neither can I fall in with Swinburnian diatribes against Carlyle, Emerson, and Walt Whitman. These divergences of opinion however have never made the smallest breach in our mutual good understanding. Among people whom he likes, no one can be more affectionate, sweet-natured, and confiding, than Algernon Swinburne. His courtesy is extreme, his attachments are steady. Superb as are his own powers, he is most willing to recognize in others any points of superiority, whether to the mass of mankind or even to himself; and, where he recognizes this, he can be not only compliant but I might say deferential. That he can retaliate fiercely, and this upon quondam friends as well as professed foes, is a fact sufficiently notorious; I cannot however recollect a single instance in which he attacked without being first needlessly provoked. To provoke him is a tolerably easy process, and a very imprudent one; for no man living has a more vigorous command of the powers of invective, to which his ingenuity of mind, and consummate mastery of literary resource, lend a lash of the most cutting and immedicable keenness. As a generous praiser of what he considers praiseworthy he stands supreme: it may very

fairly be said that in this line he is *too* generous—never that he is parsimonious. His golden words, like the beams of the morning and the evening sun, flush into splendour whatever they fall upon.

WILLIAM HOLMAN HUNT

Holman Hunt is the son of a warehouseman employed by a City firm; he himself published in 1886 an account of his early and most manful struggles to obtain a training in fine art, and to conquer the position which was due to his remarkable endowments, so I need not enlarge upon that matter, nor will I enter into details as to the personal appearance of my living friend. If the other P.R.B.'s had had to pass a vote as to which of their colleagues they admired most, they would all, I conceive, have named Holman Hunt, while he himself would have named Millais. We thoroughly admired him for his powers in art, his strenuous efforts, his vigorous personality, his gifts of mind and character, his warm and helpful friendship. Not indeed that we should have ignored the more than co-equal claims of Millais as a pictorial executant; but he had not had to fight a savage fight—Hunt was still fighting it, and under very severe pressure, in 1848–50—and Millais had obviously not the same force and tenacity of thought. To manage to work without enduring privations in the process was not in those days the lot of Hunt; he endured them in tough and silent magnanimity, being ambitious no less than resolute. In conversation he was sagacious, anecdotical, and, within certain limits, well-informed, with a full gusto for the humorous side of things. Like Woolner, he was a reading man according to his moderate opportunities, with perhaps rather less turn for estimating books critically. Some of us, off and on, called him 'the maniac'; I never much saw why, for few young men could be less maniacal, though most of them might be freer from those elements of character which, upon occasion, go to make a fanatic. Some arbitrary oddities of manner there may have been, yet nothing which could rightly be dubbed eccentric.

JOHN EVERETT MILLAIS

[Lastly] I come to Millais. He, as we all know, had been a
student of art in the Royal Academy from a very early period
of boyhood, had won various academic honours, and was,
before the formation of the Brotherhood, a clever, promising,
and well-accepted exhibiting painter. Those earlier produc-
tions of his had nothing 'Præraphaelite' about them; i.e. they
evinced no tendency to a new movement in art, whether in
idea or in execution, and, though quite competent works for a
student who was fast becoming a proficient, they bore no
evidence of a minute and solicitous study of nature. As soon as
he proclaimed himself a Præraphaelite, Millais altered his
methods entirely, and set to work upon the rather extensive
composition, of which he made an admirable picture, *Lorenzo
and Isabella*, from the poem by Keats. I sat to him for the head
of Lorenzo—presenting only an approximate resemblance to
me; the head of Dante Rossetti appears in the background,
and more prominently another head which I take to be that of
Stephens. Millais lived in comfort, but not in anything to be
called affluence, in a well-sized house, No. 83 (now 7) Gower
Street, Bedford Square, along with his father, mother, and
brother (my old schoolfellow). His father was a native of
Jersey, a musician, professional or semi-professional—
principally, I understood, a flute player; a rather fine-looking,
easy-going, hearty, and very good-natured man. The mother
was a much more energetic and active character, and obviously
took the lead. Before marrying Mr Millais, she had been (as I
heard) the widow of a tailor, Mr Hodgkinson, having two sons
by her first union. Mrs Millais, when I knew her, had the
remains of good features, without much amenity; she was
decisive in manner and voice, brisk and rather jerky in
gesture. She always wore a cap; it was not always a smart one.
To myself she was uniformly kind, and I remember her with
regard. Millais was a very handsome, or more strictly a
beautiful, youth: his face came nearer to the type which we
term angelic than perhaps any other male visage that I have
seen. His voice hardly corresponded to his countenance; it
was harsh rather than otherwise. In talk he was something of

what one calls 'a rattle'; saying sprightly things in an off-hand way, but not entering into anything claiming the name of conversation. He sometimes started a subject, but never developed it. We all entertained the highest estimate of what he had now set about doing, and what else he was certain to achieve in a short time. In this sense he led us all, and moreover we had a genuine personal liking for him: yet I do not think that Millais, as 'a man and a brother', ever stood quite so high with us as Holman Hunt did. He was the only P.R.B. who had some notion of music as an art: he enjoyed it much, and could speak of it with intelligence.

FORD MADOX BROWN

Mr Brown, born on 16 April 1821, was close upon twenty-seven years of age when he received this letter [written by D. G. Rossetti, asking if he could study with that painter], or about seven years older than Rossetti. He was a vigorous-looking young man, with a face full of insight and purpose; thick straight brown hair, fair skin, well-coloured visage, blueish eyes, broad brow, square and rather high shoulders, slow and distinct articulation. His face was good-looking as well as fine; but less decidedly handsome, I think, than it became towards the age of forty. As an old man—he died on 6 October 1893— he had a grand patriarchal aspect; his hair, of a pure white, being fully as abundant as when I first knew him, supplemented now by a long beard. Born in Calais of English parents, and brought up chiefly abroad, he was the sort of man who had no idea of being twitted without exacting the reason why. Such profuse praise as he now received from his unknown correspondent was what fortune had not accustomed him to, and he suspected that some ill-advised person was trying to make game of him. From his studio in Clipstone Street, very near Charlotte Street, he sallied forth with a stout stick in his hand. Knocking at No. 50, he would not give his name, nor proceed further than the passage. When Dante came down, Brown's enquiry was, 'Is your name Rossetti, and is this your writing?' An affirmative being returned, the next

question was, 'What do you mean by it?' to which Rossetti rationally replied that he meant what he had written. Brown now perceived that after all the whole affair was *bonâ fide*; and (as the Family-letters show) he not only consented to put his neophyte in the right path of painting, but would entertain no offer of payment, and made Rossetti his friend on the spot—a friend for that day, in the spring of 1848, and a friend for life.

The Founding of the Brotherhood

[Years after the Brotherhood had disintegrated, Dante Gabriel Rossetti—its leading influence though most wayward member—pretended to pour scorn on its early union. 'As for all the prattle about Praeraphaelitism [*sic*], I confess to you I am weary of it, and long have been. Why should we go on talking about the visionary vanities of half a dozen boys? What you call the movement was serious enough, but the bounding together under that title was all a joke.' But for all Rossetti's scepticism of hindsight, his brother William reported that 'the word "Brotherhood" was ... Rossetti's term, put forward as being preferable ... to any such term as Clique or Association.' A notion of warmth and personal committal was clearly implicit in their reference to a sodality.

The contents of this section fall into two categories: historical and theoretical. In the first of these W. M. Rossetti tells of the formation of the Brotherhood, placing it in its context of contemporary Victorian painting. William Michael has sometimes been regarded as the baggage mule of the Pre-Raphaelite archives; and it must be admitted that he is not a scintillating writer. At the same time, he was not perhaps the dunce which some commentators have suggested. The respected friend of Swinburne, he was certainly the best-educated member of the Brotherhood; and his sedulous assemblage of facts has left posterity indebted to him. His description of the start of Pre-Raphaelitism (entitled here *The Brotherhood in a Nutshell*) is of value in that it offers a first-hand account of the affair without any of the theorizing with which later critics and historians not infrequently imbued the Movement.

Next—drawn from Holman Hunt's massive polemical autobiography—comes some mention of those main ideas and

influences which went to form the Pre-Raphaelite approach to painting. Two poems written by Christina Rossetti serve as prologue and epilogue here.]

<div align="center">

THE P.R.B.

I

The two Rossettis (brothers they)
And Holman Hunt and John Millais,
With Stephens chivalrous and bland,
And Woolner in a distant land—
In these six men I awestruck see
Embodied the great P.R.B.
D. G. Rossetti offered two
Good pictures to the public view;
Unnumbered ones great John Millais,
And Holman more than I can say.

William Rossetti, calm and solemn,
Cuts up his brethren by the column.
19 September 1853. (Christina Rossetti).

</div>

WILLIAM MICHAEL ROSSETTI

THE BROTHERHOOD IN A NUTSHELL

In 1848 the British School of Painting was in anything but a vital or a lively condition. One very great and incomparable genius, Turner, belonged to it. He was old and past his executive prime. There were some other highly able men— Etty and David Scott, then both very near their death; Maclise, Dyce, Cope, Mulready, Linnell, Poole, William Henry Hunt, Landseer, Leslie, Watts, Cox, J. F. Lewis, and some others. There were also some distinctly clever men, such as Ward, Frith, and Egg. Paton, Gilbert, Ford Madox Brown,

Mark Anthony, had given sufficient indication of their powers, but were all in an early stage. On the whole the school had sunk very far below what it had been in the days of Hogarth, Reynolds, Gainsborough, and Blake, and its ordinary average had come to be something for which commonplace is a laudatory term, and imbecility a not excessive one.

There were in the late summer of 1848, in the Schools of the Royal Academy or barely emergent from them, four young men to whom this condition of the art seemed offensive, contemptible, and even scandalous. Their names were William Holman-Hunt, John Everett Millais, and Dante Gabriel Rossetti, painters, and Thomas Woolner, sculptor. Their ages varied from twenty-two to nineteen—Woolner being the eldest, and Millais the youngest. Being little more than lads, these young men were naturally not very deep in either the theory or the practice of art: but they had open eyes and minds, and could discern that some things were good and others bad— that some things they liked, and others they hated. They hated the lack of ideas in art, and the lack of character; the silliness and vacuity which belong to the one, the flimsiness and make-believe which result from the other. They hated those forms of execution which are merely smooth and prettyish, and those which, pretending to mastery, are nothing better than slovenly and slapdash, or what the P.R.B.'s called 'sloshy'. Still more did they hate the notion that each artist should not obey his own individual impulse, act upon his own perception and study of Nature, and scrutinize and work at his objective material with assiduity before he could attempt to display and interpret it; but that, instead of all this, he should try to be 'like somebody else', imitating some extant style and manner, and applying the cut-and-dry rules enunciated by A from the practice of B or C. They determined to do the exact contrary. The temper of these striplings, after some years of the current academic training, was the temper of rebels: they meant revolt, and produced revolution. It would be a mistake to suppose, because they called themselves Præraphaelites, that they seriously disliked the works produced by Raphael; but they disliked the works produced by Raphael's uninspired satellites, and were resolved to find out, by personal study and practice,

what their own several faculties and adaptabilities might be, without being bound by rules and big-wiggeries founded upon the performances of Raphael or of any one. They were to have no master except their own powers of mind and hand, and their own first-hand study of Nature. Their minds were to furnish them with subjects for works of art, and with the general scheme of treatment; Nature was to be their one or their paramount storehouse of materials for objects to be represented; the study of her was to be deep, and the representation (at any rate in the earlier stages of self-discipline and work) in the highest degree exact; executive methods were to be learned partly from precept and example, but most essentially from practice and experiment. As their minds were very different in range and direction, their products also, from the first, differed greatly; and these soon ceased to have any link of resemblance.

The Præraphaelite Brothers entertained a deep respect and a sincere affection for the works of some of the artists who had preceded Raphael; and they thought that they should more or less be following the lead of those artists if they themselves were to develop their own individuality, disregarding school-rules. This was really the sum and substance of their 'Præraphaelitism'. It may freely be allowed that, as they were very young, and fired by certain ideas impressive to their own spirits, they unduly ignored some other ideas and theories which have none the less a deal to say for themselves. They contemned some things and some practitioners of art not at all contemptible, and, in speech still more than in thought, they at times wilfully heaped up the scorn. You cannot have a youthful rebel with a faculty who is also a model head-boy in a school.

The P.R.B. was completed by the accession of three members to the four already mentioned. These were James Collinson, a domestic painter; Frederic George Stephens, an Academy-student of painting; and myself, a Government-clerk. These again, when the P.R.B. was formed towards September 1848, were all young, aged respectively about twenty-three, twenty-one, and nineteen.

This Præraphaelite Brotherhood was the independent creation of Holman-Hunt, Millais, Rossetti, and (in perhaps a

somewhat minor degree) Woolner: it cannot be said that they were prompted or abetted by any one. Ruskin, whose name has been sometimes inaccurately mixed up in the matter, and who had as yet published only the first two volumes of *Modern Painters*, was wholly unknown to them personally, and in his writings was probably known only to Holman-Hunt. Ford Madox Brown had been an intimate of Rossetti since March 1848, and he sympathized, fully as much as any of these younger men, with some old-world developments of art preceding its ripeness or over-ripeness: but he had no inclination to join any organization for protest and reform, and he followed his own course—more influenced, for four or five years ensuing, by what the P.R.B.'s were doing than influencing them. Among the persons who were most intimate with the members of the Brotherhood towards the date of its formation, and onwards till the inception of *The Germ*, I may mention the following. For Holman-Hunt, the sculptor John Lucas Tupper, who had been a fellow Academy-student, and was now an anatomical designer at Guy's Hospital: he and his family were equally well-acquainted with Mr Stephens. For Millais, the painter Charles Allston Collins, son of the well-known painter of domestic life and coast-scenes William Collins; the painter Arthur Hughes; also his own brother, William Henry Millais, who had musical aptitudes and became a landscape-painter. For Rossetti, William Bell Scott (brother of David Scott), painter, poet, and Master of the Government School of Design in Newcastle-on-Tyne; Major Calder Campbell, a retired Officer of the Indian army, and a somewhat popular writer of tales, verses, etc.; Alexander Munro the sculptor; Walter Howell Deverell, a young painter, son of the Secretary to the Government Schools of Design; James Hannay, the novelist, satirical writer, and journalist; and (known through Madox Brown) William Cave Thomas, a painter who had studied in the severe classical school of Germany, and had earned a name in the Westminster Hall competitions for frescoes in Parliament. For Woolner, John Hancock and Bernhard Smith, sculptors; Coventry Patmore the poet, with his connections the Orme family and Professor Masson; also William North, an eccentric young literary man,

of much effervescence and some talent, author of *Anti-Coningsby* and other novels. For Collinson, the prominent painter of romantic and biblical subjects John Rogers Herbert, who was, like Collinson himself, a Roman Catholic convert.

WILLIAM HOLMAN HUNT

THE IMPACT OF RUSKIN

Lately I had great delight in skimming over a certain book, *Modern Painters*, by a writer calling himself an Oxford Graduate; it was lent to me only for a few hours, but, by Jove! passages in it made my heart thrill. He feels the power and responsibility of art more than any author I have ever read. He describes pictures of the Venetian School in such a manner that you see them with your inner sight, and you feel that the men who did them had been appointed by God, like old prophets, to bear a sacred message, and that they delivered themselves like Elijah of old. They seemed mighty enough to overthrow any vanity of the day. He glories most in Tintoretto, and some of the series described, treating of the life of the Virgin, and others illustrating the history of the Saviour, make one see in the painter a sublime Hogarth. The Annunciation takes place in a ruined house, with walls tumbled down; the place in that condition stands as a symbol of the Jewish Church—so the author reads—and it suggests an appropriateness in Joseph's occupation of a carpenter, that at first one did not recognize; he is the new builder! The Crucifixion is given with redoubled dramatic penetration, and the author dwells upon the accumulated notes of meaning in the design, till you shudder at the darkness around you. I wish I could quote the passage about Christ. I'll tell you more of the book some day. I speak of it now because the men he describes were of such high purpose and vigour that they present a striking contrast to the uninspired men of today. This shows need for us young artists to consider what course we should follow. That art is dying at times is beyond question. The

'Oxford Graduate' reverses the judgment of Sir Joshua, for he places the Venetian in the highest rank, and disdains the Bolognese School, which until these days has never been questioned for its superiority, both under the Caraccis and Le Brun, whom the President also lauds. Students in those days would have been wise had they realized their doleful condition, and taken an independent course. I venture to conclude that we are now in a similar plight, and the book I speak of helps one to see the difference between dead and living art at a critical juncture. False taste has great power, and has often gained distinction and honour. Life is not long enough to drivel through a bad fashion and begin again. The determination to save one's self and art must be made in youth. I feel that is the only hope, at least for myself. One's thoughts must stir before the hands can do. With my picture from *The Eve of St Agnes* I am limited to architecture and night effect, but I purpose after this to paint an out-of-door picture, with a foreground and background, abjuring altogether brown foliage, smoky clouds, and dark corners, painting the whole out of doors, direct on the canvas itself, with every detail I can see, and with the sunlight brightness of the day itself. Should the system in any point prove to be wrong, well! I shall be ready to confess my mistake and modify my course.

REVISING REYNOLDS:
A Conversation between Hunt and Millais

'. . . My four years in the City deprived me seriously of opportunity for art practice, but my duties spared me many broken occasions for reading and reflecting, through which notions have grown in my head which I find it not easy to resolve. Some of my cogitations may lead me to see lions in the path which are only phantoms, but until I have faced them I can't be satisfied; in the mental wrestling, however, I have investigated current theories both within art and outside it, and have found many of them altogether unacceptable. What, you ask, are my scruples? Well, they are nothing less than irreverent,

heretical, and revolutionary.' My two years' seniority gave me courage to reveal what was at the bottom of my heart at the time. I argued, 'When art has arrived at facile proficiency of execution, a spirit of easy satisfaction takes possession of its masters, encouraging them to regard it with the paralysing content of the lotus-eaters; it has in their eyes become perfect, and they live in its realm of settled law. Under this miasma no young man has the faintest chance of developing his art into living power, unless he investigates the dogmas of his elders with critical mind, and dares to face the idea of revolt from their authority. The question comes to us whether we are not in such a position now? Of course, we have got some deucedly gifted masters, and I love many of the old boys, and know they could teach me much; but I think they suffer from the fact that the English School began the last century without the discipline of exact manipulation. Sir Joshua Reynolds thought it expedient to take the Italian School at its proudest climax as a starting-point for English art; he himself had already gone through some patient training which had made him a passionate lover of human nature; he had culled on the way an inexhaustible store of riches, and was so impatient to expend his treasures that the parts of a picture which gave him no scope for his generosity were of little interest to him.

'Under his reign came into vogue drooping branches of brown trees over a night-like sky, or a column with a curtain unnaturally arranged, as a background to a day-lit portrait; his feeble followers imitate this arrangement in such numbers that there are few rooms in an exhibition in which we can't count twenty or thirty of the kind; it is not therefore premature to demand that the backgrounds of pictures should be equally representative of nature with their principal portions; consider how disregard of this requirement affected Sir Joshua's ambitious compositions. The more he departed from pictures of the nature of portraiture, the more conventional and uninteresting he became. Look at his "Holy Family" in the National Gallery, with nothing in the child but a reflection of the infant in Correggio's picture of "Venus and Mercury teaching Cupid to read", and the absence of any natural treatment in other parts of the composition. His "Infant

Hercules with the Philosophers standing around" is equally unprofitable. The rules of art which he loved so much to lay down were no fetters to him, because he rose superior to them when his unbounded love of human nature was appealed to, and then his affection for Ludovico Caracci and the Bolognese School became light in the balance; his approval of togas went for nothing when a general stood before him in red coat with gold facings; and the playful fancies of children suggested to him vivacious fascination such as no painter ever before had noted. His lectures were admirably adapted to encourage the young to make a complete and reverential survey of what art had done in past times, for there was a danger that English painters would follow the course which Morland soon after took of treating common subjects, with only an indirect knowledge of the perfection which art had reached in the hands of the old masters. Probably Wilkie owed his more refined course to Sir Joshua's teaching. Reynolds was not then in sight of the opposite danger of conventionalism as affecting the healthy study of nature to the degree which has since been seen. The last fifty years, however, have proved that his teaching was interpreted as encouragement to unoriginality of treatment, and neglect of that delicate rendering of nature, which had led previous schools to greatness. The English School began on the top of the wave, and consequently ever since it has been sinking into the hollow. The independent genius of the first President could not be transmitted, but his binding rules were handed on. You remember how Mr Jones spoke of the evils of precocious masterliness, but he only denounced the indulgence when in excess of the accepted standard. I would go much farther, for his words would not touch the academic tradition. I am bound, because of my past loss of time, to consider my own need, and for that I feel sure it is important to question fashion and dogma: every school that reached exalted heights in art began with humility and precision. The British School skipped the training that led to the making of Michael Angelo; but even now, late as it is, children should begin as children, and wait for years to bring them to maturity.'

'I quite agree with what you say, for as to Reynolds,' replied Millais, 'he would think nothing of making the stem of

a rose as big as the butt-end of a fishing-rod.[1] You'll see I intend to turn over a new leaf; I have finished these heads more than any I ever did. Last year it was the rage to talk about "Collinson's finish" in his "Charity Boy": I'll show 'em that that wasn't finish at all.'

I added: 'With form so lacking in nervousness as his, finish of detail is wasted labour. But about the question of precedent. I would say that the course of previous generations of artists which led to excellence cannot be too studiously followed, but their treatment of subjects, perfect as they were for their time, should not be repeated. If we do only what they did so perfectly, I don't see much good to the world in our work. The language they used was then a living one, now it is dead: though their work has in it humanly and artistically such marvellous perfection, for us to repeat their treatment for subjects of sacred or historic import is mere affectation. In the figure of the risen Lord, for instance, about which we began to talk, the painters put a flag in His hands to represent His victory over Death: their public had been taught that this adjunct was a part of the alphabet of their faith; they accepted it, as they received all the legends painted at the order of the Church. Many of these were poetic and affecting; but with the New Testament in our hands we have new suggestions to make. If I were to put a flag with a cross on it in Christ's hand, the art-galvanising revivalists might be pleased, but unaffected people would regard the work as having no living interest for them. I have been trying for some treatment that might make them see this Christ with something of the surprise that the Maries themselves felt on meeting Him as One who has come out of the grave, but I must for every reason put it by for the present. In the meanwhile, the story in Keats's *Eve of St Agnes* illustrates the sacredness of honest responsible love and the weakness of proud intemperance, and I may practise my new principles to some degree on that subject.'

I blundered through this argument, not without many ejaculations from my companion; but here, laughing, I turned

[1] I never knew what particular picture he had in his mind; certainly in later years he appreciated the excellences, and regarded with no severity the failings, of the great portrait painter.

upon him with—'You see what a dangerous rebel I am, but you are every bit as bad as myself! Here are you painting a poetic subject in which you know all authorities would insist upon conventional treatment, and you cannot pretend that this work of yours is academic. . . .'

'PRE-RAPHAELITISM IS NOT PRE-RAPHAELISM'

I believe it is no wrong observation that persons of genius, and those who are capable of art, are always most fond of Nature, as such are chiefly sensible that art consists in the imitation and study of Nature. On the contrary, people of the common level of under-standing are principally delighted with the niceties and fantastic operations of art, and constantly think that finest which is least natural.—POPE.

I say to painters, Never imitate the manner of another; for thereby you become the grandson instead of the son of Nature.—*Trattato della Pittura*, cap. lxxxi., L. DA VINCI.

Not alone was the work that we were bent on producing to be more persistently derived from Nature than any having a dramatic significance yet done in the world; not simply were our productions to establish a more frank study of creation as their initial intention, but the name adopted by us negatived the suspicion of any servile antiquarianism. Pre-Raphaelitism is not Pre-Raphaelism. Raphael in his prime was an artist of the most independent and daring course as to conventions. He had adopted his principle, it is true, from the store of wisdom gained by long years of toil, experiment, renunciation of used-up thought, and repeated efforts of artists, his im-mediate predecessors and contemporaries. What had cost Perugino, Fra Bartolomeo, Leonardo da Vinci, and Michael Angelo more years to develop than Raphael lived, he seized in a day—nay, in one single inspection of his precursors' achieve-ments. His rapacity was atoned for by his never-stinted acknowledgments of his indebtedness, and by the reverent and

philosophical use in his work of the conquests he had made. He inherited the booty like a prince, and, like Prince Hal, he retained his prize against all disputants; his plagiarism was the wielding of power in order to be royally free. Secrets and tricks were not what he stole; he accepted the lessons it had been the pride of his masters to teach, and they suffered no hardship at his hands. What he gained beyond enfranchisement was his master's use of enfranchisement, the power to prove that the human figure was of nobler proportion, that it had grander capabilities of action than seen by the casual eye, and that for large work, expression must mainly depend upon movement of the body. Further also, he tacitly demonstrated that there was no fast rule of composition to trammel the arrangement dictated to the artist's will by the theme. Yet, indeed, it may be questioned whether, before the twelve glorious years had come to an end after his sight of the Sixtine chapel ceiling, he did not stumble and fall like a high-mettled steed tethered in a fat pasture who knows not that his freedom is measured. The musing reader of history, however ordinarily sceptical of divine over-rule, may, on the revelation of a catastrophe altogether masqued till the fulness of time, involuntarily proclaim the finger of God pointing behind to some forgotten trespass committed in haste to gain the coveted end. There is no need here to trace any failure in Raphael's career; but the prodigality of his productiveness, and his training of many assistants, compelled him to lay down rules and manners of work; and his followers, even before they were left alone, accentuated his poses into postures. They caricatured the turns of his heads and the lines of his limbs, so that figures were drawn in patterns; they twisted companies of men into pyramids, and placed them like pieces on the chess-board of the foreground. The master himself, at the last, was not exempt from furnishing examples of such conventionalities. Whoever were the transgressors, the artists who thus servilely travestied this prince of painters at his prime were Raphaelites. And although certain rare geniuses since then have dared to burst the fetters forged in Raphael's decline, I here venture to repeat, what we said in the days of our youth, that the traditions that went on through the Bolognese Academy, which were introduced at the foundation

of all later schools and enforced by Le Brun, Du Fresnoy, Raphael Mengs, and Sir Joshua Reynolds, to our own time were lethal in their influence, tending to stifle the breath of design. The name Pre-Raphaelite excludes the influence of such corrupters of perfection, even though Raphael, by reason of some of his works, be in the list, while it accepts that of his more sincere forerunners.

THE FRESCOES OF CAMPO SANTO

The meeting at Millais' [in 1847] was soon held. We had much to entertain us. Firstly, there was a set of outlines of Führich in the Retzsch manner, but of much larger style. The misfortune of Germans as artists had been that, from the days of Winckelmann, writers had theorized and made systems, as orders, to be carried out by future practitioners in ambitious painting. The result was an art sublimely intellectual in intention, but devoid of personal instinct and often bloodless and dead; but many book illustrators had in varying degrees dared to follow their own fancies, and had escaped the crippling yoke. The illustrations by Führich, we found, had quite remarkable merits. In addition to these modern designs, Millais had a book of engravings of the frescoes in the Camp-Santo at Pisa which had by mere chance been lent to him. Few of us had before seen the complete set of these famous compositions.

The innocent spirit which had directed the invention of the painter was traced point after point with emulation by each of us who were the workers, with the determination that a kindred simplicity should regulate our own ambition, and we insisted that the naïve traits of frank expression and unaffected grace were what had made Italian art so essentially vigorous and progressive, until the showy followers of Michael Angelo had grafted their Dead Sea fruit on to the vital tree just when it was bearing its choicest autumnal ripeness for the reawakened world. . . .

We had recognized as we turned from one print to another that the Campo Santo designs were remarkable for incident

derived from attentive observation of inexhaustible Nature,
and dwelt on all their quaint charms of invention. We ap-
praised as Chaucerian the sweet humour of Benozzo Gozzoli,
which appeared wherever the pathos of the story could by such
aid be made to claim greater sympathy, and this English spirit
we acclaimed as the standard under which we were to make
our advance. Yet we did not curb our amusement at the
immature perspective, the undeveloped power of drawing, the
feebleness of light and shade, the ignorance of any but mere
black and white differences of racial types of men, the stinted
varieties of flora, and their geometrical forms in the landscape;
these simplicities, already out of date in the painter's day, we
noted as belonging altogether to the past and to the dead
revivalists, with whom we had determined to have neither part
nor lot. That Millais was in accord with this conviction was
clear from his latest designs and from every utterance that
came from him with unmistakable heartiness as to his future
purpose, and may be understood now from all his after-work.
Rossetti's sentiment of these days is witnessed to, not from his
painting in hand (which was from a design made earlier, when
he was professedly under the fascination of the Early Christian
dogma), but by his daily words put into permanent form in the
short prospectus for *The Germ* (2nd series), issued a year or so
later, in which Nature was insisted upon as the one element
wanting in contemporary art.[1] The work which was already
done, including all the landscape on my 'Rienzi' picture, and
my past steps leading to the new course pursued, spoke for me,
and thus was justified the assumption that all our circle knew
that deeper devotion to Nature's teaching was the real point at
which we were aiming. It will be seen that the learned com-
mentators have ever since declared that our real ambition was
to be revivalists and not adventurers into new regions.

[1] The endeavour held in view throughout the writings on art will be to
encourage and enforce an entire adherence to the simplicity of Nature, and
also to direct attention, as an auxiliary medium, to the comparatively few
works which art has yet produced in this spirit. It need scarcely be added
that the chief object of the etched designs will be to illustrate this aim prac-
tically, as far as the method of execution will permit, in which purpose they
will be produced with the utmost care and completeness.—Preface to *Germ*.

THE P.R.B.

2

The P.R.B. is in its decadence:
For Woolner in Australia cooks his chops,
And Hunt is yearning for the land of Cheops;
 D. G. Rossetti shuns the vulgar optic;
While William M. Rossetti merely lops
 His B's in English disesteemed as Coptic:
Calm Stephens in the twilight smokes his pipe,
 But long the dawning of his public day;
 And he at last the champion great Millais,
Attaining academic opulence,
 Winds up his signature with A.R.A.
So rivers merge in the perpetual sea;
So luscious fruit must fall when over-ripe;
And so the consummated P.R.B.

 10 November 1853. (Christina Rossetti)

Controversy and Ideology

[A very novel thing at its inception, the work of the Pre-Raphaelite Brotherhood gave as much offence as it engendered wonder and pleasure. Carlyle—that wayward and intransigent thinker—is strangely on record as approving its aims ('These Praeraphaelites [*sic*] they talk of are said to copy the thing as it is, or invent it as they believe it must have been: now there's some sense and hearty sincerity in this. It's the only way of doing anything fit to be seen'), but a good majority of Victorian intellectuals and men of letters were powerfully opposed to it. Lord Macaulay, Charles Kingsley and Dickens were all contemptuous, the latter writing violently about it in his magazine *Household Words* (possibly at the instigation of Solomon Hart, an artist hostile to the P.R.'s).

This third section is accordingly a record of attacks upon the P.R.B., and upon elements in the poetry of Rossetti and Swinburne some fifteen to twenty years later. Writing under the pseudonym of Thomas Maitland, the journalist poet Robert Buchanan described poetic Pre-Raphaelitism—'in spite of its spasmodic ramifications in the erotic direction'—as being 'merely one of the many sub-Tennysonian schools . . . endeavouring by affectation all its own to overthrow its connections with its great original'. But, even more directly, in this article *The Fleshly School of Poetry: Mr. D. G. Rossetti*, Buchanan charged these 'fleshly gentlemen' with 'having bound themselves by solemn league and covenant to extol fleshiness as the distinct and supreme end of poetic and pictorial art, to aver that poetic expression is greater than poetic thought, and by inference that the body is greater than the soul, and sound superior to sense'. D. G. Rossetti answered the challenge in *The Stealthy School of Criticism*, just as Ruskin

sprang to the defence of the Pre-Raphaelites in the early assaults made upon them.

Together with John Morley's diatribe on Swinburne ('the libidinous laureate of a pack of satyrs') and Swinburne's salvoes in self-defence these pieces constitute an important chapter in the debate between the repressive and the permissive in Victorian culture.]

CHARLES DICKENS

'A HIDEOUS, WRY-NECKED, BLUBBERING, RED-HAIRED BOY'
[*On 'Christ in the house of His parents' by Millais (see plates)*]

In the foreground of that carpenter's shop is a hideous, wry-necked, blubbering, red-haired boy in a night gown who appears to have received a poke in the hand from the stick of another boy with whom he has been playing in the gutter, and to be holding it up for the contemplation of a woman so horrible in her ugliness that (supposing it were possible for any human creature to exist for a moment with that dislocated throat) she would stand out from the rest of the company as a monster in the vilest cabaret in France or the lowest gin-shop in England.

THE ATHENAEUM

'ABRUPTNESS, SINGULARITY, UNCOUTHNESS . . .'
(*On the P.R. pictures in the R.A. Summer Exhibition, 1850*)

We have already in the course of our Exhibition notices of this year come into contact with the doings of a school of artists whose younger members unconsciously write its condemnation in the very title which they adopt (that of Pre-Raphaelite), and we would not have troubled ourselves or our readers with any

further remark on the subject were it not that eccentricities of any kind have a sort of seduction for minds that are intellectual without belonging to the better orders of intellect . . . The idea of an association of artists whose objects are the following out of their art in a spirit of improved purity, making sentiment and expression the great ends, and subordinating to these all technical consideration, is not new. The difference between the proceedings of a band of German painters who in the early part of the present century commenced such an undertaking in Rome, and those of the English Pre-Raphaelites, is nevertheless striking . . . This school of English youths has, it may be granted, ambition, but not of that well-regulated order which, measuring the object to be attained by the resources possessed, qualifies itself for achievement. Their ambition is an unhealthy thirst which seeks notoriety by means of mere conceit. Abruptness, singularity, uncouthness, are the counters by which they play for game. Their trick is to defy the principles of beauty and the recognised axioms of taste . . . In point of religious sentiment Rossetti stands the chief of this little band. Mr Hunt stands next in his picture of *A Converted British Family* (No. 553). There is a sense of novelty in its arrangement and of expression in its parts, and a certain enthusiasm, though wrongly directed, in its conduct. Mr Millais, in his picture without a name (518) [1] which represents a Holy Family in the interior of the carpenter's shop, has been most successful in giving the least dignified features of his presentment, and in giving to the higher forms characters and meanings, a circumstantial Art Language from which we recoil with loathing and disgust. There are many to whom his work will seem a pictorial blasphemy. Great imitative talents have here been perverted to the use of an eccentricity both lamentable and revolting. *Ferdinand lured by Ariel* (504) by the same hand, though better in the painting, is yet more senseless in the conception, a scene built on the contrivances of the stage manager, but with very bad success. Another instance of perversion is to be regretted in *Berengaria's Alarm for the Safety of her Husband* (535) by Mr Charles Collins.

[1] See plates.

THE TIMES

'. . . A CLASS OF JUVENILE ARTISTS WHO STYLE THEMSELVES
P.R.B.'
[*On the P.R. pictures in the R.A. Summer Exhibition, 1850*]

We cannot censure at present as amply or as strongly as we
desire to do, that strange disorder of the mind or the eyes
which continues to rage with unabated absurdity among a
class of juvenile artists who style themselves P.R.B., which,
being interpreted, means *Pre-Raphael-brethren*. Their faith seems
to consist in an absolute contempt for perspective and the
known laws of light and shade, an aversion to beauty in every
shape, and a singular devotion to the minute accidents of their
subjects, including, or rather seeking out, every excess of
sharpness and deformity. Mr Millais, Mr Hunt, Mr Collins—
and in some degree—Mr Brown, the author of a huge picture
of Chaucer, have undertaken to reform the art on these
principles. The Council of the Academy, acting in a spirit of
toleration and indulgence to young artists, have now allowed
these extravagances to disgrace their walls for the last three
years, and though we cannot prevent men who are capable of
better things from wasting their talents on ugliness and conceit,
the public may fairly require that such offensive jests should not
continue to be exposed as specimens of the waywardness of these
artists who have relapsed into the infancy of their profession.

In the North Room will be found, too, Mr Millais' picture
of 'The Woodman's Daughter', from some verses by Mr
Coventry Patmore, and as the same remarks will apply to the
pictures of the same artist, 'The Return of the Dove to the
Ark' (651), and Tennyson's 'Mariana' (561), as well as to
similar works by Mr Collins, as 'Convent Thoughts' (493), and
to Mr Hunt's 'Valentine receiving Proteus' [sic] (59), we shall
venture to express our opinion on them all in this place. These
young artists have unfortunately become notorious by addict-
ing themselves to an antiquated style and an affected sim-
plicity in Painting, which is to genuine art what the medieval
ballads and designs in *Punch* are to Chaucer and Giotto. With

the utmost readiness to humour even the caprices of Art when they bear the stamp of originality and genius, we can extend no toleration to a mere servile imitation of the cramped style, false perspective, and crude colour of remote antiquity. We do not want to see what Fuseli termed drapery 'snapped instead of folded', faces bloated into apoplexy or extenuated to skeletons, colour borrowed from the jars in a druggist's shop, and expression forced into caricature. It is said that the gentlemen have the power to do better things, and we are referred in proof of their handicraft to the mistaken skill with which they have transferred to canvas the hay which lined the lofts in Noah's Ark, the brown leaves of the coppice where Sylvia strayed, and the prim vegetables of a monastic garden. But we must doubt a capacity of which we have seen so little proof, and if any such capacity did ever exist in them, we fear that it has already been overlaid by mannerism and conceit. To become great in art, it has been said that a painter must become as a little child, though not childish, but the authors of these offensive and absurd productions have continued to combine puerility or infancy of their art with the uppishness and self-sufficiency of a different period of life. That morbid infatuation which sacrifices truth, beauty, and genuine feeling to mere eccentricity deserves no quarter at the hands of the public, and though the patronage of art is sometimes lavished on oddity as profusely as on higher qualities, these monkish follies have no more real claim to figure in any decent collection of English paintings than the aberrations of intellect which are exhibited under the name of Mr Ward.

JOHN RUSKIN

THE PRE-RAPHAELITE BRETHREN

To the Editor of 'The Times'

Sir,—Your usual liberality will, I trust, give a place in your columns to this expression of my regret that the tone of the critique which appeared in *The Times* of Wednesday last on the

works of Mr Millais and Mr Hunt, now in the Royal Academy, should have been scornful as well as severe.

I regret it, first, because the mere labour bestowed on those works, and their fidelity to a certain order of truth (labour and fidelity which are altogether indisputable), ought at once to have placed them above the level of mere contempt; and, secondly, because I believe these young artists to be at a most critical period of their career—at a turning-point, from which they may either sink into nothingness or rise to very real greatness; and I believe also, that whether they choose the upward or the downward path, may in no small degree depend upon the character of the criticism which their works have to sustain. I do not wish in any way to dispute or invalidate the general truth of your critique on the Royal Academy; nor am I surprised at the estimate which the writer formed of the pictures in question when rapidly compared with works of totally different style and aim; nay, when I first saw the chief picture by Millais in the Exhibition of last year, I had nearly come to the same conclusion myself. But I ask your permission, in justice to artists who have at least given much time and toil to their pictures, to institute some more serious inquiry into their merits and faults than your general notice of the Academy could possibly have admitted.

Let me state, in the first place, that I have no acquaintance with any of these artists, and very imperfect sympathy with them. No one who has met with any of my writings will suspect me of desiring to encourage them in their Romanist and Tractarian tendencies. I am glad to see that Mr Millais's lady in blue is heartily tired of her painted window and idolatrous toilet table; and I have no particular respect for Mr Collins's lady in white, because her sympathies are limited by a dead wall, or divided between some gold fish and a tadpole— (the latter Mr Collins may, perhaps, permit me to suggest *en passant*, as he is already half a frog, is rather too small for his age). But I happen to have a special acquaintance with the water plant, *Alisma Plantago*, among which the said gold fish are swimming; and as I never saw it so thoroughly or so well drawn, I must take leave to remonstrate with you, when you say sweepingly that these men 'sacrifice *truth* as well as feeling

to eccentricity'. For as a mere botanical study of the water lily and *Alisma*, as well as of the common lily and several other garden flowers, this picture would be invaluable to me, and I heartily wish it were mine.

But, before entering into such particulars, let me correct an impression which your article is likely to induce in most minds, and which is altogether false. These pre-Raphaelites (I cannot compliment them on common sense in choice of a *nom de guerre*) do *not* desire nor pretend in any way to imitate antique painting as such. They know very little of ancient paintings who suppose the works of these young artists to resemble them. As far as I can judge of their aim—for, as I said, I do not know the men themselves—the Pre-Raphaelites intend to surrender no advantage which the knowledge or inventions of the present time can afford to their art. They intend to return to early days in this one point only—that, as far as in them lies, they will draw either what they see, or what they suppose might have been the actual facts of the scene they desire to represent, irrespective of any conventional rules of picture-making; and they have chosen their unfortunate though not inaccurate name because all artists did this before Raphael's time, and after Raphael's time did *not* this, but sought to paint fair pictures, rather than represent stern facts; of which the consequence has been that, from Raphael's time to this day, historical art has been in acknowledged decadence.

Now, sir, presupposing that the intention of these men was to return to archaic *art* instead of to archaic *honesty*, your critic borrows Fuseli's expression respecting ancient draperies 'snapped instead of folded', and asserts that in these pictures there is a '*servile* imitation of *false* perspective'. To which I have just this to answer:—

That there is not one single error in perspective in four out of the five pictures in question; and that in Millais' 'Mariana' there is but this one—that the top of the green curtain in the distant window has too low a vanishing-point; and that I will undertake, if need be, to point out and prove a dozen worse errors in perspective in any twelve pictures, containing architecture, taken at random from among the works of the popular painters of the day.

Secondly: that, putting aside the small Mulready, and the works of Thorburn and Sir W. Ross, and perhaps some others of those in the miniature room which I have not examined, there is not a single study of drapery in the whole Academy, be it in large works or small, which for perfect truth, power, and finish could be compared for an instant with the black sleeve of the Julia, or with the velvet on the breast and the chain mail of the Valentine, of Mr Hunt's picture; or with the white draperies on the table of Mr Millais' 'Mariana', and of the right-hand figure in the same painter's 'Dove returning to the Ark'.

And further: that as studies both of drapery and of every minor detail, there has been nothing in art so earnest or so complete as these pictures since the days of Albert Durer. This I assert generally and fearlessly. On the other hand, I am perfectly ready to admit that Mr Hunt's 'Sylvia' is not a person whom Proteus or any one else would have been likely to fall in love with at first sight; and that one cannot feel very sincere delight that Mr Millais' 'Wives of the Sons of Noah' should have escaped the Deluge; with many other faults besides on which I will not enlarge at present, because I have already occupied too much of your valuable space, and I hope to enter into more special criticism in a future letter.

<div style="text-align: center">

I have the honour to be, Sir,

Your obedient servant,

THE AUTHOR OF 'MODERN PAINTERS'.

</div>

DENMARK HILL, *May 9*.

'. . . ABSOLUTE, UNCOMPROMISING TRUTH'

Pre-Raphaelitism has but one principle, that of absolute, uncompromising truth in all that it does, obtained by working everything, down to the most minute detail, from nature, and from nature only.[1] Every Pre-Raphaelite landscape back-

[1] Or, where imagination is necessarily trusted to, by always endeavouring to conceive a fact as it really was likely to have happened, rather than as it most prettily *might* have happened. The various members of the school are not all equally severe in carrying out its principles, some of them trusting their memory or fancy very far; only all agreeing in the effort to make their memories so accurate as to seem like portraiture, and their fancy so probable as to seem like memory.

ground is painted to the last touch, in the open air, from the thing itself. Every Pre-Raphaelite figure, however studied in expression, is a true portrait of some living person. Every minute accessory is painted in the same manner. And one of the chief reasons for the violent opposition with which the school has been attacked by other artists, is the enormous cost of care and labour which such a system demands from those who adopt it, in contradistinction to the present slovenly and imperfect style.

133. This is the main Pre-Raphaelite principle. But the battle which its supporters have to fight is a hard one; and for that battle they have been fitted by a very peculiar character.

You perceive that the principal resistance they have to make is to that spurious beauty, whose attractiveness had tempted men to forget, or to despise, the more noble quality of sincerity: and in order at once to put them beyond the power of temptation from this beauty, they are, as a body, characterised by a total absence of sensibility to the ordinary and popular forms of artistic gracefulness; while, to all that still lower kind of prettiness, which regulates the disposition of our scenes upon the stage, and which appears in our lower art, as in our annuals, our commonplace portraits, and statuary, the Pre-Raphaelites are not only dead, but they regard it with a contempt and aversion approaching to disgust. This character is absolutely necessary to them in the present time; but it, of course, occasionally renders their work comparatively unpleasing. As the school becomes less aggressive, and more authoritative—which it will do—they will enlist into their ranks men who will work, mainly, upon their principles, and yet embrace more of those characters which are generally attractive, and this great ground of offence will be removed.

134. Again: you observe that as landscape painters, their principles must, in great part, confine them to mere foreground work; and singularly enough, that they may not be tempted away from this work, they have been born with comparatively little enjoyment of those evanescent effects and distant sublimities which nothing but the memory can arrest, and nothing but a daring conventionalism portray. But for this work they are not now needed. Turner, the first and greatest of the Pre-

Raphaelites, has done it already; he, though his capacity embraced everything, and though he would sometimes, in his foregrounds, paint the spots upon a dead trout, and the dyes upon a butterfly's wing, yet for the most part delighted to begin at that very point where the other branches of Pre-Raphaelitism become powerless.

135. Lastly. The habit of constantly carrying everything up to the utmost point of completion deadens the Pre-Raphaelites in general to the merits of men who, with an equal love of truth up to a certain point, yet express themselves habitually with speed and power, rather than with finish, and give abstracts of truth rather than total truth. Probably to the end of time artists will more or less be divided into these classes, and it will be impossible to make men like Millais understand the merits of men like Tintoret; but this is the more to be regretted because the Pre-Raphaelites have enormous powers of imagination, as well as of realisation, and do not yet themselves know of how much they would be capable, if they sometimes worked on a larger scale, and with a less laborious finish.

136. With all their faults, their pictures are, since Turner's death, the best—incomparably the best—on the walls of the Royal Academy; and such works as Mr Hunt's 'Claudio and Isabella' have never been rivalled, in some respects never approached, at any other period of art.

'THOMAS MAITLAND' (ROBERT BUCHANAN)

THE FLESHLY SCHOOL OF POETRY

Mr Rossetti has been known for many years as a painter of exceptional powers, who, for reasons best known to himself, has shrunk from publicly exhibiting his pictures, and from allowing anything like a popular estimate to be formed of their qualities. He belongs, or is said to belong, to the so-called Pre-Raphaelite school, a school which is generally considered to

exhibit much genius for colour, and great indifference to per-
spective. It would be unfair to judge the painter by the
glimpses we have had of his works, or by the photographs
which are sold of the principal paintings. Judged by the
photographs, he is an artist who conceives unpleasantly, and
draws ill. Like Mr Simeon Solomon, however, with whom he
seems to have many points in common, he is distinctively a
colourist, and of his capabilities in colour we cannot speak,
though we should guess that they are great; for if there is any
good quality by which his poems are specially marked, it is a
great sensitiveness to hues and tints as conveyed in poetic
epithet. These qualities, which impress the casual spectator of
the photographs from his pictures, are to be found abundantly
among his verses. There is the same thinness and transparence
of design, the same combination of the simple and the gro-
tesque, the same morbid deviation from healthy forms of life,
the same sense of weary, wasting, yet exquisite sensuality;
nothing virile, nothing tender, nothing completely sane; a
superfluity of extreme sensibility, of delight in beautiful forms,
hues, and tints, and a deep-seated indifference to all agitating
forces and agencies, all tumultuous griefs and sorrows, all the
thunderous stress of life, and all the straining storm of specula-
tion. Mr Morris is often pure, fresh, and wholesome as his own
great model; Mr Swinburne startles us more than once by
some fine flash of insight; but the mind of Mr Rossetti is like a
glassy mere, broken only by the dive of some water-bird or the
hum of winged insects, and brooded over by an atmosphere of
insufferable closeness, with a light blue sky above it, sultry
depths mirrored within it, and a surface so thickly sown with
water-lilies that it retains its glassy smoothness even in the
strongest wind. Judged relatively to his poetic associates, Mr
Rossetti must be pronounced inferior to either. He cannot tell
a pleasant story like Mr Morris, nor forge alliterative thunder-
bolts like Mr Swinburne. It must be conceded, nevertheless,
that he is neither so glibly imitative as the one, nor so trans-
cendently superficial as the other.

Although he has been known for many years as a poet as well
as a painter—as a painter and poet idolized by his own family
and personal associates—and although he has once or twice

appeared in print as a contributor to magazines, Mr Rossetti
did not formally appeal to the public until rather more than a
year ago, when he published a copious volume of poems, with
the announcement that the book, although it contained
pieces composed at intervals during a period of many years,
'included nothing which the author believes to be immature'.
This work was inscribed to his brother, Mr William Rossetti,
who, having written much both in poetry and criticism, will
perhaps be known to bibliographers as the editor of the worst
edition of Shelley which has yet seen the light. No sooner had
the work appeared than the chorus of eulogy began. 'The book
is satisfactory from end to end,' wrote Mr Morris in the
Academy; 'I think these lyrics, with all their other merits, the
most complete of their time; nor do I know what lyrics of any
time are to be called *great*, if we are to deny the title to these.'
On the same subject Mr Swinburne went into a hysteria of
admiration: 'golden affluence', 'jewel-coloured words',
'chastity of form', 'harmonious nakedness', 'consummate
fleshly sculpture', and so on in Mr Swinburne's well-known
manner when reviewing his friends. Other critics, with a
singular similarity of phrase, followed suit. Strange to say,
moreover, no one accused Mr Rossetti of naughtiness. What
had been heinous in Mr Swinburne was majestic exquisiteness
in Mr Rossetti. Yet we question if there is anything in the
unfortunate 'Poems and Ballads' quite so questionable on the
score of thorough nastiness as many pieces in Mr Rossetti's
collection. Mr Swinburne was wilder, more outrageous, more
blasphemous, and his subjects were more atrocious in them-
selves; yet the hysterical tone slew the animalism, the furious-
ness of epithet lowered the sensation; and the first feeling of
disgust at such themes as 'Laus Veneris' and 'Anactoria',
faded away into comic amazement. It was only a little mad
boy letting off squibs; not a great strong man, who might be
really dangerous to society. 'I *will* be naughty!' screamed the
little boy; but, after all, what did it matter? It is quite
different, however, when a grown man with the self-control
and easy audacity of actual experience, comes forward to
chronicle his amorous sensations, and, first proclaiming in a
loud voice his literary maturity, and consequent responsibility,

shamelessly prints and publishes such a piece of writing as this
sonnet on 'Nuptial Sleep':

> *At length their long kiss severed, with sweet smart:*
> *And as the last slow sudden drops are shed*
> *From sparkling eaves when all the storm has fled,*
> *So singly flagged the pulses of each heart.*
> *Their bosoms sundered, with the opening start*
> *Of married flowers to either side outspread*
> *From the knit stem; yet still their mouths, burnt red,*
> *Fawned on each other where they lay apart.*
>
> Sleep sank them lower than the tide of dreams,
> And their dreams watched them sink, and slid away.
> Slowly their souls swam up again, through gleams
> Of watered light and dull drowned waifs of day;
> Till from some wonder of new woods and streams
> He woke, and wondered more: for there she lay.

This, then, is 'the golden affluence of words, the firm outline,
the justice and chastity of form'. Here is a full-grown man, pre-
sumably intelligent and cultivated, putting on record for other
full-grown men to read, the most secret mysteries of sexual con-
nection, and that with so sickening a desire to reproduce the
sensual mood, so careful a choice of epithet to convey mere
animal sensations, that we merely shudder at the shameless
nakedness. We are no purists in such matters. We hold the
sensual part of our nature to be as holy as the spiritual or
intellectual part, and we believe that such things must find
their equivalent in all; but it is neither poetic, nor manly, nor
even human, to obtrude such things as the themes of whole
poems. It is simply nasty. Nasty as it is, we are very mistaken
if many readers do not think it nice. English society of one kind
purchases the *Day's Doings*. English society of another kind
goes into ecstasy over Mr Solomon's pictures—pretty pieces of
morality, such as 'Love dying by the breath of Lust'. There is
not much to choose between the two objects of admiration,
except that painters like Mr Solomon lend actual genius to
worthless subjects, and thereby produce veritable monsters—
like the lovely devils that danced round Saint Anthony. Mr

Rossetti owes his so-called success to the same causes. In poems like 'Nuptial Sleep', the man who is too sensitive to exhibit his pictures, and so modest that it takes him years to make up his mind to publish his poems, parades his private sensations before a coarse public, and is gratified by their applause.

DANTE GABRIEL ROSSETTI

THE STEALTHY SCHOOL OF CRITICISM

The primary accusation, on which this writer [Thomas Maitland] grounds all the rest, seems to be that others and myself 'extol fleshliness as the distinct and supreme end of poetic and pictorial art; aver that poetic expression is greater than poetic thought; and, by inference, that the body is greater than the soul, and sound superior to sense.'

As my own writings are alone formally dealt with in the article, I shall confine my answer to myself; and this must first take unavoidably the form of a challenge to prove so broad a statement. It is true, some fragmentary pretence at proof is put in here and there throughout the attack, and thus far an opportunity is given of contesting the assertion.

A Sonnet entitled *Nuptial Sleep* is quoted and abused at page 338 of the *Review*, and is there dwelt upon as a 'whole poem', describing 'merely animal sensations'. It is no more a whole poem, in reality, than is any single stanza of any poem throughout the book. The poem, written chiefly in sonnets, and of which this is one sonnet-stanza, is entitled *The House of Life*; and even in my first published instalment of the whole work (as contained in the volume under notice) ample evidence is included that no such passing phase of description as the one headed *Nuptial Sleep* could possibly be put forward by the author of *The House of Life* as his own representative view of the subject of love. In proof of this, I will direct attention (among the love-sonnets of this poem) to Nos. 2, 8, 11, 17, 28, and more especially 13, which, indeed, I had better print here.

LOVE-SWEETNESS

'Sweet dimness of her loosened hair's downfall
 About thy face; her sweet hands round thy head
 In gracious fostering union garlanded;
Her tremulous smiles; her glances' sweet recall
Of love; her murmuring sighs memorial;
 Her mouth's culled sweetness by thy kisses shed
 On cheeks and neck and eyelids, and so led
Back to her mouth which answers there for all :—
'What sweeter than these things, except the thing
 In lacking which all these would lose their sweet :—
 The confident heart's still fervour; the swift beat
And soft subsidence of the spirit's wing,
Then when it feels, in cloud-girt wayfaring,
 The breath of kindred plumes against its feet?'

Any reader may bring any artistic charge he pleases against
the above sonnet; but one charge it would be impossible to
maintain against the writer of the series in which it occurs, and
that is, the wish on his part to assert that the body is greater
than the soul. For here all the passionate and just delights of
the body are declared—somewhat figuratively, it is true, but
unmistakably—to be as naught if not ennobled by the concur-
rence of the soul at all times. Moreover, nearly one half of this
series of sonnets has nothing to do with love, but treats of quite
other life-influences. I would defy any one to couple with fair
quotation of Sonnets 29, 30, 31, 39, 40, 41, 43, or others, the
slander that their author was not impressed, like all other
thinking men, with the responsibilities and higher mysteries of
life; while Sonnets 35, 36, and 37, entitled *The Choice*, sum up
the general view taken in a manner only to be evaded by
conscious insincerity. Thus much for *The House of Life*, of
which the sonnet *Nuptial Sleep* is one stanza, embodying, for its
small constituent share, a beauty of natural universal func-
tion, only to be reprobated in art if dwelt on (as I have shown
that it is not here) to the exclusion of those other highest things
of which it is the harmonious concomitant.

At page 342, an attempt is made to stigmatize four short
quotations as being specially 'my own property', that is (for

the context shows the meaning), as being grossly sensual; though all guiding reference to any precise page or poem in my book is avoided here. The first of these unspecified quotations is from the *Last Confession*; and is the description referring to the harlot's laugh, the hideous character of which, together with its real or imagined resemblance to the laugh heard soon afterwards from the lips of one long cherished as an ideal, is the immediate cause which makes the maddened hero of the poem a murderer. Assailants may say what they please; but no poet or poetic reader will blame me for making the incident recorded in these seven lines as repulsive to the reader as it was to the hearer and beholder. Without this, the chain of motive and result would remain obviously incomplete. Observe also that these are but seven lines in a poem of some five hundred, not one other of which could be classed with them.

A second quotation gives the last two lines *only* of the following sonnet, which is the first of four sonnets in *The House of Life* jointly entitled *Willowwood*:—

'I sat with Love upon a woodside well,
 Leaning across the water, I and he;
 Nor ever did he speak nor looked at me,
But touched his lute wherein was audible
The certain secret thing he had to tell:
 Only our mirrored eyes met silently
 In the low wave; and that sound seemed to be
The passionate voice I knew; and my tears fell.

'And at their fall, his eyes beneath grew hers;
 And with his foot and with his wing-feathers
 He swept the spring that watered my heart's drouth.
Then the dark ripples spread to waving hair,
 And as I stopped, her own lips rising there
 Bubbled with brimming kisses at my mouth.'

The critic has quoted (as I said) only the last two lines, and he has italicized the second as something unbearable and ridiculous. Of course the inference would be that this was really my own absurd bubble-and-squeak notion of an actual kiss. The reader will perceive at once, from the whole sonnet transcribed

above, how untrue such an inference would be. The sonnet describes a dream or trance of divided love momentarily reunited by the longing fancy; and in the imagery of the dream, the face of the beloved rises through deep dark waters to kiss the lover. Thus the phrase, 'Bubbled with brimming kisses' etc., bears purely on the special symbolism employed, and from that point of view will be found, I believe, perfectly simple and just.

A third quotation is from *Eden Bower*, and says,

> 'What more prize than love to impel thee?
> Grip and lip my limbs as I tell thee!'

Here again no reference is given, and naturally the reader would suppose that a human embrace is described. The embrace, on the contrary, is that of a fabled snake-woman and a snake. It would be possible still, no doubt, to object on other grounds to this conception; but the ground inferred and relied on for full effect by the critic is none the less an absolute misrepresentation. These three extracts, it will be admitted, are virtually, though not verbally, garbled with malicious intention; and the same is the case, as I have shown, with the sonnet called *Nuptial Sleep* when purposely treated as a 'whole poem'.

The last of the four quotations grouped by the critic as conclusive examples consists of two lines from *Jenny*. Neither some thirteen years ago, when I wrote this poem, nor last year when I published it, did I fail to foresee impending charges of recklessness and aggressiveness, or to perceive that even some among those who could really *read* the poem, and acquit me on these grounds, might still hold that the thought in it had better have dispensed with the situation which serves it for framework. Nor did I omit to consider how far a treatment from without might here be possible. But the motive powers of art reverse the requirement of science, and demand first of all an *inner* standing-point. The heart of such a mystery as this must be plucked from the very world in which it beats or bleeds; and the beauty and pity, the self-questionings and all-questionings which it brings with it, can come with full force only from the mouth of one alive to its whole appeal, such as the speaker put

forward in the poem,—that is, of a young and thoughtful man of the world. To such a speaker, many half-cynical revulsions of feeling and reverie, and a recurrent presence of the impressions of beauty (however artificial) which first brought him within such a circle of influence, would be inevitable features of the dramatic relations portrayed. Here again I can give the lie, in hearing of honest readers, to the base or trivial ideas which my critic labours to connect with the poem. There is another little charge, however, which this minstrel in mufti brings against *Jenny*, namely, one of plagiarism from that very poetic self of his which the tutelary prose does but enshroud for the moment. This question can, fortunately, be settled with ease by others who have read my critic's poems; and thus I need the less regret that, not happening myself to be in that position, I must be content to rank with those who cannot pretend to an opinion on the subject.

JOHN MORLEY

MR SWINBURNE'S NEW POEMS: POEMS AND BALLADS

It is mere waste of time, and shows a curiously mistaken conception of human character, to blame an artist of any kind for working at a certain set of subjects rather than at some other set which the critic may happen to prefer. An artist, at all events an artist of such power and individuality as Mr Swinburne, works as his character compels him. If the character of his genius drives him pretty exclusively in the direction of libidinous song, we may be very sorry, but it is of no use to advise him and to preach to him. What comes of discoursing to a fiery tropical flower of the pleasant fragrance of the rose or the fruitfulness of the fig-tree? Mr Swinburne is much too stoutly bent on taking his own course to pay any attention to critical monitions as to the duty of the poet, or any warnings of the worse than barrenness of the field in which he has chosen to labour. He is so firmly and avowedly fixed in an attitude of

revolt against the current notions of decency and dignity and
social duty that to beg of him to become a little more decent,
to fly a little less persistently and gleefully to the animal side of
human nature, is simply to beg him to be something different
from Mr Swinburne. It is a kind of protest which his whole
position makes it impossible for him to receive with anything
but laughter and contempt. A rebel of his calibre is not to be
brought to a better mind by solemn little sermons on the
loyalty which a man owes to virtue. His warmest prayer to the
gods is that they should

> Come down and redeem us from virtue.

His warmest hope for men is that they should change

> The lilies and languors of virtue
> For the raptures and roses of vice.

It is of no use, therefore, to scold Mr Swinburne for grovelling
down among the nameless shameless abominations which
inspire him with such frenzied delight. They excite his
imagination to its most vigorous efforts, they seem to him the
themes most proper for poetic treatment, and they suggest
ideas which, in his opinion, it is highly to be wished that
English men and women should brood upon and make their
own. He finds that these fleshly things are his strong part, so he
sticks to them. Is it wonderful that he should? And at all
events he deserves credit for the audacious courage with which
he has revealed to the world a mind all aflame with the feverish
carnality of a schoolboy over the dirtiest passages in Lemprière.
It is not every poet who would ask us all to go hear him tuning
his lyre in a stye. It is not everybody who would care to let the
world know that he found the most delicious food for poetic
reflection in the practices of the great island of the Ægean, in
the habits of Messalina, of Faustina, of Pasiphaë. Yet these
make up Mr Swinburne's version of the dreams of fair women,
and he would scorn to throw any veil over pictures which
kindle, as these do, all the fires of his imagination in their
intensest heat and glow. It is not merely 'the noble, the nude,
the antique' which he strives to reproduce. If he were a rebel
against the fat-headed Philistines and poor-blooded Puritans

who insist that all poetry should be such as may be wisely
placed in the hands of girls of eighteen, and is fit for the use of
Sunday schools, he would have all wise and enlarged readers
on his side. But there is an enormous difference between an
attempt to revivify among us the grand old pagan conceptions
of Joy, and attempt to glorify all the bestial delights that the
subtleness of Greek depravity was able to contrive. It is a good
thing to vindicate passion, and the strong and large and right-
ful pleasures of sense, against the narrow and inhuman tyranny
of shrivelled anchorites. It is a very bad and silly thing to try to
set up the pleasures of sense in the seat of the reason they have
dethroned. And no language is too strong to condemn the
mixed vileness and childishness of depicting the spurious
passion of a putrescent imagination, the unnamed lusts of sated
wantons, as if they were the crown of character and their
enjoyment the great glory of human life. The only comfort
about the present volume is that such a piece as 'Anactoria'
will be unintelligible to a great many people, and so will the
fevered folly of 'Hermaphroditus', as well as much else that is
nameless and abominable. Perhaps if Mr Swinburne can a
second and third time find a respectable publisher willing to
issue a volume of the same stamp, crammed with pieces which
many a professional vendor of filthy prints might blush to sell
if he only knew what they meant, English readers will gradually
acquire a truly delightful familiarity with these unspeakable
foulnesses; and a lover will be able to present to his mistress a
copy of Mr Swinburne's latest verses with a happy confidence
that she will have no difficulty in seeing the point of every
allusion to Sappho or the pleasing Hermaphroditus, or the
embodiment of anything else that is loathsome and horrible.
It will be very charming to hear a drawing-room discussion on
such verses as these, for example:

> Stray breaths of Sapphic song that blew
> Through Mitylene
> Shook the fierce quivering blood in you
> By night, Faustine.
> The shameless nameless love that makes
> Hell's iron gin

> Shut on you like a trap that breaks
> > The soul, Faustine.
> And when your veins were void and dead,
> > What ghosts unclean
> Swarmed round the straitened barren bed
> > That hid Faustine?
> What sterile growths of sexless root
> > Or epicene?
> What flower of kisses without fruit
> > Of love, Faustine?

We should be sorry to be guilty of anything so offensive to Mr Swinburne as we are quite sure an appeal to the morality of all the wisest and best men would be. The passionate votary of the goddess whom he hails as 'Daughter of Death and Priapus' has got too high for this. But it may be presumed that common sense is not too insulting a standard by which to measure the worth and place of his new volume. Starting from this sufficiently modest point, we may ask him whether there is really nothing in women worth singing about except 'quivering flanks' and 'splendid supple thighs', 'hot sweet throats' and 'hotter hands than fire', and their blood as 'hot wan wine of love'? Is purity to be expunged from the catalogue of desirable qualities? Does a poet show respect to his own genius by gloating, as Mr Swinburne does, page after page and poem after poem, upon a single subject, and that subject kept steadily in a single light? Are we to believe that having exhausted hot lustfulness, and wearied the reader with a luscious and nauseating iteration of the same fervid scenes and fervid ideas, he has got to the end of his tether?

ALGERNON CHARLES SWINBURNE

A REJOINDER

Certain poems of mine, it appears, have been impugned by judges, with or without a name, as indecent or as blasphemous.

To me, as I have intimated, their verdict is a matter of infinite indifference: it is of equally small moment to me whether in such eyes as theirs I appear moral or immoral, Christian or pagan. But, remembering that science must not scorn to investigate animalcules and infusoria, I am ready for once to play the anatomist.

With regard to any opinion implied or expressed throughout my book, I desire that one thing should be remembered: the book is dramatic, many-faced, multifarious; and no utterance of enjoyment or despair, belief or unbelief, can properly be assumed as the assertion of its author's personal feeling or faith. Were each poem to be accepted as the deliberate outcome and result of the writer's conviction, not mine alone but most other men's verses would leave nothing behind them but a sense of cloudy chaos and suicidal contradiction. Byron and Shelley, speaking in their own persons, and with what sublime effect we know, openly and insultingly mocked and reviled what the English of their day held most sacred. I have not done this. I do not say that if I chose, I would not do so to the best of my power; I do say that hitherto I have seen fit to do nothing of the kind.

It remains then to inquire what in that book can be reasonably offensive to the English reader. In order to resolve this problem, I will not fish up any of the ephemeral scurrilities born only to sting if they can, and sink as they must. I will take the one article that lies before me; the work (I admit) of an enemy, but the work (I acknowledge) of a gentleman. I cannot accept it as accurate; but I readily and gladly allow that it neither contains nor suggests anything false or filthy. To him therefore, rather than to another, I address my reclamation. Two among my poems, it appears, are in his opinion 'especially horrible'. Good. Though the phrase be somewhat 'inexpressive', I am content to meet him on this ground. It is something —nay, it is much—to find an antagonist who has a sufficient sense of honesty and honour to mark out the lists in which he, the challenger, is desirous to encounter the challenged.

The first, it appears, of these especially horrible poems is *Anactoria*. I am informed, and have not cared to verify the assertion, that this poem has excited, among the chaste and

candid critics of the day or hour or minute, a more vehement
reprobation, a more virtuous horror, a more passionate
appeal, than any other of my writing. Proud and glad as I must
be of this distinction, I must yet, however reluctantly, inquire
what merit or demerit has incurred such unexpected honour.
I was not ambitious of it; I am not ashamed of it; but I am
overcome by it. I have never lusted after the praise of re-
viewers; I have never feared their abuse; but I would fain
know why the vultures should gather here of all places; what
congenial carrion they smell, who can discern such (it is
alleged) in any rose-bed. And after a little reflection I do know,
or conjecture. Virtue, as she appears incarnate in British
journalism and voluble through that unsavoury organ, is
something of a compound creature—

> A lump neither alive nor dead,
> Dog-headed, bosom-eyed, and bird-footed;

nor have any dragon's jaws been known to emit on occasion
stronger and stranger sounds and odours. But having, not
without astonishment and disgust, inhaled these odours, I find
myself at last able to analyse their component parts. What my
poem means, if any reader should want that explained, I am
ready to explain, though perplexed by the hint that explanation
may be required. What certain reviewers have imagined it to
imply, I am incompetent to explain, and unwilling to imagine.
I am evidently not virtuous enough to understand them. I
thank Heaven that I am not. *Ma corruption rougirait de leur
pudeur.* I have not studied in those schools whence that full-
fledged phœnix, the 'virtue' of professional pressmen, rises
chuckling and crowing from the dunghill, its birthplace and
its deathbed. But there are birds of alien feather, if not of
higher flight; and these I would now recall into no hencoop or
preserve of mind, but into the open and general field where
all may find pasture and sunshine and fresh air: into places
whither the prurient prudery and the virulent virtue of press-
men and prostitutes cannot follow; into an atmosphere where
calumny cannot speak, and fatuity cannot breathe; in a word,
where backbiters and imbeciles become impossible. I neither
hope nor wish to change the unchangeable, to purify the

impure. To conciliate them, to vindicate myself in their eyes, is a task which I should not condescend to attempt, even were I sure to accomplish.

In this poem I have simply expressed, or tried to express, that violence of affection between one and another which hardens into rage and deepens into despair. The key-note which I have here touched was struck long since by Sappho. We in England are taught, are compelled under penalties to learn, to construe, and to repeat, as schoolboys, the imperishable and incomparable verses of that supreme poet; and I at least am grateful for the training. I have wished, and I have even ventured to hope, that I might be in time competent to translate into a baser and later language the divine words which even when a boy I could not but recognise as divine. That hope, if indeed I dared ever entertain such a hope, I soon found fallacious. To translate the two odes and the remaining fragments of Sappho is the one impossible task; and as witness of this I will call up one of the greatest among poets. Catullus 'translated'—or as his countrymen would now say 'traduced'—the Ode to Anactoria—Εἰς Ἐρωμέναν: a more beautiful translation there never was and will never be; but compared with the Greek, it is colourless and bloodless, puffed out by additions and enfeebled by alterations. Let any one set against each other the two first stanzas, Latin and Greek, and pronounce. (This would be too much to ask of all my critics; but some among the journalists of England may be capable of achieving the not exorbitant task.) Where Catullus failed I could not hope to succeed; I tried instead to reproduce in a diluted and dilated form the spirit of a poem which could not be reproduced in the body.

Now, the ode Εἰς Ἐρωμέναν—the 'Ode to Anactoria' (as it is named by tradition)—the poem which English boys have to get by heart—the poem (and this is more important) which has in the whole world of verse no companion and no rival but the Ode to Aphrodite, has been twice at least translated or 'traduced'. I am not aware that Mr Ambrose Phillips, or M. Nicolas Boileau-Despréaux, was ever impeached before any jury of moralists for his sufficiently grievous offence. By any jury of poets both would assuredly have been convicted. Now,

what they did I have not done. To the best (and bad is the best) of their ability, they have 'done into' bad French and bad English the very words of Sappho. Feeling that although I might do it better I could not do it well, I abandoned the idea of translation—ἔκων ἀέκοντί γε θυμῷ. I tried, then, to write some paraphrase of the fragment which the Fates and the Christians have spared us. I have not said, as Boileau and Phillips have, that the speaker sweats and swoons at sight of her favourite by the side of a man. I have abstained from touching on such details, for this reason: that I felt myself incompetent to give adequate expression in English to the literal and absolute words of Sappho; and would not debase and degrade them into a viler form. No one can feel more deeply than I do the inadequacy of my work. 'That is not Sappho,' a friend said once to me. I could only reply, 'It is as near as I can come; and no man can come close to her.' Her remaining verses are the supreme success, the final achievement, of the poetic art.

But this, it may be, is not to the point. I will try to draw thither; though the descent is immeasurable from Sappho's verse to mine, or to any man's. I have striven to cast my spirit into the mould of hers, to express and represent not the poem but the poet. I did not think it requisite to disfigure the page with a foot-note wherever I had fallen back upon the original text. Here and there, I need not say, I have rendered into English the very words of Sappho. I have tried also to work into words of my own some expression of their effect: to bear witness how, more than any other's, her verses strike and sting the memory in lonely places, or at sea, among all loftier sights and sounds—how they seem akin to fire and air, being themselves 'all air and fire'; other element there is none in them. As to the angry appeal against the supreme mystery of oppressive heaven, which I have ventured to put into her mouth at that point only where pleasure culminates in pain, affection in anger, and desire in despair—as to the 'blasphemies' [1] against God or Gods of which here and elsewhere I

[1] As I shall not return to this charge of 'blasphemy', I will here cite a notable instance of what does seem permissible in that line to the English reader. (I need not say that I do not question the right, which hypocrisy and servility

stand accused,—they are to be taken as the first outcome or outburst of foiled and fruitless passion recoiling on itself. After this, the spirit finds time to breathe and repose above all vexed senses of the weary body, all bitter labours of the revolted soul; the poet's pride of place is resumed, the lofty conscience of invincible immortality in the memories and the mouths of men.

What is there now of horrible in this? the expression of fierce fondness, the ardours of passionate despair? Are these so unnatural as to affright or disgust? Where is there an unclean detail? where an obscene allusion? A writer as impure as my critics might of course have written, on this or on any subject, an impure poem; I have not. And if to translate or paraphrase Sappho be an offence, indict the heavier offenders who have handled and rehandled this matter in their wretched versions of the ode. Is my poem more passionate in detail, more unmistakable in subject? I affirm that it is less; and what I affirm I have proved.

Next on the list of accusation stands the poem of *Dolores*. The gist and bearing of this I should have thought evident enough, viewed by the light of others which precede and follow it. I have striven here to express that transient state of spirit through which a man may be supposed to pass, foiled in love and weary of loving, but not yet in sight of rest; seeking refuge in those 'violent delights' which 'have violent ends', in fierce and frank sensualities which at least profess to be no more than they are. This poem, like *Faustine*, is so distinctly symbolic and fanciful that it cannot justly be amenable to judgment as a

would deny, of author and publisher to express and produce what they please. I do not deprecate, but demand for all men freedom to speak and freedom to hear. It is the line of demarcation which admits, if offence there be, the greater offender and rejects the less—it is this that I do not understand.) After many alternate curses and denials of God, a great poet talks of Christ 'veiling his horrible Godhead', of his 'malignant soul', his 'godlike malice'. Shelley outlived all this and much more; but Shelley wrote all this and much more. Will no Society for the Suppression of Common Sense—no Committee for the Propagation of Cant—see to it a little? or have they not already tried their hands at it and broken down? For the poem which contains the words above quoted continues at this day to bring credit and profit to its publishers—Messrs. Moxon and Co.

study in the school of realism. The spirit, bowed and dis-
coloured by suffering and by passion (which are indeed the
same thing and the same word), plays for a while with its
pleasures and its pains, mixes and distorts them with a sense
half-humorous and half-mournful, exults in bitter and doubt-
ful emotions—

> Moods of fantastic sadness, nothing worth.

It sports with sorrow, and jests against itself; cries out for free-
dom and confesses the chain; decorates with the name of
goddess, crowns anew as the mystical Cotytto, some woman,
real or ideal, in whom the pride of life with its companion lusts
is incarnate. In her lover's half-shut eyes, her fierce unchaste
beauty is transfigured, her cruel sensual eyes have a meaning
and a message; there are memories and secrets in the kisses of
her lips. She is the darker Venus, fed with burnt-offering and
blood-sacrifice; the veiled image of that pleasure which men
impelled by satiety and perverted by power have sought
through ways as strange as Nero's before and since his time;
the daughter of lust and death, and holding of both her
parents; Our Lady of Pain, antagonist alike of trivial sins and
virtues; no Virgin, and unblessed of men; no mother of the
Gods or God; no Cybele, served by sexless priests or monks,
adored of Origen or of Atys; no likeness of her in Dindymus or
Loreto.

The next act in this lyrical monodrame of passion represents
a new stage and scene. The worship of desire has ceased; the
mad commotion of sense has stormed itself out; the spirit,
clear of the old regret that drove it upon such violent ways for
a respite, healed of the fever that wasted it in the search for
relief among fierce fancies and tempestuous pleasures, dreams
now of truth discovered and repose attained. Not the martyr's
ardour of selfless love, an unprofitable flame that burnt out
and did no service—not the rapid rage of pleasure that seemed
for a little to make the flesh divine, to clothe the naked senses
with the fiery raiment of faith; but a stingless love, an in-
nocuous desire. 'Hesperia', the tenderest type of woman or of
dream, born in the westward 'islands of the blest', where the
shadows of all happy and holy things live beyond the sunset a

sacred and a sleepless life, dawns upon his eyes a western dawn, risen as the fiery day of passion goes down, and risen where it sank. Here, between moonrise and sunset, lives the love that is gentle and faithful, neither giving too much nor asking—a bride rather than a mistress, a sister rather than a bride. But not at once, or not for ever, can the past be killed and buried; hither also the temptress follows her flying prey, wounded and weakened, still fresh from the fangs of passion; the cruel hands, the amorous eyes, still glitter and allure. *Qui a bu boira*: the feet are drawn back towards the ancient ways. Only by lifelong flight, side by side with the goddess that redeems, shall her slave of old escape from the goddess that consumes: if even thus one may be saved, even thus distance the bloodhounds. . . .

I have heard that even the little poem of *Faustine* has been to some readers a thing to make the scalp creep and the blood freeze. It was issued with no such intent. Nor do I remember that any man's voice or heel was lifted against it when it first appeared, a new-born and virgin poem, in the *Spectator* newspaper for 1862. Virtue, it would seem, has shot up surprisingly in the space of four years or less—a rank and rapid growth, barren of blossom and rotten at root. *Faustine* is the reverie of a man gazing on the bitter and vicious loveliness of a face as common and as cheap as the morality of reviewers, and dreaming of past lives in which this fair face may have held a nobler or fitter station; the imperial profile may have been Faustina's, the thirsty lips a Mænad's, when first she learnt to drink blood or wine, to waste the loves and ruin the lives of men . . .

Two Magazines

[One of the innovations of the Pre-Raphaelite Movement is that species of periodical publication, the avant-garde manifesto-cum-magazine. The house magazine of the P.R.B., *The Germ* (which ran for four numbers), is the prototype of other forward-feeling journals of the arts which played an important cultural role in the second half of Victoria's reign: *The Oxford and Cambridge Magazine*, *The Hobby Horse*, *The Pageant*, *The Savoy*, *The Dome*. The first of these was, of course, a direct off-spring of *The Germ*, being the product of William Morris's and Burne-Jones's enthusiasm for all thing Pre-Raphaelite while at Exeter College, Oxford, as undergraduates together. Work from this periodical and *The Germ* make up this section.

In terms of intellectual and artistic maturity, one notices the almost total superiority of *The Oxford and Cambridge Magazine* to *The Germ*. Apart from the verse and prose of D. G. Rossetti and his brother William, and the critical contributions of Ford Madox Brown and F. G. Stephens, there is evident in the latter a great deal of emotional and cultural naïvety. Nor can the deficiency be laid at the door of youth alone, since the contributors to *The Oxford and Cambridge Magazine* were likewise young men but show both knowledge and power of argument in advance of the writers of *The Germ*. A partial explanation may be that *The Germ* was the by-product of a college of art (albeit the Royal Academy Schools) whereas *The Oxford and Cambridge Magazine* was imbued with the humanistic culture of the ancient universities. 'Not one of them,' wrote W. M. Rossetti of the members of the Brotherhood, 'if I except my brother and myself, had that kind of liberal education which comprises Latin and Greek, nor did any of them . . . read or speak French.'

56

From the occasional mawkishness, pietistic blether and intellectual over-softness of certain pages in *The Germ*, it is a relief to pass to the world of *The Oxford and Cambridge Magazine* where a more developed sense of intellectual *savoir faire* informs almost all the contributions.]

WILLIAM MICHAEL ROSSETTI

AN ACCOUNT OF 'THE GERM' BY ITS EDITOR

The Prærapahaelite Brotherhood having been founded in September 1848, the members exhibited in 1849 works conceived in the new spirit. These were received by critics and by the public with more than moderate though certainly not unmixed favour: it had not as yet transpired that there was a league of unquiet and ambitious young spirits, bent upon making a fresh start of their own, and a clean sweep of some effete respectabilities. It was not until after the exhibitions were near closing in 1849 that any idea of bringing out a magazine came to be discussed. The author of the project was Dante Gabriel Rossetti. He alone among the P.R.B.'s had already cultivated the art of writing in verse and in prose to some noticeable extent (*The Blessed Damozel* had been produced before May 1847), and he was better acquainted than any other member with British and foreign literature. There need be no self-conceit in saying that in these respects I came next to him. Holman-Hunt, Woolner, and Stephens, were all reading men (in British literature only) within straiter bounds than Rossetti: not any one of them, I think, had as yet done in writing anything worth mentioning. Millais and Collinson, more especially the former, were men of the brush, not the pen, yet both of them capable of writing with point, and even in verse. By July 13 and 14, 1849, some steps were taken towards discussing the project of a magazine. The price, as at first proposed, was to be sixpence; the title, 'Monthly Thoughts in Literature, Poetry and Art'; each number was to have an

etching. Soon afterwards a price of one shilling was decided upon, and two etchings per number: but this latter intention was not carried out. All the P.R.B.'s were to be proprietors of the magazine. . . .

The then title, invented by my brother, was 'Thoughts towards Nature', a phrase which, though somewhat extra-peculiar, indicated accurately enough the predominant conception of the Præraphaelite Brotherhood, that an artist, whether painter or writer, ought to be bent upon defining and expressing his own personal thoughts, and that these ought to be based upon a direct study of Nature, and harmonized with her manifestations. It was not until December 19, when the issue of our No. 1 was closely impending, that a different title, 'The Germ', was proposed. On that evening there was a rather large gathering at Dante Rossetti's studio, 72 Newman Street; the seven P.R.B.'s, Madox Brown, Cave Thomas, Deverell, Hancock, and John and George Tupper. Mr Thomas had drawn up a list of no less than sixty-five possible titles (a facsimile of his MS. of some of them appears in the *Letters of Dante Gabriel Rossetti to William Allingham*, edited by George Birkbeck Hill—Unwin, 1897). Only a few of them met with favour; and one of them, 'The Germ', going to the vote along with 'The Seed' and 'The Scroll', was approved by a vote of six to four. The next best were, I think, 'The Harbinger', 'First Thoughts', 'The Sower', 'The Truth-Seeker', and 'The Acorn'. Appended to the new title we retained, as a sub-title, something of what had been previously proposed; and the serial appeared as *The Germ. Thoughts towards Nature in Poetry, Literature, and Art.* At this same meeting Mr Woolner suggested that authors' names should not be published in the magazine. I alone opposed him, and his motion was carried. I cannot at this distance of time remember with any precision what his reasons were; but I think that he, and all the other artists concerned, entertained a general feeling that to appear publicly as writers, and especially as writers opposing the ordinary current of opinions on fine art, would damage their professional position, which already involved uphill work more than enough.

The Germ, No. 1, came out on or about January 1, 1850.

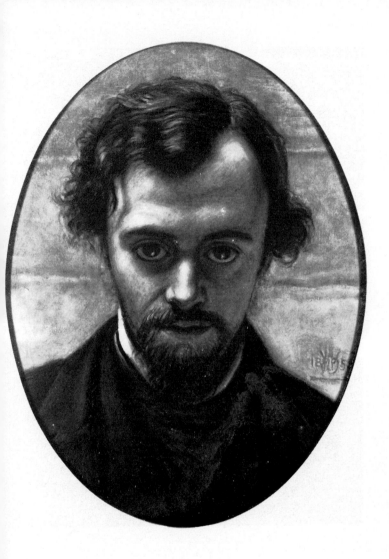

DANTE GABRIEL ROSSETTI (1853)
by William Holman Hunt
Oil painting copied from the original crayon portrait after the
sitter's death in 1882 with the earlier date appended.

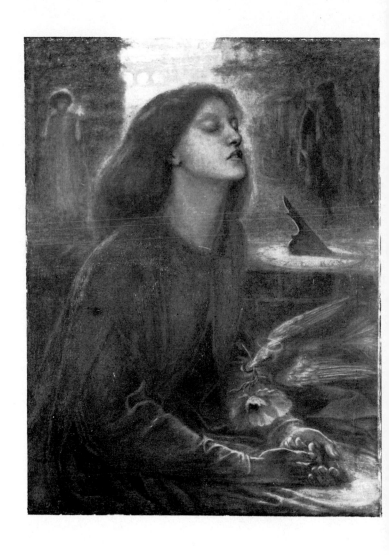

BEATA BEATRIX (1863) *by D. G. Rossetti*
An imaginative portrait of Elizabeth Siddal, the artist's wife,
made a year after her death.

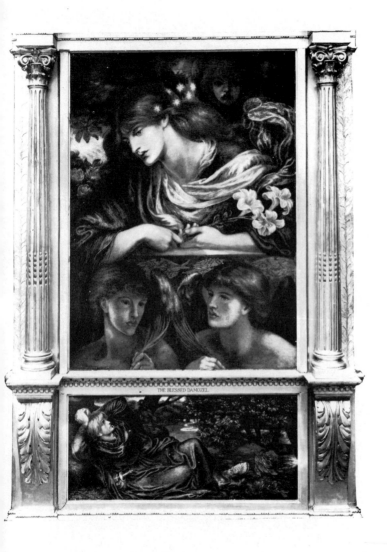

THE BLESSED DAMOZEL (1871–79) *by D. G. Rossetti*
This work looks back with heavy melancholy to Rossetti's
poem which first appeared in *The Germ*.

APRIL LOVE (1855–6) *by Arthur Hughes*
Hughes (1830–1915) was deeply influenced by Millais.
Ruskin terms this picture 'exquisite in every way'.

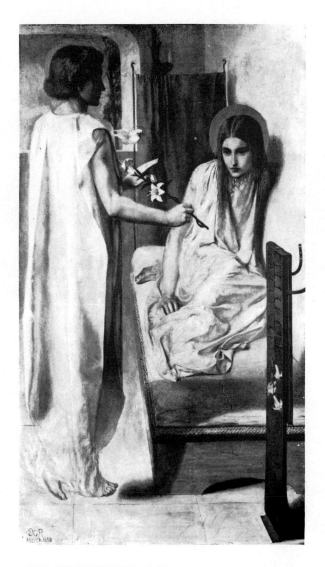

THE ANNUNCIATION (1850) *by D. G. Rossetti*
William Gaunt notes that 'the virgin was a likeness of
Christina Rossetti and . . . Thomas Woolner seems to have
posed for the angel.'

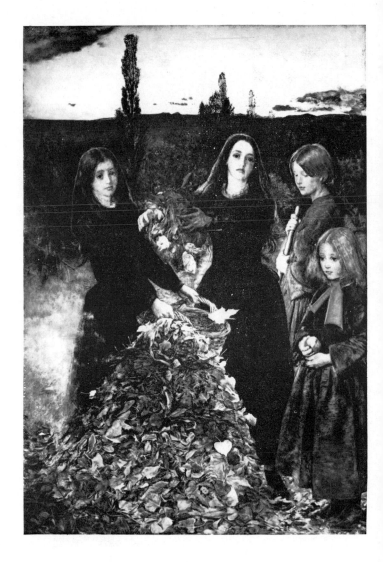

AUTUMN LEAVES (1856) *by J. E. Millais*
Painted in Perthshire, it may be thought to illustrate Millais'
saying: 'Pathos is my poetry.'

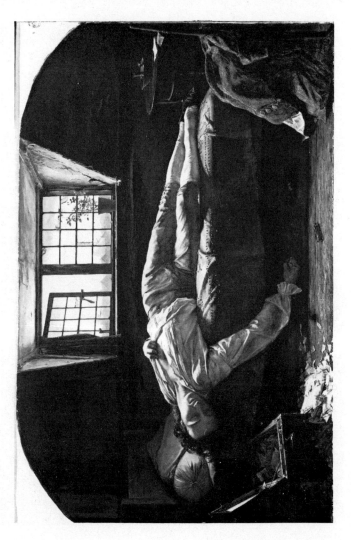

CHATTERTON
(1856) *by Henry Wallis*
Ruskin calls this 'fault-
less and wonderful';
and Mr. Quentin Bell
describes Wallis (1830–
1916) as 'more Pre-
Raphaelite than the
Pre-Raphaelites'.

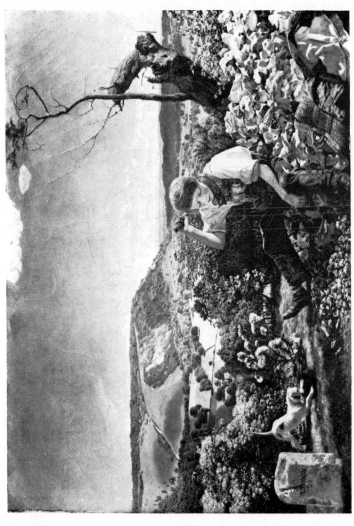

THE STONE
BREAKER (1858)
by *John Brett*
A protégé of Ruskin,
Brett (1831–1902) pain-
ted this above Box Hill
—'an example of social
landscape . . . poten-
tially tragic in its
message'.

The number of copies printed was 700. Something like 200 were sold, in about equal proportions by the publishers, and by ourselves among acquaintances and well-wishers. This was not encouraging, so we reduced the issue of No. 2 to 500 copies. It sold less well than No. 1. With this number was introduced the change of printing on the wrapper the names of most of the contributors: not of all, for some still preferred to remain unnamed, or to figure under a fancy designation. Had we been left to our own resources, we must now have dropped the magazine. But the printing-firm—or Mr George I. F. Tupper as representing it—came forward, and undertook to try the chance of two numbers more. The title was altered (at Mr Alexander Tupper's suggestion) to *Art and Poetry, being Thoughts towards Nature, conducted principally by Artists*; and Messrs Dickinson and Co., of New Bond Street, the printsellers, consented to join their name as publishers to that of Messrs Aylott and Jones. Mr Robert Dickinson, the head of this firm, and more especially his brother, the able portrait-painter Mr Lowes Dickinson, were well known to Madox Brown, and through him to members of the P.R.B. I continued to be editor; but, as the money stake of myself and my colleagues in the publication had now ceased, I naturally accommodated myself more than before to any wish evinced by the Tupper family. No. 3, which ought to have appeared on March 1, was delayed by these uncertainties and changes till March 31. No. 4 came out on April 30. Some small amount of advertising was done, more particularly by posters carried about in front of the Royal Academy (then in Trafalgar Square), which opened at the beginning of May. All efforts proved useless. People would not buy *The Germ*, and would scarcely consent to know of its existence. So the magazine breathed its last, and its obsequies were conducted in the strictest privacy. Its debts exceeded its assets, and a sum of £33 odd, due on Nos. 1 and 2, had to be cleared off by the seven (or eight) proprietors, conscientious against the grain. What may have been the loss of Messrs Tupper on Nos. 3 and 4 I am unable to say. It is hardly worth specifying that neither the editor, not any of the contributors whether literary or artistic, received any sort of payment.

WILLIAM MICHAEL ROSSETTI

'WHEN WHOSO MERELY HATH A LITTLE THOUGHT'

When whoso merely hath a little thought
 Will plainly think the thought which is in him,—
 Not imaging another's bright or dim,
Not mangling with new words what others taught;
When whoso speaks, from having either sought
 Or only found,—will speak, nor just to skim
 A shallow surface with words made and trim,
But in that very speech the matter brought:
Be not too keen to cry—'So this is all!—
 A thing I might myself have thought as well,
 But would not say it, for it was not worth!'
 Ask: 'Is this truth?' For is it still to tell
That, be the theme a point or the whole earth,
Truth is a circle, perfect, great or small?

DANTE GABRIEL ROSSETTI

THE BLESSED DAMOZEL

The blessed Damozel leaned out
 From the gold bar of Heaven:
Her blue grave eyes were deeper much
 Than a deep water, even.
She had three lilies in her hand,
 And the stars in her hair were seven.

Her robe, ungirt from clasp to hem,
 No wrought flowers did adorn,

But a white rose of Mary's gift
 On the neck meetly worn;
And her hair, lying down her back,
 Was yellow like ripe corn.

Herseemed she scarce had been a day
 One of God's choristers;
The wonder was not yet quite gone
 From that still look of hers;
Albeit to them she left, her day
 Had counted as ten years.

(To *one* it is ten years of years:
 Yet now, here in this place
Surely she leaned o'er me,—her hair
 Fell all about my face.
Nothing: the Autumn-fall of leaves.
 The whole year sets apace.)

It was the terrace of God's house
 That she was standing on,—
By God built over the sheer depth
 In which Space is begun;
So high, that looking downward thence,
 She could scarce see the sun.

It lies from Heaven across the flood
 Of ether, as a bridge.
Beneath, the tides of day and night
 With flame and blackness ridge
The void, as low as where this earth
 Spins like a fretful midge.

But in those tracts, with her, it was
 The peace of utter light
And silence. For no breeze may stir
 Along the steady flight
Of seraphim; no echo there,
 Beyond all depth or height.

Heard hardly, some of her new friends,
 Playing at holy games,
Spake, gentle-mouthed, among themselves,
 Their virginal chaste names;
And the souls, mounting up to God,
 Went by her like thin flames.

And still she bowed herself, and stooped
 Into the vast waste calm;
Till her bosom's pressure must have made
 The bar she leaned on warm,
And the lilies lay as if asleep
 Along her bended arm.

From the fixt lull of heaven, she saw
 Time, like a pulse, shake fierce
Through all the worlds. Her gaze still strove,
 In that steep gulph, to pierce
The swarm: and then she spake, as when
 The stars sang in their spheres.

'I wish that he were come to me,
 For he will come,' she said.
'Have I not prayed in solemn heaven?
 On earth, has he not prayed?
Are not two prayers a perfect strength?
 And shall I feel afraid?

'When round his head the aureole clings,
 And he is clothed in white,
I'll take his hand, and go with him
 To the deep wells of light,
And we will step down as to a stream
 And bathe there in God's sight.

'We two will stand beside that shrine,
 Occult, withheld, untrod,
Whose lamps tremble continually
 With prayer sent up to God;

And where each need, revealed, expects
 Its patient period.

'We two will lie i' the shadow of
 That living mystic tree
Within whose secret growth the Dove
 Sometimes is felt to be,
While every leaf that His plumes touch
 Saith His name audibly.

'And I myself will teach to him—
 I myself, lying so,—
The songs I sing here; which his mouth
 Shall pause in, hushed and slow,
Finding some knowledge at each pause
 And some new thing to know.'

(Alas! to *her* wise simple mind
 These things were all but known
Before: they trembled on her sense,—
 Her voice had caught their tone.
Alas for lonely Heaven! Alas
 For life wrung out alone!

Alas, and though the end were reached?
 Was *thy* part understood
Or borne in trust? And for her sake
 Shall this too be found good?—
May the close lips that knew not prayer
 Praise ever, though they would?)

'We two,' she said, 'will seek the groves
 Where the lady Mary is,
With her five handmaidens, whose names
 Are five sweet symphonies:—
Cecily, Gertrude, Magdalen,
 Margaret, and Rosalys.

'Circle-wise sit they, with bound locks
 And bosoms covered;
Into the fine cloth, white like flame,
 Weaving the golden thread,
To fashion the birth-robes for them
 Who are just born, being dead.

'He shall fear haply, and be dumb.
 Then I will lay my cheek
To his, and tell about our love,
 Not once abashed or weak:
And the dear Mother will approve
 My pride, and let me speak.

'Herself shall bring us, hand in hand,
 To Him round whom all souls
Kneel—the unnumber'd solemn heads
 Bowed with their aureoles:
And Angels, meeting us, shall sing
 To their citherns and citoles.

'There will I ask of Christ the Lord
 Thus much for him and me:—
To have more blessing than on earth
 In nowise; but to be
As then we were,—being as then
 At peace. Yea, verily.

'Yea, verily; when he is come
 We will do thus and thus:
Till this my vigil seem quite strange
 And almost fabulous;
We two will live at once, one life;
 And peace shall be with us.'

She gazed, and listened, and then said,
 Less sad of speech than mild:
'All this is when he comes.' She ceased;
 The light thrilled past her, filled

With Angels, in strong level lapse.
　Her eyes prayed, and she smiled.

(I saw her smile.) But soon their flight
　Was vague 'mid the poised spheres.
And then she cast her arms along
　The golden barriers,
And laid her face between her hands,
　And wept. (I heard her tears.)

MY SISTER'S SLEEP

She fell asleep on Christmas Eve.
　Upon her eyes' most patient calms
　The lids were shut; her uplaid arms
Covered her bosom, I believe.

Our mother, who had leaned all day
　Over the bed from chime to chime,
　Then raised herself for the first time,
And as she sat her down, did pray.

Her little work-table was spread
　With work to finish. For the glare
　Made by her candle, she had care
To work some distance from the bed.

Without, there was a good moon up,
　Which left its shadows far within;
　The depth of light that it was in
Seemed hollow like an altar-cup.

Through the small room, with subtle sound
　Of flame, by vents the fireshine drove
　And reddened. In its dim alcove
The mirror shed a clearness round.

I had been sitting up some nights,
　　And my tir'd mind felt weak and blank;
　　Like a sharp strengthening wine, it drank
The stillness and the broken lights.

Silence was speaking at my side
　　With an exceedingly clear voice:
　　I knew the calm as of a choice
Made in God for me, to abide.

I said, 'Full knowledge does not grieve:
　　This which upon my spirit dwells
　　Perhaps would have been sorrow else:
But I am glad 'tis Christmas Eve.'

Twelve struck. That sound, which all the years
　　Hear in each hour, crept off; and then
　　The ruffled silence spread again,
Like water that a pebble stirs.

Our mother rose from where she sat.
　　Her needles, as she laid them down,
　　Met lightly, and her silken gown
Settled: no other noise than that.

'Glory unto the Newly Born!'
　　So, as said angels, she did say;
　　Because we were in Christmas-day,
Though it would still be long till dawn.

She stood a moment with her hands
　　Kept in each other, praying much;
　　A moment that the soul may touch
But the heart only understands.

Almost unwittingly, my mind
　　Repeated her words after her;
　　Perhaps tho' my lips did not stir;
It was scarce thought, or cause assign'd.

Just then in the room over us
 There was a pushing back of chairs,
 As some who had sat unawares
So late, now heard the hour, and rose.

Anxious, with softly stepping haste,
 Our mother went where Margaret lay,
 Fearing the sounds o'erhead—should they
Have broken her long-watched for rest!

She stooped an instant, calm, and turned;
 But suddenly turned back again;
 And all her features seemed in pain
With woe, and her eyes gazed and yearned.

For my part, I but hid my face,
 And held my breath, and spake no word:
 There was none spoken; but *I heard
The silence* for a little space.

Our mother bowed herself and wept.
 And both my arms fell, and I said:
 'God knows I knew that she was dead.'
And there, all white, my sister slept.

Then kneeling, upon Christmas morn
 A little after twelve o'clock
 We said, ere the first quarter struck,
'Christ's blessing on the newly born!'

'ELLEN ALLEYN'
(CHRISTINA ROSSETTI)

DREAM LAND

Where sunless rivers weep
Their waves into the deep,
She sleeps a charmed sleep;
 Awake her not.
Led by a single star,
She came from very far,
To seek where shadows are
 Her pleasant lot.

She left the rosy morn,
She left the fields of corn,
For twilight cold and lorn,
 And water-springs.
Thro' sleep, as thro' a veil,
She sees the sky look pale,
And hears the nightingale,
 That sadly sings.

Rest, rest, a perfect rest,
Shed over brow and breast;
Her face is toward the west,
 The purple land.
She cannot see the grain
Ripening on hill and plain;
She cannot feel the rain
 Upon her hand.

Rest, rest, for evermore
 Upon a mossy shore,
Rest, rest, that shall endure,
 Till time shall cease;—
Sleep that no pain shall wake,
Night that no morn shall break,
Till joy shall overtake
 Her perfect peace.

'JOHN SEWARD'
(F. G. STEPHENS)

THE PURPOSE AND TENDENCY OF EARLY ITALIAN ART

The object we have proposed to ourselves in writing on Art, has
been 'an endeavour to encourage and enforce an entire
adherence to the simplicity of nature; and also to direct
attention, as an auxiliary medium, to the comparatively few
works which Art has yet produced in this spirit.' It is in
accordance with the former and more prominent of these
objects that the writer proposes at present to treat.

An unprejudiced spectator of the recent progress and main
direction of Art in England will have observed, as a great
change in the character of the productions of the modern
school, a marked attempt to lead the taste of the public into a
new channel by producing pure transcripts and faithful studies
from nature, instead of conventionalities and feeble reminis-
cences from the Old Masters; an entire seeking after origin-
ality in a more humble manner than has been practised since
the decline of Italian Art in the Middle Ages. This has been
most strongly shown by the landscape painters, among whom
there are many who have raised an entirely new school of
natural painting, and whose productions undoubtedly surpass
all others in the simple attention to nature in detail as well as
in generalities. By this they have succeeded in earning for
themselves the reputation of being the finest landscape painters
in Europe. But, although this success has been great and
merited, it is not of them that we have at present to treat, but
rather to recommend their example to their fellow-labourers,
the historical painters.

That the system of study to which this would necessarily lead
requires a somewhat longer and more devoted course of
observation than any other is undoubted; but that it has a
reward in a greater effect produced, and more delight in the
searching, is, the writer thinks, equally certain. We shall find
a greater pleasure in proportion to our closer communion with
nature, and by a more exact adherence to all her details, (for

nature has no peculiarities or eccentricities) in whatsoever direction her study may conduct.

This patient devotedness appears to be a conviction peculiar to, or at least more purely followed by, the early Italian Painters; a feeling which, exaggerated, and its object mistaken by them, though still held holy and pure, was the cause of the retirement of many of the greatest men from the world to the monastery; there, in undisturbed silence and humility,

> 'Monotonous to paint
> Those endless cloisters and eternal aisles
> With the same series, Virgin, Babe, and Saint,
> With the same cold, calm, beautiful regard.'

Even with this there is not associated a melancholy feeling alone; for, although the object was mistaken, yet there is evinced a consciousness of purpose definite and most elevated; and again, we must remember, as a great cause of this effect, that the Arts were, for the most part, cleric, and not laic, or at least were under the predominant influence of the clergy, who were the most important patrons by far, and their houses the safest receptacles for the works of the great painter.

The modern artist does not retire to monasteries, or practise discipline; but he may show his participation in the same high feeling by a firm attachment to truth in every point of representation, which is the most just method. For how can good be sought by evil means, or by falsehood, or by slight in any degree? By a determination to represent the thing and the whole of the thing, by training himself to the deepest observation of its fact and detail, enabling himself to reproduce, as far as is possible, nature herself, the painter will best evince his share of faith.

It is by this attachment to truth in its most severe form that the followers of the Arts have to show that they share in the peculiar character of the present age,—a humility of knowledge, a diffidence of attainment; for, as Emerson has well observed,

> 'The time is infected with Hamlet's unhappiness,—
> "Sicklied o'er with the pale cast of thought."

Is this so bad then? Sight is the last thing to be pitied. Would we be blind? Do we fear lest we should outsee nature and God, and drink truth dry?'

It has been said that there is presumption in this movement of the modern school, a want of deference to established authorities, a removing of ancient landmarks. This is best answered by the profession that nothing can be more humble than the pretension to the observation of facts alone, and the truthful rendering of them. If we are not to depart from established principles, how are we to advance at all? Are we to remain still? Remember, no thing remains still; that which does not advance falls backward. That this movement is an advance, and that it is of nature herself, is shown by its going nearer to truth in every object produced, and by its being guided by the very principles the ancient painters followed, as soon as they attained the mere power of representing an object faithfully. These principles are now revived, not from them, though through their example, but from nature herself.

That the earlier painters came nearer to fact, that they were less of the art, artificial, cannot be better shown than by the statement of a few examples from their works. There is a magnificent Niello work by an unknown Florentine artist, on which is a group of the Saviour in the lap of the Virgin. She is old (a most touching point); lamenting aloud, clutches passionately the heavy-weighted body on her knee; her mouth is open. Altogether it is one of the most powerful appeals possible to be conceived; for there are few but will consider this identification with humanity to be of more effect than any refined or emasculate treatment of the same subject by later artists, in which we have the fact forgotten for the sake of the type of religion, which the Virgin was always taken to represent, whence she is shown as still young; as if, nature being taken typically, it were not better to adhere to the emblem throughout, confident by this means to maintain its appropriateness, and, therefore, its value and force.

In the Niello work here mentioned there is a delineation of the Fall, in which the serpent has given to it a human head with a most sweet, crafty expression. Now in these two instances the style is somewhat rude; but there are passion and

feeling in it. This is not a question of mere execution, but of mind, however developed. Let us not mistake, however, from this that execution should be neglected, but only maintained as a most important *aid*, and in that quality alone, so that we do not forget the soul for the hand. The power of representing an object, that its entire intention may be visible, its lesson felt, is all that is absolutely necessary: mere technicalities of performance are but additions; and not the real intent and end of painting, as many have considered them to be. For as the knowledge is stronger and more pure in Masaccio than in the Caracci, and the faith higher and greater,—so the first represents nature with more true feeling and love, with a deeper insight into her tenderness; he follows her more humbly, and has produced to us more of her simplicity; we feel his appeal to be more earnest: it is the crying out of the man, with none of the strut of the actor.

Let us have the mind and the mind's-workings, not the remains of earnest thought which has been frittered away by a long dreary course of preparatory study, by which all life has been evaporated. Never forget that there is in the wide river of nature something which every body who has a rod and line may catch, precious things which every one may dive for.

It need not be feared that this course of education would lead to a repetition of the toe-trippings of the earliest Italian school, a sneer which is manifestly unfair; for this error, as well as several others of a similar kind, was not the result of blindness or stupidity, but of the simple ignorance of what had not been applied to the service of painting at their time. It cannot be shown that they were incorrect in expression, false in drawing, or unnatural in what is called composition. On the contrary, it is demonstrable that they exceeded all others in these particulars, that they partook less of coarseness and of conventional sentiment than any school which succeeded them, and that they looked more to nature; in fact, were more true, and less artificial. That their subjects were generally of a melancholy cast is acknowledged, which was an accident resulting from the positions their pictures were destined to occupy. No man ever complained that the Scriptures were morbid in their tendency because they treat of serious and earnest subjects:

then why of the pictures which represent such? A certain gaunt length and slenderness have also been commented upon most severely; as if the Italians of the fourteenth century were as so many dray horses, and the artists were blamed for not following his model. The consequence of this direction of taste is that we have life-guardsmen and pugilists taken as models for kings, gentlemen, and philosophers. The writer was once in a studio where a man, six feet two inches in height, with atlantean shoulders, was sitting for King Alfred. That there is no greater absurdity than this will be perceived by any one that has ever read the description of the person of the king given by his historian and friend Asser.

The sciences have become almost exact within the present century. Geology and chemistry are almost re-instituted. The first has been nearly created; the second expanded so widely that it now searches and measures the creation. And how has this been done but by bringing greater knowledge to bear upon a wider range of experiment; by being precise in the search after truth? If this adherence to fact, to experiment and not theory,—to begin at the beginning and not fly to the end,— has added so much to the knowledge of man in science; why may it not greatly assist the moral purposes of the Arts? It cannot be well to degrade a lesson by falsehood. Truth in every particular ought to be the aim of the artist. Admit no untruth: let the priest's garment be clean.

Let us now return to the Early Italian Painters. A complete refutation of any charge that the character of their school was necessarily gloomy will be found in the works of Benozzo Gozzoli, as in his 'Vineyard' where there are some grape-gatherers the most elegant and graceful imaginable; this painter's children are the most natural ever painted. In Ghiberti,—in Fra Angilico (well named),—in Masaccio,—in Ghirlandajo, and in Baccio della Porta, in fact in nearly all the works of the painters of this school, will be found a character of gentleness, grace, and freedom, which cannot be surpassed by any other school, be that which it may; and it is evident that this result must have been obtained by their peculiar attachment to simple nature alone, their casting aside all ornament, or rather their perfect ignorance of such—a happy

fortune none have shared with them. To show that with all these qualifications they have been pre-eminent in energy and dignity, let us instance the 'Air Demons' of Orcagna, where there is a woman borne through the air by an Evil Spirit. Her expression is the most terrible imaginable; she grasps her bearer with desperation, looking out around her into space, agonized with terror. There are other figures in the same picture of men who have been cast down, and are falling through the air: one descends with his hands tied, his chin up, and long hair hanging from his head in a mass. One of the Evil Spirits hovering over them has flat wings, as though they were made of plank: this gives a most powerful character to the figure. Altogether, this picture contains perhaps a greater amount of bold imagination and originality of conception than any of the kind ever painted. For sublimity there are few works which equal the 'Archangels' of Giotto, who stand singly, holding their sceptres, and with relapsed wings. The 'Paul' of Masaccio is a well-known example of the dignified simplicity of which these artists possessed so large a share. These instances might be multiplied without end; but surely enough have been cited in the way of example to show the surpassing talent and knowledge of these painters, and their consequent success, by following natural principles, until the introduction of false and meretricious ornament led the Arts from the simple chastity of nature, which it is as useless to attempt to elevate as to endeavour to match the works of God by those of man. Let the artist be content to study nature alone, and not dream of elevating any of her works, which are alone worthy of repre-sesentation.[1]

The Arts have always been most important moral guides. Their flourishing has always been coincident with the most wholesome period of a nation's: never with the full and gaudy

[1] The sources from which these examples are drawn, and where many more might be found, are principally:—*D'Agincourt*: '*Histoire de l'Art par les Monumens*';—*Rossini*: '*Storia della Pittura*';—*Ottley*: '*Italian School of Design*', and his 120 Fac-similes of scarce prints;—and the 'Gates of San Giovanni', by Ghiberti; of which last a cast of one entire is set up in the Central School of Design, Somerset House; portions of the same are also in the Royal Academy.

bloom which but hides corruption, but the severe health of its
most active and vigorous life; its mature youth, and not the
floridity of age, which, like the wide full open petals of a flower,
indicates that its glory is about to pass away. There has
certainly always been a period like the short warm season the
Canadians call the 'Indian Summer', which is said to be pro-
duced by the burning of the western forests, causing a facti-
tious revival of the dying year: so there always seems to have
been a flush of life before the final death of the Arts in each
period:—in Greece, in the sculptors and architects of the time
after Pericles; in the Germans, with the successors of Albert
Durer. In fact, in every school there has been a spring, a
summer, an autumn, an 'Indian Summer', and then winter;
for as surely as the 'Indian Summer' (which is, after all, but an
unhealthy flush produced by destruction) so surely does winter
come. In the Arts, the winter has been exaggerated action,
conventionalism, gaudy colour, false sentiment, voluptuous-
ness, and poverty of invention: and, of all these characters,
that which has been the most infallible herald of decease,
voluptuousness, has been the most rapid and sure. Corruption
lieth under it; and every school, and indeed every individual,
that has pandered to this, and departed from the true spirit in
which all study should be conducted, sought to degrade and
sensualize, instead of chasten and render pure, the humanity
it was instructed to elevate. So has that school, and so have
those individuals, lost their own power and descended from
their high seat, fallen from the priest to the mere parasite, from
the law-giver to the mere courtier.

If we have entered upon a new age, a new cycle of man, of
which there are many signs, let us have it unstained by this
vice of sensuality of mind. The English school has lately lost a
great deal of this character; why should we not be altogether
free from it? Nothing can degrade a man or a nation more than
this meanness; why should we not avoid it? Sensuality is a
meanness repugnant to youth, and disgusting in age: a
degradation at all times. Let us say

> 'My strength is as the strength of ten,
> Because my heart is pure.'

Bearing this in mind,—the conviction that, without the pure heart, nothing can be done worthy of us; by this, that the most successful school of painters has produced upon us the intention of their earnestness at this distance of time,—let us follow in their path, guided by their light: not so subservient as to lose our own freedom, but in the confidence of equal power and equal destiny; and then rely that we shall obtain the same success and equal or greater power, such as is given to the age in which we live. This is the only course that is worthy of the influence which might be exerted by means of the Arts upon the character of the people: therefore let it be the only one for us to follow if we hope to share in the work.

That the real power of the Arts, in conjunction with Poetry, upon the actions of any age is, or might be, predominant above all others will be readily allowed by all that have given any thought to the subject: and that there is no assignable limit to the good that may be wrought by their influence is another point on which there can be small doubt. Let us then endeavour to call up and exert this power in the worthiest manner, not forgetting that we chose a difficult path in which there are many snares, and holding in mind the motto, '*No Cross, no Crown*'.

Believe that there is that in the fact of truth, though it be only in the character of a single leaf earnestly studied, which may do its share in the great labour of the world: remember that it is by truth alone that the Arts can ever hold the position for which they were intended, as the most powerful instruments, the most gentle guides; that, of all classes, there is none to whom the celebrated words of Lessing, 'That the destinies of a nation depend upon its young men between nineteen and twenty-five years of age', can apply so well as to yourselves. Recollect, that your portion in this is most important: that your share is with the poet's share; that, in every careless thought or neglected doubt, you shelve your duty, and forsake your trust; fulfil and maintain these, whether in the hope of personal fame and fortune, or from a sense of power used to its intentions; and you may hold out both hands to the world. Trust it, and it will have faith in you; will hearken to the precepts you may have permission to impart.

EDWARD BURNE-JONES

INTRODUCING THE OXFORD AND CAMBRIDGE MAGAZINE [*from a letter to Maria Choyce, Burne-Jones's cousin, 1855*]

Shall I tell you about our Magazine, as you are so good as to take an interest in it? In the enclosed envelope I have sent you a prospectus. It appeared in nearly all the magazines of the month, and will be in the Quarterly reviews of January and in the Times. We have thoroughly set ourselves to the work now, banded ourselves into an exclusive Brotherhood of seven. Mr Morris is proprietor. The expenses will fall very heavily upon him, I fear, for it cannot be published under £500 per annum, exclusive of engravings which we shall sometimes give: he hopes not to lose more than £300, but even that is a great deal. Not one Magazine in a hundred pays, but we are full of hope. We have such a deal to tell people, such a deal of scolding to administer, so many fights to wage and opposition to encounter that our spirits are quite rising with the emergency. We shall restrict ourselves to our present contributors, and not receive any indiscriminate contributions, for we wish to keep before us one aim and end throughout the Magazine, and I question if we should find many to join us in all the undertaking, and answer for all our opinions. . . .

Two of the most able young writers of Cambridge have joined us, and for three of our Oxford contributors I should look up and down the world before I could name their peers. . . .

Such is our little Brotherhood. We may do a world of good, for we start from new principles and those of the strongest kind, and are as full of enthusiasm as the first crusaders, and we may perish in a year as others have done before. Well, if we are wanted I suppose we shall remain, and if not, what have we to want? Nothing, I know, for I can safely affirm for all that no mean and contemptible desire for a little contemporary fame, no mere purpose of writing for writing's sake has prompted one amongst us, but a sole and only wish to teach others principles and truths which they may not know and which have made us happy.

The Oxford and Cambridge Magazine

WILLIAM MORRIS

PRAY BUT ONE PRAYER FOR ME

Pray but one prayer for me 'twixt thy closed lips,
 Think but one thought of me up in the stars.
The summer night waneth, the morning light slips,
 Faint and grey 'twixt the leaves of the aspen, betwixt the
 cloud-bars,
That are patiently waiting there for the dawn
 Patient and colourless, though Heaven's gold
Waits to float through them along with the sun.
Far out in the meadows, above the young corn,
 The heavy elms wait, and restless and cold
The uneasy wind rises; the roses are dim;
Through the long twilight they pray for the dawn,
Round the lone house in the midst of the corn.
 Speak but one word to me over the corn,
 Over the tender, bow'd locks of the corn.

RIDING TOGETHER

 For many, many days together
 The wind blew steady from the East;
 For many days hot grew the weather,
 About the time of our Lady's Feast.

 For many days we rode together,
 Yet met we neither friend nor foe;
 Hotter and clearer grew the weather,
 Steadily did the East wind blow.

We saw the trees in the hot, bright weather,
 Clear-cut, with shadows very black,
As freely we rode on together
 With helms unlaced and bridles slack.

And often, as we rode together,
 We, looking down the green-bank'd stream,
Saw flowers in the sunny weather,
 And saw the bubble-making bream.

And in the night lay down together,
 And hung above our heads the rood,
Or watch'd night-long in the dewy weather,
 The while the moon did watch the wood.

Our spears stood bright and thick together,
 Straight out the banners stream'd behind,
As we gallop'd on in the sunny weather,
 With faces turn'd towards the wind.

Down sank our three-score spears together,
 As thick we saw the pagans ride;
His eager face in the clear fresh weather
 Shone out that last time by my side.

Up the sweep of the bridge we dash'd together,
 It rock'd to the crash of the meeting spears,
Down rain'd the buds of the dear spring weather,
 The elm-tree flowers fell like tears.

There, as we roll'd and writhed together,
 I threw my arms above my head,
For close by my side, in the lovely weather,
 I saw him reel and fall back dead.

I and the slayer met together,
 He waited the death-stroke there in his place,
With thoughts of death, in the lovely weather,
 Gapingly mazed at my madden'd face.

Madly I fought as we fought together;
 In vain: the little Christian band
The pagans drown'd, as in stormy weather,
 The river drowns low-lying land.

They bound my blood-stain'd hands together,
 They bound his corpse to nod by my side:
Then on we rode, in the bright March weather,
 With clash of cymbals did we ride.

We ride no more, no more together;
 My prison-bars are thick and strong,
I take no heed of any weather,
 The sweet Saints grant I live not long.

THE STORY OF THE UNKNOWN CHURCH

I was the master-mason of a church that was built more than
six hundred years ago; it is now two hundred years since that
church vanished from the face of the earth; it was destroyed
utterly,—no fragment of it was left; not even the great pillars
that bore up the tower at the cross, where the choir used to
join the nave. No one knows now even where it stood, only in
this very autumn-tide, if you knew the place, you would see the
heaps made by the earth-covered ruins heaving the yellow
corn into glorious waves, so that the place where my church
used to be is as beautiful now as when it stood in all its splen-
dour. I do not remember very much about the land where my
church was; I have quite forgotten the name of it, but I know
it was very beautiful, and even now, while I am thinking of it,
comes a flood of old memories, and I almost seem to see it
again,—that old beautiful land! only dimly do I see it in spring
and summer and winter, but I see it in autumn-tide clearly
now; yes, clearer, clearer, oh! so bright and glorious! yet it
was beautiful too in spring, when the brown earth began to
grow green: beautiful in summer, when the blue sky looked so
much bluer, if you could hem a piece of it in between the new
white carving; beautiful in the solemn starry nights, so solemn

that it almost reached agony—the awe and joy one had in their great beauty. But of all these beautiful times, I remember the whole only of autumn-tide; the others come in bits to me; I can think only of parts of them, but all of autumn; and of all days and nights in autumn, I remember one more particularly. That autumn day the church was nearly finished, and the monks, for whom we were building the church, and the people, who lived in the town hard by, crowded round us oftentimes to watch us carving.

Now the great Church, and the buildings of the Abbey where the monks lived, were about three miles from the town, and the town stood on a hill overlooking the rich autumn country: it was girt about with great walls that had overhanging battlements, and towers at certain places all along the walls, and often we could see from the churchyard or the Abbey garden, the flash of helmets and spears, and the dim shadowy waving of banners, as the knights and lords and men-at-arms passed to and fro along the battlements; and we could see too in the town the three spires of the three churches; and the spire of the Cathedral, which was the tallest of the three, was gilt all over with gold, and always at night-time a great lamp shone from it that hung in the spire midway between the roof of the church and the cross at the top of the spire. The Abbey where we built the Church was not girt by stone walls, but by a circle of poplar trees, and whenever a wind passed over them, were it ever so little a breath, it set them all a-ripple; and when the wind was high, they bowed and swayed very low, and the wind, as it lifted the leaves, and showed their silvery white sides, or as again in the lulls of it, it let them drop, kept on changing the trees from green to white, and white to green; moreover, through the boughs and trunks of the poplars, we caught glimpses of the great golden corn sea, waving, waving, waving for leagues and leagues; and among the corn grew burning scarlet poppies, and blue corn-flowers; and the corn-flowers were so blue, that they gleamed, and seemed to burn with a steady light, as they grew beside the poppies among the gold of the wheat. Through the corn sea ran a blue river, and always green meadows and lines of tall poplars followed its windings. The old Church had been burned, and that was the

reason why the monks caused me to build the new one; the buildings of the Abbey were built at the same time as the burned-down Church, more than a hundred years before I was born, and they were on the north side of the Church, and joined to it by a cloister of round arches, and in the midst of the cloister was a lawn, and in the midst of that lawn, a fountain of marble, carved round about with flowers and strange beasts; and at the edge of the lawn, near the round arches, were a great many sun-flowers that were all in blossom on that autumn day; and up many of the pillars of the cloister crept passion-flowers and roses. Then farther from the Church, and past the cloister and its buildings, were many detached buildings, and a great garden round them, all within the circle of the poplar trees; in the garden were trellises covered over with roses, and convolvolus, and the great-leaved fiery nasturtium; and specially all along by the poplar trees were there trellises, but on these grew nothing but deep crimson roses; the hollyhocks too were all out in blossom at that time, great spires of pink, and orange, and red, and white, with their soft, downy leaves. I said that nothing grew on the trellises by the poplars but crimson roses, but I was not quite right, for in many places the wild flowers had crept into the garden from without; lush green briony, with green-white blossoms, that grows so fast, one could almost think that we see it grow, and deadly night-shade, La bella donna, O! so beautiful; red berry, and purple, yellow-spiked flower, and deadly, cruel-looking, dark green leaf, all growing together in the glorious days of early autumn. And in the midst of the great garden was a conduit, with its sides carved with histories from the Bible, and there was on it too, as on the fountain in the cloister, much carving of flowers and strange beasts. Now the Church itself was surrounded on every side but the north by the cemetery, and there were many graves there, both of monks and of laymen, and often the friends of those, whose bodies lay there, had planted flowers about the graves of those they loved. I remember one such par-ticularly, for at the head of it was a cross of carved wood, and at the foot of it, facing the cross, three tall sun-flowers; then in the midst of the cemetery was a cross of stone, carved on one side with the Crucifixion of our Lord Jesus Christ, and on the

other with Our Lady holding the Divine Child. So that day, that I specially remember, in Autumn-tide, when the church was nearly finished, I was carving in the central porch of the west front; (for I carved all those bas-reliefs in the west front with my own hand); beneath me my sister Margaret was carving at the flower-work, and the little quatrefoils that carry the signs of the zodiac and emblems of the months: now my sister Margaret was rather more than twenty years old at that time, and she was very beautiful, with dark brown hair and deep calm violet eyes. I had lived with her all my life, lived with her almost alone latterly, for our father and mother died when she was quite young, and I loved her very much, though I was not thinking of her just then, as she stood beneath me carving. Now the central porch was carved with a bas-relief of the Last Judgment, and it was divided into three parts by horizontal bands of deep flower-work. In the lowest division, just over the doors, was carved The Rising of the Dead; above were angels blowing long trumpets, and Michael the Archangel weighing the souls, and the blessed led into heaven by angels, and the lost into hell by the devil; and in the topmost division was the Judge of the world.

All the figures in the porch were finished except one, and I remember when I woke that morning my exultation at the thought of my Church being so nearly finished; I remember, too, how a kind of misgiving mingled with the exultation, which, try all I could, I was unable to shake off; I thought then it was a rebuke for my pride, well, perhaps it was. The figure I had to carve was Abraham, sitting with a blossoming tree on each side of him, holding in his two hands the corners of his great robe, so that it made a mighty fold, wherein, with their hands crossed over their breasts, were the souls of the faithful, of whom he was called Father: I stood on the scaffolding for some time, while Margaret's chisel worked on bravely down below. I took mine in my hand, and stood so, listening to the noise of the masons inside, and two monks of the Abbey came and stood below me, and a knight, holding his little daughter by the hand, who every now and then looked up at him, and asked him strange questions. I did not think of these long, but began to think of Abraham, yet I could not think of

him sitting there, quiet and solemn, while the Judgment-Trumpet was being blown; I rather thought of him as he looked when he chased those kings so far; riding far ahead of any of his company, with his mail-hood off his head, and lying in grim folds down his back, with the strong west wind blowing his wild black hair far out behind him, with the wind rippling the long scarlet pennon of his land; riding there amid the rocks and the sands alone; with the last gleam of the armour of the beaten kings disappearing behind the winding of the pass; with his company a long, long way behind, quite out of sight, though their trumpets sounded faintly among the clefts of the rocks; and so I thought I saw him, till in his fierce chase he leapt, horse and man, into a deep river, quiet, swift, and smooth; and there was something in the moving of the water-lilies as the breast of the horse swept them aside, that suddenly took away the thought of Abraham and brought a strange dream of lands I had never seen; and the first was of a place where I was quite alone, standing by the side of a river, and there was the sound of singing a very long way off, but no living thing of any kind could be seen, and the land was quite flat, quite without hills, and quite without trees too, and the river wound very much, making all kinds of quaint curves, and on the side where I stood there grew nothing but long grass, but on the other side grew, quite on to the horizon, a great sea of red corn-poppies, only paths of white lilies wound all among them, with here and there a great golden sun-flower. So I looked down at the river by my feet, and saw how blue it was, and how, as the stream went swiftly by, it swayed to and fro the long green weeds, and I stood and looked at the river for long, till at last I felt someone touch me on the shoulder, and, looking round, I saw standing by me my friend Amyot, whom I love better than any one else in the world, but I thought in my dream that I was frightened when I saw him, for his face had changed so, it was so bright and almost transparent, and his eyes gleamed and shone as I had never seen them do before. Oh! he was so wondrously beautiful, so fearfully beautiful! and as I looked at him the distant music swelled, and seemed to come close up to me, and then swept by us, and fainted away, at last died off entirely;

and then I felt sick at heart, and faint, and parched, and I stooped to drink of the water of the river, and as soon as the water touched my lips, lo! the river vanished, and the flat country with its poppies and lilies, and I dreamed that I was in a boat by myself again, floating in an almost land-locked bay of the northern sea, under a cliff of dark basalt. I was lying on my back in the boat, looking up at the intensely blue sky, and a long low swell from the outer sea lifted the boat up and let it fall again and carried it gradually nearer and nearer towards the dark cliff; and as I moved on, I saw at last, on the top of the cliff, a castle, with many towers, and on the highest tower of the castle there was a great white banner floating, with a red chevron on it, and three golden stars on the chevron; presently I saw too on one of the towers, growing in a cranny of the worn stones, a great bunch of golden and blood-red wall-flowers, and I watched the wall-flowers and banner for long; when suddenly I heard a trumpet blow from the castle, and saw a rush of armed men on to the battlements, and there was a fierce fight, till at last it was ended, and one went to the banner and pulled it down, and cast it over the cliff into the sea, and it came down in long sweeps, with the wind making little ripples in it;—slowly, slowly it came, till at last it fell over me and covered me from my feet till over my breast, and I let it stay there and looked again at the castle, and then I saw that there was an amber-coloured banner floating over the castle in place of the red chevron, and it was much larger than the other: also now, a man stood on the battlements, looking towards me; he had a tilting helmet on, with the visor down, and an amber-coloured surcoat over his armour: his right hand was un-gauntletted, and he held it high above his head, and in his hand was the bunch of wall-flowers that I had seen growing on the wall; and his hand was white and small, like a woman's, for in my dream I could see even very far off things much clearer than we see real material things on the earth: presently he threw the wall-flowers over the cliff, and they fell in the boat just behind my head, and then I saw, looking down from the battlements of the castle, Amyot. He looked down towards me very sorrowfully, I thought, but, even as in the other dream, said nothing; so I thought in my dream that I wept for

very pity, and for love of him, for he looked as a man just risen
from a long illness, and who will carry till he dies a dull pain
about with him. He was very thin, and his long black hair
drooped all about his face, as he leaned over the battlements
looking at me : he was quite pale, and his cheeks were hollow,
but his eyes large, and soft, and sad. So I reached out my arms
to him, and suddenly I was walking with him in a lovely
garden, and we said nothing, for the music which I had heard
at first was sounding close to us now, and there were many
birds in the boughs of the trees : oh, such birds ! gold and ruby,
and emerald,but they sung not at all, but were quite silent,
as though they too were listening to the music. Now all this
time Amyot and I had been looking at each other, but just
then I turned my head away from him, and as soon as I did so,
the music ended with a long wail, and when I turned again
Amyot was gone ; then I felt even more sad and sick at heart
than I had before when I was by the river, and I leaned against
a tree, and put my hands before my eyes. When I looked again
the garden was gone, and I knew not where I was, and
presently all my dreams were gone. The chips were flying
bravely from the stone under my chisel at last, and all my
thoughts now were in my carving, when I heard my name,
'Walter', called, and when I looked down I saw one standing
below me, whom I had seen in my dreams just before—
Amyot. I had no hopes of seeing him for a long time, perhaps
I might never see him again, I thought, for he was away (as I
thought) fighting in the holy wars, and it made me almost
beside myself to see him standing close by me in the flesh. I got
down from my scaffolding as soon as I could, and all thoughts
else were soon drowned in the joy of having him by me ;
Margaret, too, how glad she must have been, for she had been
betrothed to him for some time before he went to the wars, and
he had been five years away ; five years ! and how we had
thought of him through those many weary days ! how often his
face had come before me ! his brave, honest face, the most
beautiful among all the faces of men and women I have ever
seen. Yes, I remember how five years ago I held his hand as we
came together out of the cathedral of that great, far-off city,
whose name I forget now ; and then I remember the stamping

of the horses' feet; I remember how his hand left mine at last, and then, some one looking back at me earnestly as they all rode on together—looking back, with his hand on the saddle behind him, while the trumpets sang in long solemn peals as they all rode on together, with the glimmer of arms and the fluttering of banners, and the clinking of the rings of the mail, that sounded like the falling of many drops of water into the deep, still waters of some pool that the rocks nearly meet over; and the gleam and flash of the swords, and the glimmer of the lance-heads and the flutter of the rippled banners, that streamed out from them, swept pass me, and were gone, and they seemed like a pageant in a dream, whose meaning we know not; and those sounds too, the trumpets, and the clink of the mail, and the thunder of the horse-hoofs, they seemed dream-like too—and it was all like a dream that he should leave me, for we had said that we should always be together; but he went away, and now he is come back again.

We were by his bed-side, Margaret and I; I stood and leaned over him, and my hair fell sideways over my face and touched his face; Margaret kneeled beside me, quivering in every limb, not with pain, I think, but rather shaken by a passion of earnest prayer. After some time (I know not how long), I looked up from his face to the window underneath which he lay; I do not know what time of the day it was, but I know that it was a glorious autumn day, a day soft with melting, golden haze: a vine and a rose grew together, and trailed half across the window, so that I could not see much of the beautiful blue sky, and nothing of town or country beyond; the vine leaves were touched with red here and there, and three over-blown roses, light pink roses, hung amongst them. I remember dwelling on the strange lines the autumn had made in red on one of the gold-green vine leaves, and watching one leaf of one of the overblown roses, expecting it to fall every minute; but as I gazed, and felt disappointed that the rose leaf had not fallen yet, I felt my pain suddenly shoot through me, and I remembered what I had lost; and then came bitter, bitter dreams,—dreams which had once made me happy—dreams of the things I had hoped would be, of the things that would never be now; they came between the

fair vine leaves and rose blossoms, and that which lay before
the window; they came as before, perfect in colour and
form, sweet sounds and shapes. But now in every one was
something unutterably miserable; they would not go away,
they put out the steady glow of the golden haze, the sweet light
of the sun through the vine leaves, the soft leaning of the full
blown roses. I wandered in them for a long time; at last I
felt a hand put me aside gently, for I was standing at the head
of—of the bed; then some one kissed my forehead, and words
were spoken—I know not what words. The bitter dreams left
me for the bitterer reality at last; for I had found him that
morning lying dead, only the morning after I had seen him
when he had come back from his long absence—I had found
him lying dead, with his hands crossed downwards, with his
eyes closed, as though the angels had done that for him; and
now when I looked at him he still lay there, and Margaret
knelt by him with her face touching his: she was not quivering
now, her lips moved not at all as they had done just before;
and so, suddenly these words came to my mind which she had
spoken when she kissed me, and which at the time I had only
heard with my outward hearing, for she had said, 'Walter,
farewell, and Christ keep you; but for me, I must be with him,
for so I promised him last night that I would never leave him
any more, and God will let me go.' And verily Margaret and
Amyot did go, and left me very lonely and sad.

It was just beneath the westernmost arch of the nave, there
I carved their tomb: I was a long time carving it; I did not
think I should be so long at first, and I said, 'I shall die when
I have finished carving it,' thinking that would be a very short
time. But so it happened after I had carved those two whom I
loved, lying with clasped hands like husband and wife above their
tomb, that I could not yet leave carving it; and so that I might
be near them I became a monk, and used to sit in the choir and
sing, thinking of the time when we should all be together again.
And as I had time I used to go to the westernmost arch of the
nave and work at the tomb that was there under the great, sweep-
ing arch; and in process of time I raised a marble canopy that
reached quite up to the top of the arch, and I painted it too as
fair as I could, and carved it all about with many flowers and

histories, and in them I carved the faces of those I had known on earth (for I was not as one on earth now, but seemed quite away out of the world). And as I carved, sometimes the monks and other people too would come and gaze, and watch how the flowers grew; and sometimes too as they gazed, they would weep for pity, knowing how all had been. So my life passed, and I lived in that abbey for twenty years after he died, till one morning, quite early, when they came into the church for matins, they found me lying dead, with my chisel in my hand, underneath the last lily of the tomb.

VERNON LUSHINGTON

TWO PICTURES

[' *Dante's Vision of Beatrice* ', *by D. G. Rossetti*]

It is a chamber in the city of Florence. Invisibly, as it were some sympathizing Spirit, we take up our station in the middle of the room, and look on in silence. In the farther wall, which is decorated with a simple diaper pattern of gold on a purple ground, is hollowed out an oblong recess containing a narrow bed, such as was common in those simple times, and the like of which may yet be often seen in old rustic dwellings; fit offering-place for an evening prayer! Stretched upon this bed lies Beatrice, in the fixed peace of after-death; her stately form folded in a pure white robe—shroud I will not call it, for the arms are free, in delicately-fitting sleeves, and the fair taper hands meet palm to palm, in that sweet attitude of faithful resignation in which the Christians of the thirteenth century loved to portray the dying believer. And as we look, we see there is no marriage ring: Beatrice has died unwedded. Her head inclines towards us, propped upon the pillow;—it is one worthy of Dante's love; its sculptured lines are full of intellectual beauty and fairest grace of mind and manners;—the rose of life has left her cheeks, and her eyes are closed for ever; but her rich amber hair, evenly parted over the brow is streaming silently down,

wandering unrestrained in long waves down either side of her face over neck and shoulders and bosom, and divides over this left arm which is nearest us, like a river towards the close of its course. Two maidens, in the flower of womanhood, 'ladies' as the poem honourably calls them, are about to cover the dead with a sheet, whereon lie sprinkled a few flowers of the blushing May, gathered like her in their lovely prime; one stands at her head, the other at her feet, and with according motion they reverently raise the sheet, and sustain it there; for, behold, One shall see Beatrice yet again before her face be hid, her own Dante. He has entered the chamber, Love leading him:— Love, a youth clad in intensest azure flushed with emerald green, and with long angel-wings of mantling crimson and scarlet that over-arch bare arms; in his right hand he holds Dante's left, in his own a bow and arrow to mark who he is, and he stoops over the bed lovingly and kisses in last farewell those pallid lips. But Dante—He stands there, meekly submitting, with bowed head and body leaning slightly forward, gazing intently as in a trance, fixed by the spell of unutterable thoughts; he speaks no word, nor makes any sign of surprise— his lips are closed, his right arm hangs at rest by his side, he is all eye and soul, and keeps gazing, gazing, on his lost loved one with a look of deep still grief.

['*The Last of England*', *by Ford Madox Brown* (*see plates*)]

An easterly gale is blowing down Channel, keen and chill. The sky is one dull gray; the sea a sullen green ridged with white waves; the horizon seawards a line of leaden purple. On the weather quarter stands unmoved a wall of chalky cliffs; the cliffs we know and love so well. The Outward-bound is scudding with the wind on her starboard quarter, heeling over to it, the weather shrouds showing taut against the sky; the surges follow her, spirting now and then freely over the taffrail. It is afternoon, I think; and just an hour ago the cap-stern was running merrily round with the clinking cable; the topsails were filling; and on the deck might be seen farewell embraces, farewell kisses and tears. But now these are over, and the waving pockethandkerchiefs have ceased to flutter,

and friends are lost to view; still the deck is crowded, and eyes are all astrain—to see THE LAST OF ENGLAND.

Seated on the poop are a young husband and wife, side by side. It is November channel weather, as I said, and very cold. His brown pea-coat is close buttoned to the chin, the collar up like a wall on either side the face; his brown wide-awake is firmly set on his head, and tethered down to the large horn-button. His left hand is in his breast, the naked flesh just glimpses through the buttonhole; in it he holds the umbrella over his wife to shelter her from the wind and spray. Their right hands are clasped together, her's gloved, but his gloveless; the east wind spares it not, so that the warm life-blood mutinies within and gathers in discoloured patches round the rigid knuckles; but there is blanching where the touch of loving fingers presses. Her shawl is wrapt closely over neck and bosom, but the wind has slightly raised it below, and shows the glossy purple of her dress within; discloses too her bare left hand (witness of altar vows) clasping yet another hand—a tiny one, the hand of their first-born! A fold of warm green coverlet is just seen opposing the purple; and two little socks of knitted wool, scarlet and white, peer out elsewhere. Happy little one! others have their home to seek; but thy home is safe and here, in a mother's bosom; all proof as yet to sorrow; kindly guarded from east wind and salt spray, that hurtle past in vain. The Father's countenance is somewhat shadowed under the broad brim, and is white with cold. It is the face of a man of some five-and-twenty years, evidently a 'gentleman'; bred in all the comforts and refined ways of 'good society'; we see that he knows how to dress, for this occasion or for gayer ones. He has a mind too; we read quick sympathies of thought in that thin face, those keen restless features, and think that he, like many a young Englishman, has had his speculations about Religion and Politics. In practice he has not been a successful man; his presence here says as much, and the mouse-coloured moustache he has suffered to grow, as if in defiance of an unkind world; and in that earnest sorrowful gaze there is a touch of bitterness, as if angry thoughts of the past, too-anxious thoughts for the future were not wanting. But now nobler emotions prevail; for he has a heart, and has loved and loves: beside him

are wife and child, and there—fading away is Fatherland,—
fading away.

But it is on *her* that our eye chiefly dwells. A pure English
face; and very beautiful; just ripened into fulness by duly
numbered years and maternal offices; ruddy with the cold,
red also with crying, yet clear and rosy with youthful health.
A coronet of brown hair is plaited over her forehead; but the
gale has caught a stray band, and it is streaming across her
brow, unheeded; the red ribbons of her bonnet and the blue
veil are likewise flying upward, dancing and fluttering, and the
tarpaulin covering has fallen from her knees—all unheeded.
Her thoughts are elsewhere, far away; not with the rough
present, not with the dim future, but in the sacred Past—with
childhood, home, parents; a thousand happy memories as
maiden wooed and bride won; the dear land which saw and
held them all; which she shall see no more.

WILLIAM MORRIS

CRAFTSMEN OF THE PAST

Not long ago I saw for the first time some of the churches of
North France; still more recently I saw them for the second
time; and, remembering the love I have for them and the
longing that was in me to see them, during the time that came
between the first and second visit, I thought I should like to
tell people of some of those things I felt when I was there;—
there among those mighty tombs of the long-dead ages.

And I thought that even if I could say nothing else about
these grand churches, I could at least tell men how much I
loved them; so that, though they might laugh at me for my
foolish and confused words, they might yet be moved to see
what there was that made me speak my love, though I could
give no reason for it.

For I will say here that I think those same churches of North
France the grandest, the most beautiful, the kindest and most

loving of all the buildings that the earth has ever borne; and, thinking of their past-away builders, can I see through them, very faintly, dimly, some little of the medieval times, else dead, and gone from me for ever,—voiceless for ever.

And those same builders, still surely living, still real men, and capable of receiving love, I love no less than the great men, poets and painters and such like, who are on earth now, no less than my breathing friends whom I can see looking kindly on me now. Ah! do I not love them with just cause, who certainly loved me, thinking of me sometimes between the strokes of their chisels; and for this love of all men that they had, and moreover for the great love of God, which they certainly had too; for this, and for this work of theirs, the upraising of the great cathedral front with its beating heart of the thoughts of men, wrought into the leaves and flowers of the fair earth; wrought into the faces of good men and true, fighters against the wrong, of angels who upheld them, of God who rules all things; wrought through the lapse of years, and years, and years, by the dint of chisel, and stroke of hammer, into stories of life and death, the second life, the second death, stories of God's dealing in love and wrath with the nations of the earth, stories of the faith and love of man that dies not: for their love, and the deeds through which it worked, I think they will not lose their reward.

So I will say what I can of their works, and I have to speak of Amiens first, and how it seemed to me in the hot August weather.

I know how wonderful it would look if you were to mount one of the steeples of the town, or were even to mount up to the roof of one of the houses westward of the cathedral; for it rises up from the ground, grey from the paving of the street, the cavernous porches of the west front opening wide, and marvellous with the shadows of the carving you can only guess at; and above stand the kings, and above that you would see the twined mystery of the great flamboyant rose window with its thousand openings, and the shadows of the flower-work carved round it, then the grey towers and gable, grey against the blue of the August sky, and behind them all, rising high into the quivering air, the tall spire over the crossing.

Icons and Images

[The cult of woman plays a leading role in Pre-Raphaelite art and letters. For good or for bad, the wives, mistresses and models of the P.R. painters and poets were imitated as to their appearance by many thousands of women who had never seen an easel or entered an artist's studio. The following section sets out to give a notion of the P.R. idea of the feminine ideal by quoting from letters and biographical extracts concerning the wives, mistresses and models of these painters.

The critic and poet F. W. H. Myers spoke of D. G. Rossetti's portraits of Elizabeth Siddal and Jane Morris as 'the sacred pictures of a new religion', so one may see that the term 'icon' here is no misnomer. Along with a passage from this critic's essay *Rossetti and the Religion of Beauty*, in which he describes and analyses the artist's image of his ideal woman, an amusing extract from Walter Hamilton's *The Aesthetic Movement in England* is included. Here the Pre-Raphaelite feminine ideal is guyed as 'a pale distraught lady'. The sexual allure of these ideal women is remarked on diversely by different writers, the tone varying from one of reverence to interested amusement. It took, however, the crude humour of the Scots journalist Robert Buchanan to infer from the appearance of these beauties an erotic activity more in line with a parody of the *Kama Sutra* than the model boudoir behaviour expected of middle-class Victorian women. 'Females who bite, scratch, scream, bubble, munch, sweat, writhe, twist, and in a general way slaver over their lovers', was how Buchanan chose to picture them. This, of course, has all the exaggerations of satire about it; though we do know that Elizabeth Siddal showed something of a penchant for lying on the floor and kicking with anger.]

FREDERICK WILLIAM HENRY MYERS

'SACRED PICTURES OF A NEW RELIGION . . .'

Much of Rossetti's art, in speech or colour, spends itself in the effort to communicate the incommunicable. It is toward 'the vale of magical dark mysteries' that those grave low-hanging brows are bent, and 'vanished hours and hours eventual' brood in the remorseful gaze of Pandora, the yearning gaze of Proserpine. The pictures that perplex us with their obvious incompleteness, their new and haunting beauty, are not the mere caprices of a richly-dowered but wandering spirit. Rather they may be called (and none the less so for their short-comings) the sacred pictures of a new religion; forms and faces which bear the same relation to that mystical worship of Beauty on which we have dwelt so long, as the forms and faces of a Francia or a Leonardo bear to the mediæval mysteries of the worship of Mary or of Christ. And here it is that in Rossetti's pictures we find ourselves in the midst of a novel symbolism—a symbolism genuine and deeply felt as that of the fifteenth century, and using once more birds and flowers and stars, colours and lights of the evening or the dawn, to tell of beauties impalpable, spaces unfathomed, the setting and resurrection of no measurable or earthly day.

It is chiefly in a series of women's faces that these ideas seek expression. All these have something in common, some union of strange and puissant physical loveliness with depth and remoteness of gaze. They range from demon to angel—as such names may be interpreted in a Religion of Beauty—from Lilith, whose beauty is destruction, and Astarte, throned between the Sun and Moon in her sinister splendour, to the *Blessed Damozel* [1] and the 'maiden pre-elect', type of the love whose look regenerates and whose assumption lifts to heaven. But all have the look—characteristic of Rossetti's faces as the mystic smile of Leonardo's—the look which bids the spectator murmur—

[1] See plates.

> 'What netherworld gulf-whispers doth she hear,
> In answering echoes from what planisphere,
> Along the wind, along the estuary?'

And since these primal impulses, at any rate, will remain to mankind, since Love's pathway will be re-trodden by many a generation, and all of faith or knowledge to which that pathway leads will endure, it is no small part of the poet's function to show in how great a measure Love does actually presuppose and consist of this exaltation of the mystic element in man; and how the sense of unearthly destinies may give dignity to Love's invasion, and steadfastness to his continuance, and surround his vanishing with the mingled ecstasy of anguish and of hope.

HENRY JAMES

A PRE-RAPHAELITE LADY IN HER HOME SETTING

Yesterday, my dear old sister, was my crowning day—seeing as how I spent the greater part of it in the house of Mr Wm Morris, Poet. Fitly to tell the tale, I should need a fresh pen, paper and spirits. A few hints must suffice. To begin with, I breakfasted, by way of a change, with the Nortons, along with Mr Sam Ward, who has just arrived, and Mr Aubrey de Vere, *tu sais*, the Catholic poet, a pleasant honest old man and very much less high-flown than his name. He tells good stories in a light natural way. After a space I came home and remained until 4½ p.m., when I have given rendez-vous to C. N. and ladies at Mr Morris's door, they going by appointment to see his shop and C. having written to say he would bring me. Morris lives on the same premises as his shop, in Queen's Square, Bloomsbury, an antiquated ex-fashionable region, smelling strong of the last century, with a hoary effigy of Queen Anne in the middle. Morris's poetry, you see, is only his sub-trade. To begin with, he is a manufacturer of stained glass windows, tiles, ecclesiastical and medieval tapestry, altar-

cloths, and in fine everything quaint, archaic, pre-Raphaelite—
and I may add, exquisite. Of course his business is small and
may be carried on in his house: the things he makes are so
handsome, rich and expensive (besides being articles of the
very last luxury) that his *fabrique* can't be on a very large scale.
But everything he has and does is superb and beautiful. But
more curious than anything is himself. He designs with his own
head and hands all the figures and patterns used in his glass
and tapestry, and furthermore works the latter, stitch by
stitch, with his own fingers—aided by those of his wife and
little girls. Oh, ma chère, such a wife! either case she is a
wonder. Imagine a tall lean woman in a long dress of some
dead purple stuff, guiltless of hoops (or of anything else, I
should say,) with a mass of crisp black hair heaped into great
wavy projections on each of her temples, a thin pale face, a
pair of strange sad, deep, dark Swinburnian eyes, with great
thick black oblique brows, joined in the middle and tucking
themselves away under her hair, a mouth like the 'Oriana' in
our illustrated Tennyson, a long neck, without any collar, and
in lieu thereof some dozen strings of outlandish beads—in fine
complete. On the wall was a large nearly full-length portrait of
her by Rossetti, so strange and unreal that if you hadn't seen
her you'd pronounce it a distempered vision, but in fact an
extremely good likeness. After dinner (we stayed to dinner,
Miss Grace, Miss S. S. and I,) Morris read us one of his un-
published poems, from the second series of his un-'Earthly
Paradise', and his wife, having a bad toothache, lay on the
sofa, with her handkerchief to her face. There was something
very quaint and remote from our actual life, it seemed to me,
in the whole scene: Morris reading in his flowing antique
numbers a legend of prodigies and terrors (the story of
Bellerophon, it was), around us all the picturesque bric-a-
brac of the apartment (every article of furniture literally a
'specimen' of something or other,) and in the corner this dark
silent medieval woman with her medieval toothache.

WILLIAM MICHAEL ROSSETTI

ELIZABETH SIDDAL

Dante Rossetti—though there was nothing of the Puritan in his feelings, nor in his demeanour or conversation—had no juvenile amours, *liaisons*, or flirtations. In 1850 he fell seriously in love.

Outside the compact circle of the Præraphaelite Brotherhood there was no man he liked better than Walter Howell Deverell, a youthful painter, son of the Secretary of the Government Schools of Design—artistic, clever, genial, and remarkably good-looking. One day—early in 1850, if not late in 1849—Deverell accompanied his mother to a bonnet-shop in Cranborne Alley (now gone—close to Leicester Square); and among the shop-assistants he saw a young woman who lifted down a bandbox or what not. She was a most beautiful creature, with an air between dignity and sweetness mixed with something which exceeded modest self-respect, and partook of disdainful reserve; tall, finely formed, with a lofty neck, and regular yet somewhat uncommon features, greenish-blue unsparkling eyes, large perfect eyelids, brilliant complexion, and a lavish heavy wealth of coppery-golden hair. It was what many people call red hair, and abuse under that name—but the colour, when not rank and flagrant, happens to have been always much admired by Dante Rossetti, and I dare say by Deverell as well. All this fine development, and this brilliancy of hue, were only too consistent with a consumptive taint in the constitution. Her voice was clear and low, but with a certain sibilant tendency which reduced its attractiveness. Deverell got his mother to enquire whether he might be privileged to have sittings from this beauty, and the petition was granted. He painted from her the head of Viola in the picture which he exhibited in the early spring of 1850, from Shakespear's *Twelfth Night, The Duke with Viola listening to the Court Minstrels*; he also drew from her the head of Viola in the etching of *Olivia and Viola* which appeared in the final number of *The Germ*. In the oil-picture Rossetti sat for the head of the

Jester. It is a fair likeness, but rather grim. I may as well add here that Hunt, not long afterwards, painted from the same damsel the Sylvia in his picture from the *Two Gentlemen of Verona*, and Millais his drowning *Ophelia* [1]—but I fancy that both these heads, or at any rate the first, have been a good deal altered at a more recent date. This milliner's girl was Elizabeth Eleanor Siddal. When Deverell first saw her, she was, I believe, not fully seventeen years of age.

JANE BURDEN

The Union artists, or some of them, went to the Oxford Theatre one evening, and saw, in the front box above them, a very youthful lady whose aspect fascinated them all. My brother was the first to observe her. Her face was at once tragic, mystic, passionate, calm, beautiful, and gracious—a face for a sculptor, and a face for a painter—a face solitary in England, and not at all like that of an Englishwoman, but rather of an Ionian Greek. It was not a face for that large class of English people who only take to the 'pretty', and not to the beautiful or superb. Her complexion was dark and pale, her eyes a deep penetrating grey, her massive wealth of hair gorgeously rippled, and tending to black, yet not without some deep-sunken glow. Soon she was traced to be Miss Burden, daughter of a businessman in the University-city. My brother obtained the privilege of painting from her, and several of his paintings and designs in Oxford bear trace of her countenance. In later years hers was the ideal face which speaks to you out of very many of his principal works. Others among the Oxford band of painters secured the like privilege; and soon Miss Burden became Mrs William Morris. If Rossetti had done nothing else in painting (and some people seem to suppose, most erroneously, that he *did* little else) except the ideal, and also very real, transcription of this unique type of female beauty, he might still, on that ground alone, survive in the chronicles of the art.

[1] See plates.

WALTER HAMILTON

'A PALE DISTRAUGHT LADY'—THE PRE-RAPHAELITE AND AESTHETIC TYPE.

But it is in the portrayal of female beauty that Aesthetic art is most peculiar, both in conception as to what constitutes female loveliness, and in the treatment of it.

The type most usually found is that of a pale distraught lady with matted dark auburn hair falling in masses over the brow, and shading eyes full of lovelorn languor, or feverish despair, emaciated cheeks and somewhat heavy jaws; protruding upper lip, the lower being withdrawn, long crane neck, flat breasts, and long thin nervous hands.

It naturally follows that artists having selected this ideal of loveliness, certain ladies should endeavour to attain it, and in not a few cases they have earned the derision of the Philistines, one of whom thus describes:

A FEMALE AESTHETE

Maiden of the sallow brow,
Listen while my love I vow!
By thy kisses which consume;
By thy spikenard-like perfume;
By thy hollow parboiled eyes;
By thy heart-devouring sighs;
By thy sodden pasty cheek;
By thy poses from the Greek;
By thy tongue, the asp which stings;
By thy zither's twangy strings;
By thy dress of stewed-sage green;
By thy idiotic mien;—
By these signs, O aesthete mine,
Thou shalt be my Valentine!

Fiction

[This section is given over to three extracts: one from a prose romance by William Morris; one from a novel by Swinburne; and one from the gipsy fiction *Aylwin* by Theodore Watts-Dunton.

Pre-Raphaelitism is not, indeed, rich in fiction; but it is certainly Morris who, in his own individual fashion, is most at home in fiction form. When his romance *The Wood beyond the World* was published, he took the opportunity to quash the conjecture of whether this work, like others of the kind by him, was allegorical. 'I had not', he wrote in *The Spectator*, 'the least intention of thrusting an allegory into *The Wood beyond the World*: it is meant for a tale pure and simple.'

The short extract from Swinburne's novel *Love's Cross-Currents—A Year's Letters* shows the poet utilizing a model quite different from Morris. As the latter returned to medieval tales of the marvellous, so Swinburne reverted to the French classical epistolary novel such as Choderlos de Laclos's *Les Liaisons Dangereuses* (although in his dedication to the 1905 edition of the work he mentions the opening of Walter Scott's *Redgauntlet* and an earlier version of *The Fortunes of Nigel*, commenced in letter-form, as his models). Despite the brevity of this excerpt, and even though the correspondent is only a young schoolboy, the worldliness is evident. This is a Swinburne we sometimes forget—the aristocrat whose mother was a daughter of the Earl of Ashburnham, and who had, if he chose, an *entrée* to all the best houses.

Belonging, again, to a quite different genre is Theodore Watts-Dunton's *Aylwin*. It has frequently been spoken of as a 'gipsy' novel, but we can now see it as a fiction created from the fusion of Pre-Raphaelitism and the Celtic Revival in its

Cymric or Welsh aspect. Its contemporary popularity was great—between its publication in 1898 and 1904, it went into twenty-two editions—but today much of its interest must lie in the portrait of the painter D'Arcy, which was assembled from Watts-Dunton's memories of D. G. Rossetti.]

WILLIAM MORRIS

GOLDEN WALTER AND A VERY STRANGE CREATURE
[*In Chapter IX of Morris's romance ' The Wood Beyond the World' the ' valiant youth' Walter, ' son of a great merchant', meets in his journeying with a monstrous dwarf.*]

What with one thing, what with another, as his having to turn out of his way for sheer rocks, or for slopes so steep that he might not try the peril of them, and again for bogs impassable, he was fully three days more before he had quite come out of the stony waste, and by that time, though he had never lacked water, his scanty victual was quite done, for all his careful husbandry thereof. But this troubled him little, whereas he looked to find wild fruits here and there, and to shoot some small deer, as hare or coney, and make a shift to cook the same, since he had with him flint and fire-steel. Moreover the further he went, the surer he was that he should soon come across a dwelling, so smooth and fair as everything looked before him. And he had scant fear, save that he might happen on men who should enthrall him.

But when he was come down past the first green slopes, he was so worn, that he said to himself that rest was better than meat, so little as he had slept for the last three days; so he laid him down under an ash-tree by a stream-side, nor asked what was o'clock, but had his fill of sleep, and even when he awoke in the fresh morning was little fain of rising, but lay betwixt sleeping and waking for some three hours more; then he arose, and went further down the next green bent, yet somewhat slowly because of his hunger-weakness. And the scent of that

fair land came up to him like the odour of one great nosegay.

So he came to where the land was level, and there were many trees, as oak and ash, and sweet-chestnut and wych-elm, and hornbeam and quicken-tree, not growing in a close wood or tangled thicket, but set as though in order on the flowery greensward, even as it might be in a great king's park.

So came he to a big bird-cherry, whereof many boughs hung low down laden with fruit: his belly rejoiced at the sight, and he caught hold of a bough, and fell to plucking and eating. But whiles he was amidst of this, he heard suddenly, close anigh him, a strange noise of roaring and braying, not very great, but exceeding fierce and terrible, and not like to the voice of any beast that he knew. As has been aforesaid, Walter was no faint-heart; but what with the weakness of his travail and hunger, what with the strangeness of his adventure and his loneliness, his spirit failed him; he turned round towards the noise, his knees shook and he trembled: this way and that he looked, and then gave a great cry and tumbled down in a swoon; for close before him, at his very feet, was the dwarf whose image he had seen before, clad in his yellow coat, and grinning up at him from his hideous hairy countenance.

How long he lay there as one dead, he knew not, but when he woke again there was the dwarf sitting on his hams close by him. And when he lifted up his head, the dwarf sent out that fearful harsh voice again; but this time Walter could make out words therein, and knew that the creature spoke and said:

How now! What art thou? Whence comest? What wantest?

Walter sat up and said: I am a man; I hight Golden Walter; I come from Langton; I want victual.

Said the dwarf, writhing his face grievously, and laughing forsooth: I know it all: I asked thee to see what wise thou wouldst lie. I was sent forth to look for thee; and I have brought thee loathsome bread with me, such as ye aliens must needs eat: take it!

Therewith he drew a loaf from a satchel which he bore, and thrust it towards Walter, who took it somewhat doubtfully for all his hunger.

The dwarf yelled at him: Art thou dainty, alien? Wouldst thou have flesh? Well, give me thy bow and an arrow or two,

since thou art lazy-sick, and I will get thee a coney or a hare, or a quail maybe. Ah, I forgot; thou art dainty, and wilt not eat flesh as I do, blood and all together, but must needs half burn it in the fire, or mar it with hot water; as they say my Lady does: or as the Wretch, the Thing does; I know that, for I have seen It eating.

Nay, said Walter, this sufficeth; and he fell to eating the bread, which was sweet between his teeth. Then when he had eaten a while, for hunger compelled him, he said to the dwarf: But what meanest thou by the Wretch and the Thing? And what Lady is thy Lady?

The creature let out another wordless roar as of furious anger; and then the words came: It hath a face white and red, like to thine; and hands white as thine, yea, but whiter; and the like it is underneath its raiment, only whiter still: for I have seen It . . . yes, I have seen It; ah yes and yes and yes.

And therewith his words ran into gibber and yelling, and he rolled about and smote at the grass: but in a while he grew quiet again and sat still, and then fell to laughing horribly again, and then said: But thou, fool, wilt think It fair if thou fallest into It's hands, and wilt repent it thereafter, as I did. Oh, the mocking and gibes of It, and the tears and shrieks of It; and the knife! What! sayest thou of my Lady? . . . What Lady? O alien, what other Lady is there? And what shall I tell thee of her? it is like that she made me, as she made the Bear men. But she made not the Wretch, the Thing; and she hateth It sorely, as I do. And some day to come . . .

Thereat he brake off and fell to wordless yelling a long while, and thereafter spake all panting: Now I have told thee overmuch, and O if my Lady come to hear thereof. Now I will go.

And therewith he took out two more loaves from his wallet, and tossed them to Walter, and so turned and went his ways; while walking upright, as Walter had seen his image on the quay of Langton; whiles bounding and rolling like a ball thrown by a lad; whiles scuttling along on all-fours like an evil beast, and ever and anon giving forth that harsh and evil cry.

Walter sat a while after he was out of sight, so stricken with horror and loathing and a fear of he knew not what, that he

might not move. Then he plucked up a heart, and looked to his weapons and put the other loaves into his scrip.

Then he arose and went his ways wondering, yea and dreading, what kind of creature he should next fall in with. For soothly it seemed to him that it would be worse than death if they were all such as this one; and that if it were so, he must needs slay and be slain.

THEODORE WATTS-DUNTON

HAROUN-AL-RASCHID THE PAINTER

[*In Chapter V of Watts-Dunton's novel ' Aylwin', the author paints a portrait of D. G. Rossetti and his* ménage *in Chelsea as he had known them. His character of the famous professional artist Mr D'Arcy is called Haroun-al-Raschid because he has 'never been known to perambulate the streets of London, except by night'.*

Next morning, after I had finished my solitary breakfast, I asked the servant if Mr D'Arcy had yet risen. On being told that he had not, I went downstairs into the studio where I had spent the previous evening. After examining the pictures on the walls and the easels, I walked to the window and looked out at the garden. It was large, and so neglected and untrimmed as to be a veritable wilderness. While I was marvelling why it should have been left in this state, I saw the eyes of some animal staring at me from the distance, and was soon astonished to see that they belonged to a little Indian bull. My curiosity induced me to go into the garden and look at the creature. He seemed rather threatening at first, but after a while allowed me to go up to him and stroke him. Then I left the Indian bull and explored this extraordinary domain. It was full of unkempt trees, including two fine mulberries, and surrounded by a very high wall. Soon I came across an object which, at first, seemed a little mass of black and white oats moving along, but I

presently discovered it to be a hedgehog. It was so tame that it
did not curl up as I approached it, but allowed me, though
with some show of nervousness, to stroke its pretty little black
snout. As I walked about the garden, I found it was populated
with several kinds of animals such as are never seen except in
menageries or in the Zoological Gardens. Wombats, kangaroos
and the like, formed a kind of happy family.

My love of animals led me to linger in the garden. When I
returned to the house I found D'Arcy in the green dining-
room, where we talked, and he read aloud some verses to me.
We then went to the studio. He said,

'No doubt you are surprised at my menagerie. Every man
has one side of his character where the child remains. I have a
love of animals which, I suppose, I may call a passion. The
kind of amusement they can afford me is like none other. It is
the self-consciousness of men and women that makes them, in
a general way, intensely unamusing. I turn from them to the
unconscious brutes, and often get a world of enjoyment. To
watch a kitten or a puppy play, or the funny antics of a parrot
or a cockatoo, or the wise movements of a wombat, will keep
me for hours from being bored.'

'And children,' I said—'do you like children?'

'Yes, so long as they remain like the young animals—until
they become self-conscious, I mean, and that is very soon.
Then their charm goes. Has it ever occurred to you how
fascinating a beautiful young girl would be if she were as
unconscious as a young animal? What makes you sigh?'

My thoughts had flown to Winifred breakfasting with her
'Prince of the Mist' on Snowdon. And I said to myself, 'How
he would have been fascinated by a sight like that!'

My experience of men at that time was so slight that the
opinion I then formed of D'Arcy as a talker was not of much
account. But since then I have seen very much of men, and I
find that I was right in the view I then took of his conversa-
tional powers. When his spirits were at their highest he was
without an equal as a wit, without an equal as a humourist. He
had more than even Cyril Aylwin's quickness of repartee, and
it was of an incomparably rarer quality. To define it would be,
of course, impossible, but I might perhaps call it poetic fancy

suddenly stimulated at moments by animal spirits into rapid movements—so rapid, indeed, that what in slower movement would be merely fancy, in him became wit. Beneath the coruscations of this wit a rare and deep intellect was always perceptible.

His humour was also so fanciful that it seemed poetry at play, but here was the remarkable thing: although he was not unconscious of his other gifts, he did not seem to be in the least aware that he was a humourist of the first order; every *jeu d'esprit* seemed to leap from him involuntarily, like the spray from a fountain. A dull man like myself must not attempt to reproduce these qualities here.

While he was talking he kept on painting, and I said to him, 'I can't understand how you can keep up a conversation while you are at work.'

I took care not to tell him that I was an amateur painter.

'It is only when the work that I am on is in some degree mechanical that I can talk while at work. These flowers, which were brought to me this morning for my use in painting this picture, will very soon wither, and I can put them into the picture without being disturbed by talk; but if I were at work upon this face, if I were putting dramatic expression into these eyes, I should have to be silent.'

He then went on talking upon art and poetry, letting fall at every moment gems of criticism that would have made the fortune of a critic.

After a while, however, he threw down the brush and said, 'Sometimes I can paint with another man in the studio; sometimes I can't.'

I rose to go.

'No, no,' he said; 'I don't want you to go, yet I don't like keeping you in this musty studio on such a morning. Suppose we take a stroll together.'

'But you never walk out in the daytime.'

'Not often; indeed, I may say never, unless it is to go to the Zoo, or to Jamrach's, which I do about once in three months.'

'Jamrach's!' I said. 'Why, he's the importer of animals, isn't he? Of all places in London that is the one I should most like to see.' He then took me into a long panelled room with

bay windows looking over the Thames, furnished with remarkable Chinese chairs and tables. And then we left the house.

In Maud Street a hansom passed us; D'Arcy hailed it.

'We will take this to the Bank,' said he, 'and then walk through the East End to Jamrach's. Jump in.'

As we drove off, the sun was shining brilliantly, and London seemed very animated—seemed to be enjoying itself. Until we reached the Bank our drive was through all the most cheerful-looking and prosperous streets of London. It acted like a tonic on me, and for the first time since my trouble I felt really exhilarated. As to D'Arcy, after we had left behind us what he called the 'stucco world' of the West End, his spirits seemed to rise every minute, and by the time we reached the Strand he was as boisterous as a boy on a holiday.

ALGERNON CHARLES SWINBURNE

A PRE-RAPHAELITE LADY IN CAPTIVITY

[*In Chapter VII of his epistular novel 'Love's Cross-Currents', Swinburne shows us the young Reginald Harewood—possibly something of a self-portrait—writing to a friend about Clara Radworth, Reginald's lovely cousin, now married to an elderly scientist. Published in 1877, and revised in 1905, as a novel, the work had originally appeared as a serial in the 'Tatler' as 'A Year's Letters' under the psuedonym 'Mrs Horace Manners'.*]

LIDCOMBE, March 1st

Did you see last year in the Exhibition a portrait by Fairfax of my cousin Mrs Radworth? You know of course I am perfectly well aware the man is an exquisite painter, with no end of genius and great qualities in his work; but I declare he made a mull of that picture. It was what fellows call a fiasco—complete. Imagine sticking her into a little crib of a room with a window and some flowers and things behind her, and all that splendid hair of hers done up in some beastly way. And then people say the geraniums and the wainscot were stunning pieces of colour,

or some such rot; when the fellow ought to have painted her out-of-doors, or on horse-back, or something. I wish I could sit a horse half as well; she is the most graceful and the pluckiest rider you ever saw. I rode with her yesterday to Hadleigh, down by the sea, and we had a gallop over the sands; three miles good, and all hard sand; the finest ground possible; when I was staying here as a boy I used to go out with the grooms before breakfast, and exercise the horses there instead of taking them up to the downs. She had been out of spirits in the morning, and wanted the excitement to set her up. I never saw her look so magnificent; her hair was blown down and fell in heavy uncurling heaps to her waist; her face looked out of the frame of it, hot and bright, with the eyes lighted, expanding under the lift of those royal wide eyelids of hers. I could hardly speak to her for pleasure, I confess; don't show my avowals. I rode between her and the sea, a thought behind; a gust of wind blowing off land drove a wave of her hair across my face, upon my lips; she felt it somehow, I suppose, for she turned and laughed. When we came to ride back, and had to go slower (that Nourmahal of hers is not my notion of what her horse should be—I wish one could get her a real good one), she changed somehow, and began to talk seriously at last; I knew she was not really over-happy. Fancy that incredible fool Ernest Radworth never letting her see any one when they are at home, except some of his scientific acquaintances—not a lady in the whole country-side for her to speak to. You should have heard her account of the entertainments in that awful house of theirs, about as much life as there used to be at my father's. Don't I remember the holiday dinners there!—a parson, a stray military man of the stodgier kind, my tutor, and the pater; I kept after dinner to be chaffed, or lectured, or examined—a jolly time that was. Well, I imagine her life is about as pleasant; or worse, for she can hardly get out to go about at all. People come there with cases of objects, curiosities, stones and bones and books, and lumber the whole place. She had to receive three scientific professors last month; two of them noted osteologists, she said, and one a comparative ichthyologist, or something—a man with pink eyes and a mouth all on one side, who was always blinking and talking—

a friend of my great-uncle's, it seems, who presented him years ago to that insane ass Radworth. Think of the pair of them, and of Clara obliged to sit and be civil. She became quite sad towards the end of our ride; said how nice it had been here, and that sort of thing, till I was three-quarters mad. She goes in three or four days. I should like to follow her everywhere, and be her footman or her groom, and see her constantly. I would clean knives and black boots for her. If I had no fellow to speak or write to, I can't think how I should stand things at all.

Poems

[In his popular primer *The Aesthetic Movement in England* (1882), Walter Hamilton treated six writers as specifically 'Pre-Raphaelite poets'; D. G. and W. M. Rossetti, Morris, Swinburne, Thomas Woolner and Arthur O'Shaughnessy. All these (save Woolner) have been included, along with many others, in the following section. The principle of representation is that the poem shall be humanly interesting or artistically good; and it is on this account that many of the verse contributions to *The Germ* have been excluded, where mawkishness and immaturity often went with a shaky technique. This is certainly the case with Thomas Woolner's two poems (favourably regarded in their day), *My Beautiful Lady* and *Of My Lady in Death*. In any case, the poets of *The Germ* have been well-represented in James D. Merritt's anthology *The Pre-Raphaelite Poem* (1966).

In place of these often lame, flat or halting lucubrations, it seemed better to include the work of a predominantly younger generation of Pre-Raphaelite poets: Richard Watson Dixon, Philip Burke Marston, William Allingham and others. Christina Rossetti is, of course, represented. Another figure from the original P.R. generation (without a place in James Merritt's anthology) is Elizabeth Siddal. Three of her poems are printed here as being of considerable biographical interest and not without their own imaginative pathos.]

DANTE GABRIEL ROSSETTI

From JENNY

'Vengeance of Jenny's case! Fie on her! Never name her,
child!'—*Mrs Quickly*.

Lazy laughing languid Jenny,
Fond of a kiss and fond of a guinea,
Whose head upon my knee to-night
Rests for a while, as if grown light
With all our dances and the sound
To which the wild tunes spun you round
Fair Jenny mine, the thoughtless queen
Of kisses which the blush between
Could hardly make much daintier;
Whose eyes are as blue skies, whose hair
Is countless gold incomparable:
Fresh flower, scarce touched with signs that tell
Of Love's exuberant hotbed:—Nay,
Poor flower left torn since yesterday
Until to-morrow leave you bare;
Poor handful of bright spring-water
Flung in the whirlpool's shrieking face
Poor shameful Jenny, full of grace
Thus with your head upon my knee;—
Whose person or whose purse may be
The lodestar of your reverie?

This room of yours, my Jenny, looks
A change from mine so full of books,
Whose serried ranks hold fast, forsooth,
So many captive hours of youth,—
The hours they thieve from day and night
To make one's cherished work come right,
And leave it wrong for all their theft,
Even as to-night my work was left:
Until I vowed that since my brain
And eyes of dancing seemed so fain,

My feet should have some dancing too:—
And thus it was I met with you.
Well, I suppose 'twas hard to part,
For here I am. And now, sweetheart,
You seem too tired to get to bed.

 It was a careless life I led
When rooms like this were scarce so strange
Not long ago. What breeds the change,—
The many aims or the few years?
Because to-night it all appears
Something I do not know again.

 The cloud's not danced out of my brain,—
The cloud that made it turn and swim
While hour by hour the books grew dim.
Why, Jenny, as I watch you there,—
For all your wealth of loosened hair,
Your silk ungirdled and unlaced
And warm sweets open to the waist,
All golden in the lamplight's gleam,—
You know not what a book you seem,
Half-read by lightning in a dream!
How should you know, my Jenny? Nay,
And I should be ashamed to say:—
Poor beauty, so well worth a kiss!
But while my thought runs on like this
With wasteful whims more than enough,
I wonder what you're thinking of.

 If of myself you think at all,
What is the thought?—conjectural
On sorry matters best unsolved?—
Or inly is each grace revolved
To fit me with a lure?—or (sad
To think!) perhaps you're merely glad
That I'm not drunk or ruffianly
And let you rest upon my knee.

For sometimes, were the truth confessed,
You're thankful for a little rest,—
Glad from the crush to rest within,
From the heart-sickness and the din
Where envy's voice at virtue's pitch
Mocks you because your gown is rich;
And from the pale girl's dumb rebuke,
Whose ill-clad grace and toil-worn look
Proclaim the strength that keeps her weak
And other nights than yours bespeak;
And from the wise unchildish elf,
To schoolmate lesser than himself
Pointing you out, what thing you are:—
Yes, from the daily jeer and jar,
From shame and shame's outbraving too,
Is rest not sometimes sweet to you?—
But most from the hatefulness of man,
Who spares not to end what he began,
Whose acts are ill and his speech ill,
Who, having used you at his will,
Thrusts you aside, as when I dine
I serve the dishes and the wine.

* * * * *

Come, come, what use in thoughts like this?
Poor little Jenny, good to kiss,—
You'd not believe by what strange roads
Thought travels, when your beauty goads
A man to-night to think of toads!
Jenny, wake up. . . . Why, there's the dawn!

And there's an early waggon drawn
To market, and some sheep that jog
Bleating before a barking dog;
And the old streets come peering through
Another night that London knew;
And all as ghostlike as the lamps.

So on the wings of day decamps
My last night's frolic. Glooms begin

To shiver off as lights creep in
Past the gauze curtains half drawn-to,
And the lamp's doubled shade grows blue,—
Your lamp, my Jenny, kept alight,
Like a wise virgin's, all one night!
And in the alcove coolly spread
Glimmers with dawn your empty bed;
And yonder your fair face I see
Reflected lying on my knee,
Where teems with first foreshadowings
Your pier-glass scrawled with diamond rings.
And on your bosom all night worn
Yesterday's rose now droops forlorn
But dies not yet this summer morn.

 And now without, as if some word
Had called upon them that they heard,
The London sparrows far and nigh
Clamour together suddenly;
And Jenny's cage-bird grown awake
Here in their song his part must take,
Because here too the day doth break,

 And somehow in myself the dawn
Among stirred clouds and veils withdrawn
Strikes greyly on her. Let her sleep.
But will it wake her if I heap
These cushions thus beneath her head
Where my knee was? No,—there's your bed,
My Jenny, while you dream. And there
I lay among your golden hair
Perhaps the subject of your dreams,
These golden coins.
 For still one deems
That Jenny's flattering sleep confers
New magic on the magic purse,—
Grim web, how clogged with shrivelled flies!
Between the threads fine fumes arise

And shape their pictures in the brain.
There roll no streets in glare and rain,
Nor flagrant man-swine whets his tusk;
But delicately sighs in musk
The homage of the dim boudoir;
Or like a palpitating star
Thrilled into song, the opera-night
Breathes faint in the quick pulse of light;
Or at the carriage-window shine
Rich wares for choice; or, free to dine,
Whirls through its hour of health (divine
For her) the concourse of the Park.
And though in the discounted dark
Her functions there and here are one,
Beneath the lamps and in the sun
There reigns at least the acknowledged belle
Apparelled beyond parallel.
Ah Jenny, yes, we know your dreams.

For even the Paphian Venus seems
A goddess o'er the realms of love,
When silver-shrined in shadowy grove:
Aye, or let offerings nicely plac'd
But hide Priapus to the waist,
And whoso looks on him shall see
An eligible deity.

Why, Jenny, waking here alone
May help you to remember one,
Though all the memory's long outworn
Of many a double-pillowed morn.
I think I see you when you wake,
And rub your eyes for me, and shake
My gold, in rising, from your hair,
A Danaë for a moment there.

Jenny, my love rang true! for still
Love at first sight is vague, until
That tinkling makes him audible.

And must I mock you to the last,
Ashamed of my own shame,—aghast
Because some thoughts not born amiss
Rose at a poor fair face like this?
Well, of such thoughts so much I know:
In my life, as in hers, they show,
By a far gleam which I may near,
A dark path I can strive to clear.

Only one kiss. Goodbye, my dear.

NUPTIAL SLEEP

At length their long kiss severed, with sweet smart;
 And as the last slow sudden drops are shed
 From sparkling eaves when all the storm has fled,
So singly flagged the pulses of each heart.
Their bosom sundered, with the opening start
 Of married flowers to either side outspread
 From the knit stem; yet still their mouths, burnt red,
Fawned on each other where they lay apart.

Sleep sank them lower than the tide of dreams,
 And their dreams watched them sink, and slid away.
Slowly their souls swam up again, through gleams
 Of watered light and dull drowned waifs of day;
Till from some wonder of new woods and streams
 He woke, and wondered more: for there she lay.

THE ORCHARD-PIT

Piled deep below the screening orchard-branch
 They lie with bitter apples in their hands:
And some are only ancient bones that blanch,
And some had ships that last year's wind did launch,
 And some were yesterday the lords of lands.

In the soft dell, among the apple-trees,
　　High up above the hidden pit she stands,
And there for ever sings, who gave to these,
That lie below, her magic hour of ease,
　　And those her apples holden in their hands.

This in my dreams is shown me; and her hair
　　Crosses my lips and draws my burning breath;
Her song spreads golden wings upon the air,
Life's eyes are gleaming from her forehead fair,
　　And from her breasts the ravishing eyes of Death.

Men say to me that sleep hath many dreams,
　　Yet I knew never but this dream alone:
There, from a dried-up channel, once the stream's,
The glen slopes up; even such in sleep it seems
　　As to my waking sight the place well known.

*　　*　　*　　*　　*　　*

My love I call her, and she loves me well:
　　But I love her as in the maelstrom's cup
The whirled stone loves the leaf inseparable
That clings to it round all the circling swell,
　　And that the same last eddy swallows up.

CHRISTINA ROSSETTI

SONG

When I am dead, my dearest,
　　Sing no sad songs for me;
Plant thou no roses at my head,
　　Nor shady cypress tree:
Be the green grass above me
　　With showers and dewdrops wet:
And if thou wilt, remember,
　　And if thou wilt, forget.

I shall not see the shadows,
 I shall not feel the rain;
I shall not hear the nightingale
 Sing on as if in pain:
And dreaming through the twilight
 That doth not rise nor set,
Haply I may remember,
 And haply may forget.

From GOBLIN MARKET

Morning and evening
Maids heard the goblins cry:
'Come buy our orchard fruits,
Come buy, come buy:
Apples and quinces,
Lemons and oranges,
Plump unpecked cherries,
Melons and raspberries,
Bloom-down-cheeked peaches,
Swart-headed mulberries,
Wild free-born cranberries,
Crab-apples, dewberries,
Pine-apples, blackberries,
Apricots, strawberries;—
All ripe together
In summer weather,—
Morns that pass by,
Fair eves that fly;
Come buy, come buy:
Our grapes fresh from the vine,
Pomegranates full and fine,
Dates and sharp bullaces,
Rare pears and greengages,
Damsons and bilberries,
Taste them and try:
Currants and gooseberries,
Bright-fire-like barberries,

Figs to fill your mouth,
Citrons from the South,
Sweet to tongue and sound to eye;
Come buy, come buy.'

Evening by evening
Among the brookside rushes,
Laura bowed her head to hear,
Lizzie veiled her blushes:
Crouching close together
In the cooling weather,
With clasping arms and cautioning lips,
With tingling cheeks and finger tips.
'Lie close,' Laura said,
Pricking up her golden head:
'We must not look at goblin men,
We must not buy their fruits:
Who knows upon what soil they fed
Their hungry thirsty roots?'
'Come buy,' call the goblins
Hobbling down the glen.
'Oh,' cried Lizzie, 'Laura, Laura,
You should not peep at goblin men.'
Lizzie covered up her eyes,
Covered close lest they should look;
Laura reared her glossy head,
And whispered like the restless brook:
'Look, Lizzie, look, Lizzie,
Down the glen tramp little men.
One hauls a basket,
One bears a plate,
One lugs a golden dish
Of many pounds' weight.
How fair the vine must grow
Whose grapes are so luscious;
How warm the wind must blow
Through those fruit bushes.'
'No,' said Lizzie: 'No, no, no;
Their offers should not charm us,

Their evil gifts would harm us.'
She thrust a dimpled finger
In each ear, shut eyes and ran:
Curious Laura chose to linger
Wondering at each merchant man.
One had a cat's face,
One whisked a tail,
One tramped at a rat's pace,
One crawled like a snail,
One like a wombat prowled obtuse and furry,
One like a ratel tumbled hurry skurry.
She heard a voice like voice of doves
Cooing all together:
They sounded kind and full of loves
In the pleasant weather. . . .

WILLIAM MORRIS

POMONA

I am the ancient Apple-Queen,
As once I was so am I now.
For evermore a hope unseen,
Betwixt the blossom and the bough.

Ah, where's the river's hidden Gold?
And where the windy grave of Troy?
Yet come I as I came of old,
From out the heart of Summer's joy.

FOR THE BED AT KELMSCOTT

The wind's on the wold
And the night is a-cold,
And Thames runs chill
Twixt mead and hill,

But kind and dear
Is the old house here,
And my heart is warm
Midst winter's harm.
Rest, then and rest,
And think of the best
Twixt summer and spring
When all birds sing
In the town of the tree,
And ye lie in me
But scarce dare move
Lest earth and its love
Should fade away
Ere the full of the day.

I am old and have seen
Many things that have been,
Both grief and peace,
And wane and increase.
No tale I tell
Of ill or well,
But this I say,
Night treadeth on day,
And for worst and best
Right good is rest.

ALGERNON CHARLES SWINBURNE

CHORUS FROM 'ATALANTA IN CALYDON'

When the hounds of spring are on winter's traces,
 The mother of months in meadow or plain
Fills the shadows and windy places
 With lisp of leaves and ripple of rain;

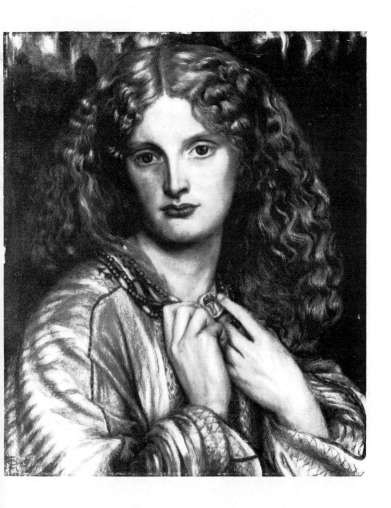

HELEN OF TROY (1863) *by D. G. Rossetti*
Helen is represented here by Annie Miller, a model whom
Holman Hunt considered marrying but who found Rossetti
more attractive.

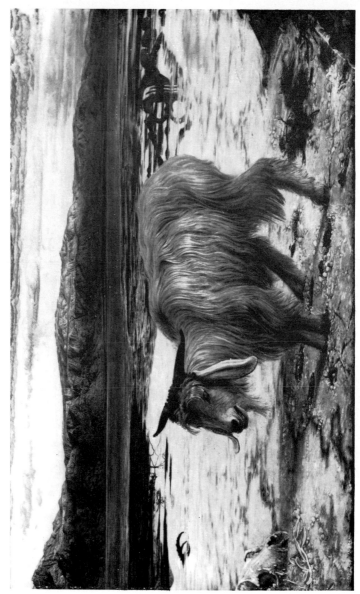

THE SCAPE GOAT (1854–5) *by W. Holman Hunt*

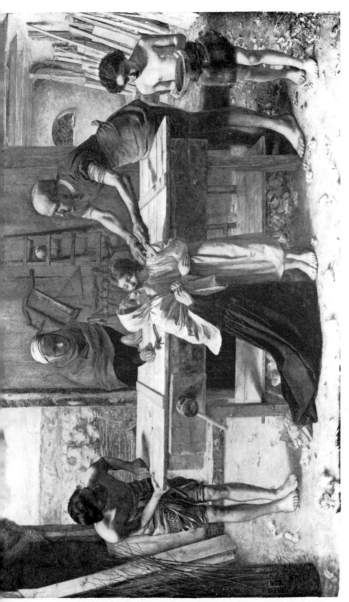

CHRIST IN THE HOUSE OF HIS PARENTS (1850) *by J. E. Millais*
The picture's uncomely realism is at variance with Millais' later trite prettifying of his subjects.

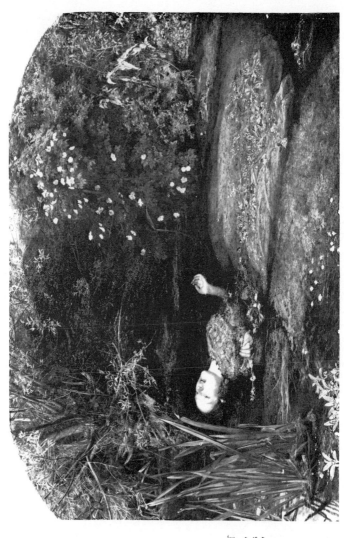

OPHELIA (1852)
by J. E. Millais
Painted on the banks of
the Ewell at Kingston,
with Elizabeth Siddal as
Ophelia, this is Millais'
most famous picture.

THE HIRELING
SHEPHERD (1851)
by W. Holman Hunt
The *Athenaeum* remarked
how 'Downright literal
truth is followed out in
every accessory', but
W. M. Rossetti noted
its intended allegory.

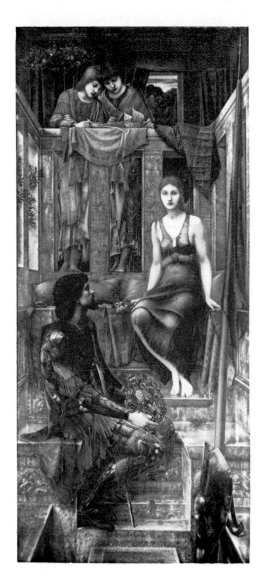

KING COPHETUA
AND THE BEGGAR
MAID (1884)
by Edward Burne-Jones
In depicting the beggar
maid Burne-Jones said
he was concerned to
express poverty without
its ugliness.

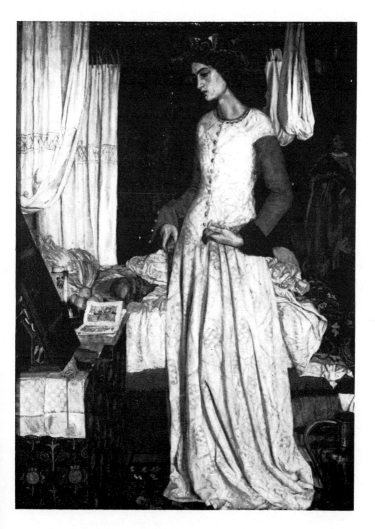

QUEEN GUINIVERE (1858) *by William Morris*
This is one of Morris's few paintings and was made one year
before his marriage to the model Jane Burden in 1859.

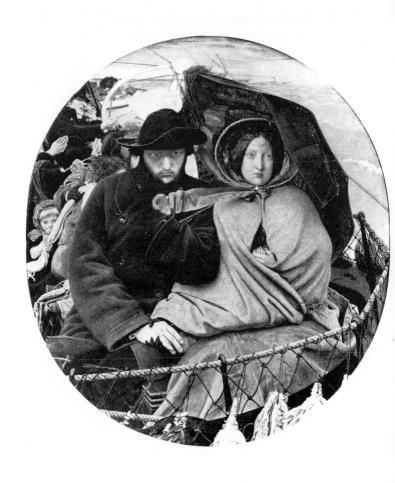

THE LAST OF ENGLAND (1852) *by Ford Madox Brown*
Inspired by the departure of Woolner and his wife on the
immigrant ship *Windsor* for Australia from Gravesend.

And the brown bright nightingale amorous
Is half assuaged for Itylus,
For the Thracian ships and the foreign faces,
 The tongueless vigil, and all the pain.

Come with bows bent and with emptying of quivers,
 Maiden most perfect, lady of light,
With a noise of winds and many rivers,
 With a clamour of waters, and with might;
Bind on thy sandals, O thou most fleet,
Over the splendour and speed of thy feet;
For the faint east quickens, the wan west shivers,
 Round the feet of the day and the feet of the night.

Where shall we find her, how shall we sing to her,
 Fold our hands round her knees, and cling?
O that man's heart were as fire and could spring to her,
 Fire, or the strength of the streams that spring!
For the stars and the winds are unto her
As raiment, as songs of the harp-player;
For the risen stars and the fallen cling to her,
 And the southwest-wind and the west-wind sing.

For winter's rains and ruins are over,
 And all the season of snows and sins;
The days dividing lover and lover,
 The light that loses, the night that wins;
And time remembered is grief forgotten,
And frosts are slain and flowers begotten,
And in green underwood and cover
 Blossom by blossom the spring begins.

The full streams feed on flower of rushes,
 Ripe grasses trammel a travelling foot,
The faint fresh flame of the young year flushes
 From leaf to flower and flower to fruit;
And fruit and leaf are as gold and fire,
And the oat is heard above the lyre,
And the hoofèd heel of a satyr crushes
 The chestnut-husk at the chestnut-root.

And Pan by noon and Bacchus by night,
 Fleeter of foot than the fleet-foot kid,
Follows with dancing and fills with delight
 The Mænad and the Bassarid;
And soft as lips that laugh and hide
The laughing leaves of the trees divide,
And screen from seeing and leave in sight
 The god pursuing, the maiden hid.

The ivy falls with the Bacchanal's hair
 Over her eyebrows hiding her eyes;
The wild vine slipping down leaves bare
 Her bright breast shortening into sighs;
The wild vine slips with the weight of its leaves,
But the berried ivy catches and cleaves
To the limbs that glitter, the feet that scare
 The wolf that follows, the fawn that flies.

From ANACTORIA

τίνος αὖ τὺ πειθοῖ
μὰψ σαγηνεύσας φιλότατα;

SAPPHO.

My life is bitter with thy love; thine eyes
Blind me, thy tresses burn me, thy sharp sighs
Divide my flesh and spirit with soft sound,
And my blood strengthens, and my veins abound.
I pray thee sigh not, speak not, draw not breath;
Let life burn down, and dream it is not death.
I would the sea had hidden us, the fire
(Wilt thou fear that, and fear not my desire?)
Severed the bones that bleach, the flesh that cleaves,
And let our sifted ashes drop like leaves.
I feel thy blood against my blood: my pain
Pains thee, and lips bruise lips, and vein stings vein.
Let fruit be crushed on fruit, let flower on flower,
Breast kindle breast, and either burn one hour.

Why wilt thou follow lesser loves? are thine
Too weak to bear these hands and lips of mine?
I charge thee for my life's sake, O too sweet
To crush love with thy cruel faultless feet,
I charge thee keep thy lips from hers or his,
Sweetest, till theirs be sweeter than my kiss.
Lest I too lure, a swallow for a dove,
Erotion or Erinna to my love.
I would my love could kill thee; I am satiated
With seeing thee live, and fain would have thee dead.
I would earth had thy body as fruit to eat,
And no mouth but some serpent's found thee sweet.
I would find grievous ways to have thee slain,
Intense device, and superflux of pain;
Vex thee with amorous agonies, and shake
Life at thy lips, and leave it there to ache;
Strain out thy soul with pangs too soft to kill,
Intolerable interludes, and infinite ill;
Relapse and reluctation of the breath,
Dumb tunes and shuddering semitones of death. . . .

From DOLORES
(NOTRE-DAME DES SEPT DOULEURS)

Cold eyelids that hide like a jewel
 Hard eyes that grow soft for an hour;
The heavy white limbs, and the cruel
 Red mouth like a venomous flower;
When these are gone by with their glories,
 What shall rest of thee then, what remain,
O mystic and sombre Dolores,
 Our Lady of Pain?

Seven sorrows the priests give their Virgin;
 But thy sins, which are seventy times seven,
Seven ages would fail thee to purge in,
 And then they would haunt thee in heaven:

Fierce midnights and famishing morrows,
 And the loves that complete and control
All the joys of the flesh, all the sorrows
 That wear out the soul.

O garment not golden but gilded,
 O garden where all men may dwell,
O tower not of ivory, but builded
 By hands that reach heaven from hell;
O mystical rose of the mire,
 O house not of gold but of gain,
O house of unquenchable fire,
 Our Lady of Pain!

O lips full of lust and of laughter,
 Curled snakes that are fed from my breast,
Bite hard, lest remembrance come after
 And press with new lips where you pressed.
For my heart too springs up at the pressure,
 Mine eyelids too moisten and burn;
Ah, feed me and fill me with pleasure,
 Ere pain come in turn.

* * * * * *

From FAUSTINE

* * * * * *

She loved the games men played with death,
 Where death must win;
As though the slain man's blood and breath
 Revived Faustine.

Nets caught the pike, pikes tore the net;
 Lithe limbs and lean
From drained-out pores dripped thick red sweat
 To soothe Faustine.

She drank the steaming drift and dust
 Blown off the scene;
Blood could not ease the bitter lust
 That galled Faustine.

All round the foul fat furrows reeked,
 Where blood sank in;
The circus splashed and seethed and shrieked
 All round Faustine.

But these are gone now: years entomb
 The dust and din;
Yea, even the bath's fierce reek and fume
 That slew Faustine.

Was life worth living then? and now
 Is life worth sin?
Where are the imperial years? and how
 Are you Faustine?

Your soul forgot her joys, forgot
 Her times of teen;
Yea, this life likewise will you not
 Forget, Faustine?

* * * * * *

ELIZABETH SIDDAL

WORN OUT

Thy strong arms are around me, love,
 My head is on thy breast:
Though words of comfort come from thee,
 My soul is not at rest:

For I am but a startled thing,
 Nor can I ever be
Aught save a bird whose broken wing
 Must fly away from thee.

I cannot give to thee the love
 I gave so long ago—
The love that turned and struck me down
 Amid the blinding snow.

I can but give a sinking heart
 And weary eyes of pain,
A faded mouth that cannot smile
 And may not laugh again.

Yet keep thine arms around me, love,
 Until I drop to sleep:
Then leave me—saying no good-bye,
 Lest I might fall and weep.

DEAD LOVE

Oh never weep for love that's dead,
 Since love is seldom true,
But changes his fashion from blue to red,
 From brightest red to blue,
And love was born to an early death
 And is so seldom true.

Then harbour no smile on your loving face
 To win the deepest sigh;
The fairest words on truest lips
 Pass off and surely die;
And you will stand alone, my dear,
 When wintry winds draw nigh.

Sweet, never weep for what cannot be,
 For this God has not given:
If the merest dream of love were true,
 Then, sweet, we should be in heaven;
And this is only earth, my dear,
 Where true love is not given.

A YEAR AND A DAY

Slow days have passed that make a year,
 Slow hours that make a day,
Since I could take my first dear love,
 And kiss him the old way:
Yet the green leaves touch me on the cheek,
 Dear Christ, this month of May.

I lie among the tall green grass
 That bends above my head,
And covers up my wasted face,
 And folds me in its bed
Tenderly and lovingly
 Like grass above the dead.

Dim phantoms of an unknown ill
 Float through my tiring brain;
The unformed visions of my life
 Pass by in ghostly train;
Some pause to touch me on the cheek,
 Some scatter tears like rain.

The river ever running down
 Between its grassy bed,
The voices of a thousand birds
 That clang above my head,
Shall bring to me a sadder dream
 When this sad dream is dead.

A silence falls upon my heart,
 And hushes all its pain.
I stretch my hands in the long grass,
 And fall to sleep again,
There to lie empty of all love,
 Like beaten corn of grain.

WILLIAM BELL SCOTT

THE WITCH'S BALLAD

O I hae come from far away,
 From a warm land far away,
A southern land across the sea,
With sailor lads about the mast,
Merry and canny, and kind to me.

And I hae been to yon town
 To try my luck in yon town;
Nort, and Mysie, Elspie too.
Right braw we were to pass the gate,
Wi' gowden clasps on girdles blue.

Mysie smiled wi' miminy mouth;
 Innocent mouth, miminy mouth;
Elspie wore a scarlet gown,
Nort's grey eyes were unco' gleg.
My Castile comb was like a crown.

We walked abreast all up the street,
 Into the market up the street;
Our hair with marigolds was wound,
Our bodices with love-knots laced,
Our merchandise with tansy bound.

Nort had chickens, I had cocks,
 Gamesome cocks, crowing cocks;
Mysie ducks, and Elspie drakes,—
For a wee groat or a pound;
We lost nae time wi' gives and takes.

—Lost nae time, for well we knew,
 In our sleeves full well we knew,
When the gloaming came that night,
Duck nor drake, nor hen nor cock
Would be found by candle light.

And when out chaffering all was done,
 All was paid for, sold and done,
We drew a glove on ilka hand,
We sweetly curtsied, each to each,
And deftly danced a saraband.

The market-lassies looked and laughed,
 Left their gear, and looked and laughed;
They made as they would join the game,
But soon their mithers, wild and wud,
With whack and screech they stopped the same.

Sae loud the tongues o' randles grew,
 The flytin' and the skirlin' grew,
At all the windows in the place,
Wi' spoons or knives, wi' needle or awl,
Was thrust out every hand and face.

And down each stair they thronged anon,
 Gentle, semple, thronged anon;
Souter and tailor, frowsy Nan,
The ancient widow young again,
Simpering behind her fan.

Without a choice, against their will,
 Doited, dazed, against their will,

The market lassie and her mither,
The farmer and his husbandman,
Hand in hand dance a' thegither.

Slow at first, but faster soon,
 Still increasing wild and fast,
Hoods and mantles, hats and hose,
Blindly doffed and cast away,
Left them naked, heads and toes.

They would have torn us limb from limb,
 Dainty limb from dainty limb;
But never one of them could win
Across the line that I had drawn
With bleeding thumb a-widdershin.

But there was Jeff the provost's son,
 Jeff the provost's only son;
There was Father Auld himsel',
The Lombard from the hostelry,
And the lawyer Peter Fell.

All goodly men we singled out,
 Waled them well, and singled out,
And drew them by the left hand in;
Mysie the priest, and Elspie won
The Lombard, Nort the lawyer carle,
I mysel' the provost's son.

Then, with cantrip kisses seven,
 Three times round with kisses seven,
Warped and woven there spun we
Arms and legs and flaming hair,
Like a whirlwind in the sea.

Like a wind that sucks the sea,
 Over and in and on the sea,
Good sooth it was a mad delight;
And every man of all the four
Shut his eyes and laughed outright.

Laughed as long as they had breath,
 Laughed while they had sense or breath;
And close about us coiled a mist
Of gnats and midges, wasps and flies,
Like the whirlwind shaft it rist.

Drawn up I was right off my feet,
 Into the mist and off my feet;
And, dancing on each chimney-top,
I saw a thousand darling imps
Keeping time with skip and hop.

And on the provost's brave ridge-tile,
 On the provost's grand ridge-tile,
The Blackamoor first to master me
I saw, I saw that winsome smile,
The mouth that did my heart beguile,
And spoke the great Word over me,
In the land beyond the sea.

I called his name, I called aloud,
 Alas! I called on him aloud;
And then he filled his hand with stour,
And threw it towards me in the air;
My mouse flew out, I lost my power!

My lusty strength, my power were gone;
 Power was gone, all was gone.
He will not let me love him more!
Of bell and whip and horse's tail
He cares not if I find a store.

But I am proud if he is fierce!
 I am proud as he is fierce;
I'll turn about and backward go,
If I meet again that Blackamoor,
And he'll help us then, for he shall know
I seek another paramour.

And we'll gang once more to yon town,
 Wi' better luck to yon town;
We'll walk in silk and cramoisie,
And I shall wed the provost's son,
My lady of the town I'll be.

For I was born a crowned king's child,
 Born and nursed a king's child,
King o' a land ayont the sea,
Where the Blackamoor kissed me first,
And taught me art and glamourie.

Each one in her wame shall hide
 Her hairy mouse, her wary mouse,
Fed on madwort and agramie,—
Wear amber beads between her breasts,
And blind-worm's skin about her knee.

The Lombard shall be Elspie's man,
 Elspie's gowden husband-man;
Nort shall take the lawyer's hand;
The priest shall swear another vow:
We'll dance again the saraband!

RICHARD WATSON DIXON

DREAM

I

With camel's hair I clothed my skin,
 I fed my mouth with honey wild;
And set me scarlet wool to spin,
 And all my breast with hyssop filled;
Upon my brow and cheeks and chin
 A bird's blood spilled.

I took a broken reed to hold,
 I took a sponge of gall to press;
I took weak water-weeds to fold
 About my sacrificial dress.

I took the grasses of the field,
 The flax was bolled upon my crine;
And ivy thorn and wild grapes healed
 To make good wine.

I took my scrip of manna sweet,
 My cruse of water did I bless;
I took the white dove by the feet,
 And flew into the wilderness.

II

The tiger came and played;
Uprose the lion in his mane;
The jackal's tawny nose
And sanguine dripping tongue
Out of the desert rose
And plunged its sand among;
The bear came striding o'er the desert plain.

Uprose the horn and eyes
And quivering flank of the great unicorn,
And galloped round and round;
Uprose the gleaming claw
Of the leviathan, and wound
In steadfast march did draw
Its course away beyond the desert's bourn.

I stood within a maze
Woven round about me by a magic art,
And ordered circle-wise:
The bear more near did tread,
And with two fiery eyes,
And with a wolfish head,
Did close the circle round in every part.

III

With scarlet corded horn,
With frail wrecked knees and stumbling pace,
The scapegoat came:
His eyes took flesh and spirit dread in flame
At once, and he died looking towards my face.

ST MARY MAGDALENE

Kneeling before the altar step,
 Her white face stretched above her hands;
In one great line her body thin
Rose robed right upwards to her chin;
Her hair rebelled in golden bands,
 And filled her hands;

Which likewise held a casket rare
 Of alabaster at that tide;
Simeon was there and looked at her,
Trancedly kneeling, sick and fair;
Three parts the light her features tried,
 The rest implied.

Strong singing reached her from within,
 Discordant, but with weighty rhymes;
Her swaying body kept the stave;
Then all the woods about her wave,
She heard, and saw, in mystic mimes,
 Herself three times.

Once, in the doorway of a house,
 With yellow lintels painted fair,
Very far off, where no men pass,
Green and red banners hung in mass
Above scorched woodwork wormed and bare,
 And spider's snare.

She, scarlet in her form and gold,
 Fallen down upon her hands and knees,
Her arms and bosom bare and white,
Her long hair streaming wild with light,
Felt all the waving of the trees,
 And hum of bees.

A rout of mirth within the house,
 Upon the ear of madness fell,
Stunned with its dread, yet made intense;
A moment, and might issue thence
Upon the prey they quested well,
 Seven fiends of hell.

She grovelled on her hands and knees,
 She bit her breath against that rout;
Seven devils inhabited within,
Each acting upon each his sin,
Limb locked in limb, snout turning snout,
 And these would out.

Twice, and the woods lay far behind,
 Gold corn spread broad from slope to slope
The copses rounded in faint light,
Far from her pathway gleaming white,
Which gleamed and wound in narrow scope,
 Her narrow hope.

She on the valley stood and hung,
 Then downward swept with steady haste;
The steady wind behind her sent
Her robe before her as she went;
Descending on the wind, she chased
 The form she traced.

She, with her blue eyes blind with flight,
 Rising and falling in their cells,
Hands held as though she played a harp,
Teeth glistening as in laughter sharp,

Flew ghostly on, a strength like hell's,
 When it rebels,

Behind her, flaming on and on,
 Rushing and streaming as she flew;
Moved over hill as if through vale,
Through vale as if o'er hill, no fail;
Her bosom trembled as she drew
 Her long breath through.

Thrice, with an archway overhead,
 Beneath, what might have seemed a tomb;
White garments fallen fold on fold,
As if limbs yet were in their hold,
Drew the light further in the gloom,
 Of the dark room.

She, fallen without thought or care,
 Heard, as it were, a ceaseless flow
Of converse muttered in her ear,
Like waters sobbing wide and near,
About things happened long ago
 Of utter woe.

THE WIZARD'S FUNERAL

For me, for me, two horses wait,
Two horses stand before my gate:
Their vast black plumes on high are cast,
Their black manes swing in the midnight blast,
Red sparkles from their eyes fly fast.
But can they drag the hearse behind,
Whose black plumes mystify the wind?
What a thing for this heap of bones and hair!
Despair, despair!
Yet think of half the world's winged shapes
Which have come to thee wondering:
At thee the terrible idiot gapes,
At thee the running devil japes,

And angels stoop to thee and sing
From the soft midnight that enwraps
Their limbs, so gently, sadly fair;—
Thou seest the stars shine through their hair.
The blast again, ho, ho, the blast!
I go to a mansion that shall outlast;
And the stoled priest who steps before
Shall turn and welcome me at the door.

ARTHUR WILLIAM EDGAR O'SHAUGHNESSY

ODE

We are the music-makers,
 And we are the dreamers of dreams,
Wandering by lone sea-breakers,
 And sitting by desolate streams;
World-losers and world-forsakers,
 On whom the pale moon gleams:
Yet we are the movers and shakers
 Of the world for ever, it seems.

With wonderful deathless ditties
We build up the world's great cities,
 And out of a fabulous story
 We fashion an empire's glory:
One man with a dream, at pleasure,
 Shall go forth and conquer a crown;
And three with a new song's measure
 Can trample an empire down.

We, in the ages lying
 In the buried past of the earth,
Built Nineveh with our sighing,
 And Babel itself with our mirth;

And o'erthrew them with prophesying
 To the old of the new world's worth;
For each age is a dream that is dying,
 Or one that is coming to birth.

PHILIP BOURKE MARSTON

NOT THOU BUT I

It must have been for one of us, my own,
 To drink this cup and eat this bitter bread.
 Had not my tears upon thy face been shed,
Thy tears had dropped on mine; if I alone
Did not walk now, thy spirit would have known
 My loneliness, and did my feet not tread
 This weary path and steep, thy feet had bled
For mine, and thy mouth had for mine made moan:
 And so it comforts me, yea, not in vain,
To think of thy eternity of sleep,
. To know thine eyes are tearless though mine weep:
 And when this cup's last bitterness I drain,
One thought shall still its primal sweetness keep—
Thou hadst the peace and I the undying pain.

THE OLD CHURCHYARD OF BONCHURCH

[*This old churchyard has been for many years slipping toward the sea,
which it is expected will ultimately engulf it.*]

The churchyard leans to the sea with its dead—
It leans to the sea with its dead so long.
Do they hear, I wonder, the first bird's song,
When the winter's anger is all but fled,

The high, sweet voice of the west wind,
The fall of the warm, soft rain,
When the second month of the year
Puts heart in the earth again?

Do they hear, through the glad April weather,
The green grasses waving above them?
Do they think there are none left to love them,
They have lain for so long there, together?
Do they hear the note of the cuckoo,
The cry of gulls on the wing,
The laughter of winds and waters,
The feet of the dancing Spring?

Do they feel the old land slipping seaward,
The old land, with its hills and its graves,
As they gradually slide to the waves
With the wind blowing on them from leeward?
Do they know of the change that awaits them,
The sepulchre vast and strange?
Do they long for days to go over,
And bring that miraculous change?

Or they love, perhaps, their night with no moonlight,
With no starlight, no dawn to its gloom,
And they sigh—''Neath the snow, or the bloom
Of the wild things that wave from our night,
We are warm, through winter and summer;
We hear the winds blow, and say—
"The storm-wind blows over our heads,
But we, here, are out of its way."'

Do they mumble low, one to another,
With a sense that the waters that thunder
Shall ingather them all, draw them under,
'Ah! how long to our moving, brother?
How long shall we quietly rest here,
In graves of darkness and ease?
The waves, even now, may be on us,
To draw us down under the seas!'

Do they think 'twill be cold when the waters
That they love not, that neither can love them,
Shall eternally thunder above them?
Have they dread of the sea's shining daughters,
That people the bright sea-regions
And play with the young sea-kings?
Have they dread of their cold embraces,
And dread of all strange sea-things?

But their dread or their joy—it is bootless:
They shall pass from the breast of their mother;
They shall lie low, dead brother by brother,
In a place that is radiant and fruitless,
And the folk that sail over their heads
In violent weather
Shall come down to them, haply, and all
They shall lie there, together.

THE BALLAD OF MONK JULIUS

Monk Julius lived in a wild countrie,
And never a purer monk than he
Was vowed and wedded to chastity.

The monk was fair, and the monk was young,
His mouth seemed shaped for kisses and song,
And tender his eyes, and gentle his tongue.

He loved the Virgin, as good monks should,
And counted his beads, and kissed the rood,
But great was the pain of his manlihood.

'Sweet Mary Mother,' the monk would pray,
'Take thou this curse of the flesh away—
Give me not up to the devil's sway.

'Oh, make me pure as thine own pure Son;
My thoughts are fain to be thine, each one,
But body and soul are alike undone.'

And, even while praying, there came between
Himself who prayed and Heaven's own Queen
A delicate presence, more felt than seen—

The sense of woman though none was there,
Her beauty near him, her breath on the air,
Almost the touch of her hand on his hair;

And when night came, and he fell on sleep,
Warm tears in a dream his eyes would weep,
For fair, strange shapes that he might not keep—

The fair dream-girls who leaned o'er his bed,
Who held his hand, and whose kisses were shed
On his lips, for a monk's too full and red.

Oh fair dream-women, with flowing tresses
And loosened vesture! Their soft caresses
Thrilled him through to his soul's recesses.

He woke on fire, with rioting blood,
To scourge himself and to kiss the rood,
And to fear the strength of his manlihood.

One stormy night, when Christ's birth was nigh,
When snow lay thick, and the winds were high
'Twixt the large light land and the large light sky,

Monk Julius knelt in his cell's scant light,
And prayed, 'If any be out to-night,
On Mother Mary, guide them aright.'

Then there came to his ears, o'er the wastes of snow,
The dreadest of sounds, now loud, now low,
The cry of the wolves, that howl as they go.

Then followed a light, quick tap at the door;
The monk rose up from the cell's cold floor,
And opened it, crossing himself once more.

A girl stood there, and 'The wolves!' she cried,
'No danger now, daughter,' the monk replied,
And drew the beautiful woman inside,

For fair she was, as few women are fair,
Most tall and shapely; her great gold hair
Crowned her brows, that as ivory were.

Her deep blue eyes were two homes of light,
Soft moons of beauty to his dark night—
What fairness was this to pasture sight?

But the sight was sin, so he turned away
And knelt him down yet again to pray;
But not one prayer could his starved lips say.

And as he knelt he became aware
Of a light hand passing across his hair,
And a sudden fragrance filled the air.

He raised his eyes, and they met her own—
How blue hers were, how they yearned and shone!
Her waist was girt with a jewelled zone,

But aside it slipped from her silken vest,
And the monk's eyes fell on her snowy breast,
Of her marvellous beauty the loveliest.

The monk sprang up, and he cried, 'Oh bliss!'
His lips sought hers in a desperate kiss;
He had given his soul to make her his.

But he clasped no woman—no woman was there,
Only the laughter of fiends on the air;
The monk was snared in the devil's own snare.

SEBASTIAN EVANS

THE SEVEN FIDDLERS

A Blue robe on their shoulder,
 And an ivory bow in hand,
Seven fiddlers came with their fiddles
 A-fiddling through the land,
And they fiddled a tune on their fiddles
 That none could understand.

For none who heard their fiddling
 Might keep his ten toes still,
E'en the cripple threw down his crutches,
 And danced against his will:
Young and old they all fell a-dancing,
 While the fiddlers fiddled their fill.

They fiddled down to the ferry—
 The ferry by Severn-side,
And they stept aboard the ferry,
 None else to row or guide,
And deftly steered the pilot,
 And stoutly the oars they plied.

Then suddenly in mid-channel
 These fiddlers ceased to row,
And the pilot spake to his fellows
 In a tongue that none may know:
'Let us home to our fathers and brothers,
 And the maidens we love below.'

Then the fiddlers seized their fiddles,
 And sang to their fiddles a song:
'We are coming, coming, O brothers,
 'To the home we have left so long,
'For the world still loves the fiddler,
 'And the fiddler's tune is strong.'

Then they stept from out the ferry
 Into the Severn-sea,

Down into the depths of the waters
 Where the homes of the fiddlers be,
And the ferry-boat drifted slowly
 Forth to the ocean free!

But where those jolly fiddlers
 Walked down into the deep,
The ripples are never quiet,
 But for ever dance and leap,
Though the Severn-sea be silent,
 And the winds be all asleep.

WILLIAM ALLINGHAM

THE FAIRIES
A CHILD'S SONG

Up the airy mountain,
 Down the rushy glen,
We daren't go a-hunting
 For fear of little men;
Wee folk, good folk,
 Trooping all together;
Green jacket, red cap,
 And white owl's feather!
Down along the rocky shore
 Some make their home,—
They live on crispy pancakes
 Of yellow tide-foam;
Some in the reeds
 Of the black mountain-lake,
With frogs for their watch-dogs,
 All night awake.

High on the hill-top
 The old King sits;
He is now so old and gray
 He's nigh lost his wits.

With a bridge of white mist
 Columbkill he crosses,
On his stately journeys
 From Slieveleague to Rosses;
Or going up with music
 On cold starry nights,
To sup with the Queen
 Of the gay Northern Lights.

They stole little Bridget
 For seven years long;
When she came down again
 Her friends were all gone.
They took her lightly back,
 Between the night and morrow,
They thought that she was fast asleep,
 But she was dead with sorrow.
They have kept her ever since
 Deep within the lakes,
On a bed of flag-leaves,
 Watching till she wakes.

By the craggy hill-side,
 Through the mosses bare,
They have planted thorn-trees
 For pleasure here and there.
Is any man so daring
 As dig one up in spite,
He shall find the thornies set
 In his bed at night.

Up the airy mountain,
 Down the rushy glen.
We daren't go a-hunting
 For fear of little men;
Wee folk, good folk,
 Trooping all together;
Green jacket, red cap,
 And white owl's feather!

JOHN PAYNE

SIBYL

This is the glamour of the world antique:
The thyme-scents of Hymettus fill the air,
And in the grass narcissus-cups are fair.
The full brook wanders through the ferns to seek
The amber haunts of bees; and on the peak
Of the soft hill, against the gold-marged sky,
She stands, a dream from out the days gone by.
Entreat her not. Indeed, she will not speak!
Her eyes are full of dreams; and in her ears
There is the rustle of immortal wings;
And ever and anon the slow breeze bears
The mystic murmur of the songs she sings.
Entreat her not: she sees thee not, nor hears
Aught but the sights and sounds of bygone springs.

OLIVER MADOX BROWN

LAURA'S SONG

Alas! who knows or cares, my love,
 If our love live or die,—
If thou thy frailty, sweet, should prove,
 Or my soul thine deny?
Yet merging sorrow in delight,
Love's dream disputes our devious night.

None know, sweet love, nor care a thought
 For our heart's vague desire,
Nor if our longing come to nought,
 Or burn in aimless fire;
Let them alone, we'll waste no sighs:
Cling closer, love, and close thine eyes!

Some Paintings

[Here the reader will find assembled the judgments and inter-
pretations of various—mostly well-known—Pre-Raphaelite
pictures by Ruskin, Swinburne and William Michael Rossetti.
The criticism is principally of an appreciative order, ranging
from the nice recognition of merit to enthusiastic encomium.
Among other things, it shows us the judicial discrimination of
Ruskin, writing with precise and exclamatory praise of some of
the lesser masterpieces of the Movement, while distinguishing,
in balanced manner, between the good and bad in Holman
Hunt's *The Scapegoat*, a largely-planned work of the highest
aspiration which none the less in part miscarries. But whether
these critics are concerned to applaud or correct, their tone is
very far removed from that of Dickens, *The Times* or the
Athenaeum who condemned the Pre-Raphaelite effort without
first bothering to understand its principles or *modus operandi*.

These critical comments should have an added value in that
they are geared to the reproductions in this book.]

JOHN RUSKIN

R.A. NOTES ON SOME P.R.S
[*Between 1855 and 1859 Ruskin published an annual series of 'Notes
on some of the Principal Pictures exhibited in the rooms of the Royal
Academy'. The four following are taken from those for 1856.*]

352. CHATTERTON. (*H. Wallis*) [1]
Faultless and wonderful: a most noble example of the great
school. Examine it well inch by inch: it is one of the pictures
[1] See plates.

which intend, and accomplish, the entire placing before your eyes of an actual fact—and that a solemn one. Give it much time. Mr Wallis has another very wonderful effort, 516, but it is harder and less successful. I suppose the face of Marvell is a portrait, but he does not look to me like a person who would return a bribe.

398. THE SCAPEGOAT. (*W. H. Hunt*)[1]

This singular picture, though in many respects faultful, and in some wholly a failure, is yet the one, of all in the gallery which should furnish us with most food for thought. First, consider it simply as an indication of the temper and aim of the rising artists of England. Until of late years, young painters have been mostly divided into two groups; one poor, hard-working, and suffering, compelled more or less, for immediate bread, to obey whatever call might be made upon them by patron or publisher; the other, of perhaps more manifest cleverness or power, able in some degree to command the market, and apt to make the pursuit of art somewhat complementary to that of pleasure; so that a successful artist's studio has not been in general a place where idle and gay people would have found themselves ill at ease, or at a loss for amusement. But here is a young painter, the slave neither of poverty nor pleasure,—emancipated from the garret, despising the green room, and selecting for his studio a place where he is liable certainly to no agreeable forms of interruption. He travels, not merely to fill his portfolio with pretty sketches, but in as determined a temper as ever mediæval pilgrim, to do a certain work in the Holy Land. Arrived there, with the cloud of Eastern War gathered to the north of him, and involving, for most men, according to their adventurous or timid temper, either an interest which would at once have attracted them to its immediate field, or a terror which would have driven them from work in its threatening neighbourhood, he pursues calmly his original purpose; and while the hills of the Crimea were white with tents of war, and the fiercest passions of the nations of Europe burned in high funeral flames over their innumerable dead, one peaceful English tent was pitched

[1] See plates.

beside a shipless sea; and the whole strength of an English
heart spent in painting a weary goat, dying upon its salt sand.

And utmost strength of heart it needed. Though the
tradition that a bird cannot fly over this sea is an exaggeration,
the air in its neighbourhood is stagnant and pestiferous, pol-
luted by the decaying vegetation brought down by the Jordan
in its floods; the bones of the beasts of burden that have died
by the 'way of the sea', lie like wrecks upon its edge, bared by
the vultures, and bleached by the salt ooze, which, though
tideless, rises and falls irregularly, swollen or wasted. Swarms
of flies, fed on the carcases, darken an atmosphere heavy at
once with the poison of the marsh, and the fever of the desert;
and the Arabs themselves will not encamp for a night amidst
the exhalations of the volcanic chasm.

This place of study the young English painter chooses. He
encamps a little way above it; sets his easel upon its actual
shore; pursues his work with patience through months of
solitude; and paints, crag by crag, the purple mountains of
Moab, and grain by grain, the pale ashes of Gomorrah.

And I think his object was one worthy of such an effort. Of
all the scenes in the Holy Land, there are none whose present
aspect tends so distinctly to confirm the statements of Scripture,
as this condemned shore. It is therefore exactly the scene of
which it might seem most desirable to give a perfect idea to
those who cannot see it for themselves; it is that also which
fewest travellers are able to see; and which, I suppose, no one
but Mr Hunt himself would ever have dreamed of making the
subject of a close pictorial study. The work was therefore worth
his effort, and he has connected it in a simple, but most
touching way, with other subjects of reflection, by the figure of
the animal upon its shore. This is, indeed, one of the instances
in which the subject of a picture is wholly incapable of explain-
ing itself; but, as we are too apt—somewhat too hastily—to
accept at once a subject as intelligible and rightly painted, if we
happen to know enough of the story to interest us in it, so we
are apt, somewhat unkindly, to refuse a painter the little
patience of inquiry or remembrance, which, once granted,
would enable him to interest us all the more deeply, because
the thoughts suggested were not entirely familiar. It is neces-

sary, in this present instance, only to remember that the view
taken by the Jews of the appointed sending forth of the scape-
goat into the Wilderness was that it represented the carrying
away of their sin into a place uninhabited and forgotten; and
that the animal on whose head the sin was laid, became
accursed; so that 'though not commanded by the law, they
used to maltreat the goat Azazel?—to spit upon him, and to
pluck off his hair'.[1] The goat, thus tormented, and with a
scarlet fillet bound about its brow, was driven by the multi-
tude wildly out of the camp: and pursued into the Wilderness.
The painter supposes it to have fled towards the Dead Sea, and
to be just about to fall exhausted at sunset—its hoofs entangled
in the crust of salt upon the shore. The opposite mountains,
seen in the fading light, are that chain of Abarim on which
Moses died.

Now, we cannot, I think, esteem too highly, or receive too
gratefully, the temper and the toil which have produced this
picture for us. Consider for a little while the feelings involved in
its conception, and the self-denial and resolve needed for its
execution; and compare them with the modes of thought in
which our former painters used to furnish us annually with
their 'Cattle pieces', or 'Lake scenes', and I think we shall see
cause to hold this picture as one more truly honourable to us,
and more deep and sure in its promise of future greatness in our
schools of painting, than all the works of 'high art' that since
the foundation of the Academy have ever taxed the wonder, or
weariness, of the English public. But, at the same time, this
picture indicates a danger to our students of a kind hitherto
unknown in any school; the danger of a too great intensity of
feeling, making them forget the requirements of painting as an
art. This picture, regarded merely as a landscape, or as a
composition, is a total failure. The mind of the painter has been
so excited by the circumstances of the scene, that, like a youth
expressing his earnest feeling by feeble verse (which seems to
him good, because he *means* so much by it), Mr Hunt has been
blinded by his intense sentiment to the real weakness of the
pictorial expression; and in his earnest desire to paint the

[1] Sermon preached at Lothbury, by the Rev. H. Melvill. (*Pulpit*, Thurs-
day, March 27th 1856.)

Scapegoat, has forgotten to ask himself first, whether he could paint a goat at all.

I am not surprised that he should fail in painting the distant mountains; for the forms of large distant landscape are a quite new study to the Pre-Raphaelites, and they cannot be expected to conquer them at first: but it is a great disappointment to me to observe, even in the painting of the goat itself, and of the fillet on its brow, a nearly total want of all that effective manipulation which Mr Hunt displayed in his earlier pictures. I do not say that there is absolute want of skill—there may be difficulties encountered which I do not perceive—but the difficulties, whatever they may have been, are not conquered: this may be very faithful and very wonderful painting—but it is not *good* painting; and much as I esteem feeling and thought in all works of art, still I repeat, again and again, a painter's business is first to *paint*. No one could sympathise more than I with the general feeling displayed in the 'Light of the World'; but unless it had been accompanied with perfectly good nettle-painting, and ivy painting, and jewel painting, I should never have praised it; and though I acknowledge the good purpose of this picture, yet, inasmuch as there is no good hair-painting, nor hoof-painting in it, I hold it to be good only as an omen, not as an achievement; and I have hardly ever seen a composition, left apparently almost to chance, come so unluckily: the insertion of the animal in the exact centre of the canvas, making it look as if it were painted for a sign. I can only, therefore, in thanking Mr Hunt heartily for his work, pray him, for practice sake, now to paint a few pictures with less feeling in them; and more handling.

448. AUTUMN LEAVES. (*J. E. Millais, A.*) [1]

By much the most poetical work the painter has yet conceived; and also, as far as I know, the first instance existing of a perfectly painted twilight. It is as easy, as it is common, to give obscurity to twilight, but to give the glow within its darkness is another matter; and though Giorgione might have come near the glow, he never gave the valley mist. Note also the subtle difference between the purple of the long nearer

[1] See plates.

range of hills, and the blue of the distant peak emerging beyond.

578. APRIL LOVE. (*A. Hughes*)[1]

Exquisite in every way: lovely in colour, most subtle in the quivering expression of the lips, and sweetness of the tender face, shaken, like a leaf by winds upon its dew, and hesitating back into peace.

WILLIAM MICHAEL ROSSETTI

THREE PICTURES BY MILLAIS AND HOLMAN HUNT

[*As art critic of ' The Spectator', W. M. Rossetti was able to defend the canvases of his Pre-Raphaelite friends when other critics were attacking them. It is interesting to compare what he says on Millais's ' Christ in the House of His Parents' with what Dickens wrote on it.*]

MILLAIS

Christ in the House of His Parents, ' *The Carpenter's Shop*' (1850).[1] Among the artists of the present year junior by position to the Academicians and Associates we find none assuming a more remarkable position in the Academy Exhibition than the really youngest—those who, but a year or two ago, were unknown to the walls of the exhibition, and who are now at any rate sufficiently *known* and argued of. Such an effect is not produced without striking qualities in its producers. Mediocrity or routine may excite attention, or even admiration, in its allotted season; but it never causes a ferment. It is spoken of, liked or disliked, or despised: but its origin and bearings are not debated; it is not the occasion of rancour or party-spirit. In truth, it would be a labour of supererogation to defend the works we allude to, among which are included those of Messrs. Hunt and Millais in this exhibition, from the charge of mediocrity, were it not that accusations, impossible in that

[1] See plates.

form against works palpably unlike the ordinary run, are launched at the assumed imitation of the elder examples in modern art; and what, in whatever shape, is imitation but the supplying of one's own deficiency in original power from the wealth of others? But these accusations, if examined, will be often found laboriously to refute themselves. The position once advanced that the works under review are imitations of the earlier Italians, it will be shown categorically that these imitators have missed everything possessed by their originals, and have aimed at many things they would have shrunk from with contempt and disgust; inasmuch as they did *not* elaborate shavings, did *not* represent disease, did *not* treat sacred subjects with an utter abnegation of sacred feeling, did *not* excel in the mere mechanism of art. We shall be enlightened with an essay on the preference due to perspective over the want of it; with an assertion that the early painters would have applied it to their practice but for the narrow limits of their executive knowledge; with a second assertion, consequent hereon, that these their imitators perversely and without any such excuse ignore perspective and the other accessions of power time has placed at their disposal: and the upshot of all will be that the living artist is a wonderful executant, and a miserable conceiver, blasphemous, profane, revolting, sickening; that his imitation, or servile copy, or attempt at galvanizing death, possesses not one quality of that which it imitates—whose characteristics are purity of feeling, devoutness, love,—and does possess in an eminent degree that for want of which its original fails of perfection. A school of men in a remote century, and a man in the present year, aim at sacred art. The one achieves the aim spiritually, and fails manually; the other, succeeding manually, achieves, because of the lowness of his ideas, something not spiritual, not even human, but brutal and degrading. And, judging from these premises, let us recognize the closeness of the copy!

It will not fail to be remembered that, in what is said above, we have been merely repeating accusations already made, and that iteration does not imply concurrence. Far indeed are we from adopting the same ground, or from arriving at the same conclusion; and most distinctly would we be understood to

dissent from the absurd charge of incorrect perspective. That Mr Millais's picture contains expression developed to a higher degree than beauty, and to a degree too merely circumstantial —that it contains limbs from nature not justifiable in being from ugly nature—we admit and lament: but that the purpose is elevated and distinctly sacred, the symbolism clear and consistent, we hope to prove. The text is this: 'And one shall say unto him "What are these wounds in thy hands?" Then he shall answer "Those with which I was wounded in the house of my friends."' The picture represents the interior of a carpenter's shop, not qualified, if we may trust our own perceptions, by squalor or dirt, but simply by the common and necessary adjuncts, tools, shavings, and planks of wood— and moreover by splendid colour and unique manipulation. Jesus, a child in the house of His parents, has wounded His *hand* with a nail, and the blood, dripping, has stained His *foot* also: smearings of it stain the *block of wood* that He was touching. His mother kneels to bind up the hurt, whom He kisses and comforts; while St Joseph, pausing from his work, draws back the hand, to look at it. The infant John the Baptist advances with a bowl of *water*—he who will in the future baptize the Lord into His ministry of suffering: St Elizabeth also is present, and an assistant to Joseph in his trade. Outside is a fold of sheep bleating into the air, unknowing yet dimly conscious. The picture tells thus, in typical utterance, of Jesus suffering and consoling; of the virgin mother loving and serving; of the Baptist ministering; of His flock. Is the idea unworthy? Of the treatment, having already expressed our dissent from its excesses, we need only say that it is throughout human—the types humanly possible and probable (never mere symbol independent of the action), and whether apt we have explained. And shall we at last say that the effect of the whole, once understood (and its meaning is sufficiently self-evident), is poetry?—poetry not of the judgment, but of the mind and the hand; poetry which informs the colour and the accessories, which is the art of the artist by and through which he works. And as for the blemishes, they would not be there but for the feebleness, the nonentity visible and concrete, against which they exaggerate re-action.

Ophelia (1852).[1] Shakspeare's description has been here strictly followed—

> 'Her clothes spread wide,
> And mermaidlike awhile they bore her up;
> Which time she chanted snatches of old tunes,
> As one incapable of her own distress,
> Or like a creature native and endued
> Unto that element.'

One of the most difficult subjects of a single figure within the range of art. There is madness to be represented—the madness of an ideal woman, whom we sympathize with almost as if we knew her—and the action of singing, and the calm 'mermaid-like' floating which is to end in pitiless death, and the unconsciousness of danger under conditions in which the spectator can only by an effort reconcile it to himself. These are points which tax equally the artist's conceptive power and his ability for truthful representation. Few persons can say conclusively in what exact position a woman would float in the resigned dreadless state of feeling imagined by Shakspeare. Probably Mr Millais cannot answer from his own observation; we certainly cannot from ours. But we find the position he has adopted highly conceivable as a fact, and a perfect emotional rendering. Ophelia is drifting slowly with the stream—the point where she fell being out of the picture; slowly the current carries the garland out of her hand, and bears onward the other flowers which she has let slip—funeral-flowers now; and slowly the water, which has covered her waist and arms, is reaching to her breast. The face is mad; yet where is the madness? We cannot tell; it is there, somewhere, because the painter is a poet. But the fair face is more than mad and calm as she floats singing to her grave, and the hands are more than helpless. There is a kind of fainting ecstasy in both, unconscious and inexplicable, as her eyes catch, perhaps, through some tangled canopy of leaves, a glimpse of the sky where she is to be 'a ministering angel',—a meaning unrealized to his own thought probably by the artist himself—the something more

[1] See plates.

than its express intention which we recognize in all intense poetry. The scene of this beautiful death is marvellous in painting: the willow-trunk with all its twigs and branches followed out—not a spray unexplained, not a leaf of the river-bank vegetation stuck in haphazard—the firm sharp rushes and the swaying duckweed—amid all which pierce the cheerful notes of a robin-redbreast. The starry detached look of the blossoms of a dog-rose bush is a subtle touch of nature. Of the water we are not so certain as of the other points of rendering: its colour is a dusky purple—we will not venture to say untruthful, but scarcely familiar to the eye, and the flow is so slight as hardly to enhance the appearance of liquidity. Nothing, however, can be more exquisite than the moveless transparency of that portion which closes round Ophelia's arm; and the delicacy, roundness, and firmness, of the flesh, the sweet features and soft bloom of the face, the living tenderness of the hands, and the rich floating hair amid which a single rose still blushes, are not to be surpassed.

HOLMAN HUNT

The Hireling Shepherd (1852).[1] Mr Hunt gives his picture this motto from 'King Lear'—

> 'Sleepest or wakest thou, jolly shepherd?
> Thy sheep be in the corn:
> And, for one blast of thy minikin mouth,
> Thy sheep shall take no harm.'

This motto is virtually the title of the picture, while its moral is expressed in the words 'The Hireling Shepherd'. The first quality which strikes in this work is its peculiar manliness, and spirit of healthful enjoyment. There is no laziness in it—no listless unappreciative copyism, or putting up with whatever comes first. The actions of all these sheep—each distinct and characteristic—have been watched and perfectly understood. In the country scene in which the incident takes place—from the marsh-mallows, elecampane-plant, and thickly-tangled grass of the foreground, to the August corn-field and pollard-

[1] See plates.

willows, and above all the elms and bean-stacks of the distance
—there is a feeling of the country, its sunny shadow-varied
openness, such as could hardly be more completely expressed;
a reality which makes the distance beyond the horizon as
conceivable and as actual to the spectator as it would be in
nature. It is evident from Mr Hunt's title that the seemingly
unimportant incident of the old song has been treated not
merely as a casual episode of shepherd life, but with a view to
its moral suggestiveness; and the same feeling is to be traced
throughout. The shepherd who neglects his flock is a 'hireling'
shepherd: he has caught a moth, which he is engaged in
showing to his lass, deeming it a fine opportunity for sidling up
to her and being idle; but it is a death's-head moth, and the ill
omen is hinted at in the girl's startled shrink, ever so slight and
involuntary though it be. She has a favourite lamb on her
knees, but gives it nothing wholesomer to eat than unripe
apples; meanwhile the sheep are in the full career of disorder.
That some of them 'be in the corn' we know by one whose
head protrudes above as he makes blind way onwards: the
bell-wether stops bleating for a moment at the entrance, but he
has already crossed the marsh; others hustle after; and in the
distance one or two have also caught the imitative impulse, and
are about to follow. The healthy-blooded rusticity of the figures
—robust, but (save in the girl's raw-beef feet) not coarse—hits
the happy medium; and the broad open-air sunlight effect has
been kept undeviatingly in view. This is the explanation of the
almost crimson redness of the faces; an explanation which,
after much indecision, we are disposed to hold sufficient. In the
object-painting we find cause for unmixed praise, except as
regards the nearer water, which is of too chalky and positive a
whiteness, and has a wiry appearance through retouching;
and the apples on the girl's lap are of a metallic green, scarcely
observable even in the unripe fruit.

ALGERNON CHARLES SWINBURNE

'BEATA BEATRIX' BY D. G. ROSSETTI

An unfinished picture of Beatrice (the Beata Beatrix of the Vita Nuova),[1] a little before death, is perhaps the noblest of Mr Rossetti's many studies after Dante. This work is wholly symbolic and ideal; a strange bird flown earthward from heaven brings her in its beak a full-blown poppy, the funereal flower of sleep. Her beautiful head lies back, sad and sweet, with fast-shut eyes in a deathlike trance that is not death; over it the shadow of death seems to impend, making sombre the splendour of her ample hair and tender faultless features. Beyond her the city and the bridged river are seen as from far, dim and veiled with misty lights as though already 'sitting alone, made as a widow'. Love, on one side, comes bearing in his hand a heart in flames, having his eyes bent upon Dante's; on the other side is Dante, looking sadly across the way towards Love. In this picture the light is subdued and soft, touching tenderly from behind the edges of Beatrice's hair and raiment; in the others there is a full fervour of daylight.

[1] See plates.

Criticism

[Swinburne and Michael William Rossetti feature in this short section, their words possessing the special importance of being pronouncements upon Pre-Raphaelite effort from the very midst of that charmed circle. Swinburne reveals himself as being of that species of critic whose powers of assessment are fuelled by enthusiasm, while W. M. Rossetti is seen as one capable of careful differentiation. What he has to say about the 'dangers of Pre-Raphaelitism' and certain re-iterated defects in Swinburne constitute some of the most balanced comments ever made upon these two subjects. Morris, less known as a critical reviewer than these two, provides an interesting comparison with Swinburne.]

WILLIAM MORRIS

'THE BLESSED DAMOZEL' AND 'JENNY'
[*The following extract is drawn from a review of D. G. Rossetti's 'Poems' which Morris contributed to 'The Academy', 14 May, 1870*]

Among pieces where the mystical feeling is by necessity of subject most simple and most on the surface, The Blessed Damozel should be noticed, a poem in which wild longing, and the shame of life, and despair of separation, and the worship of love, are wrought into a palpable dream, in which the heaven that exists as if for the sake of the beloved is as real as the earthly things about the lover, while these are scarcely less strange or less pervaded with a sense of his passion, than the things his imagination has made. The poem is as profoundly

161

sweet and touching and natural as any in the book, that is to say, as any in the whole range of modern poetry. At first sight the leap from this poem to the Jenny may seem very great, but there is, in fact, no break in the unity of the mind that imagined both these poems; rather one is the necessary complement to the other. The subject is difficult for a modern poet to deal with, but necessary for a man to think of; it is thought of here with the utmost depths of feeling, pity, and insight, with no mawkishness on the one hand, no coarseness on the other: and carried out with perfect simplicity and beauty. It is so strong, unforced, and full of nature, that I think it the poem of the whole book that would be most missed if it were taken away. With all this, its very simplicity and directness make it hard to say much about it; but it may be noticed, as leading to the consideration of one side of Mr Rossetti's powers, how perfectly the *dramatic* character of the soliloquizer is kept; his pity, his protest against the hardness of nature and chance never make him didactic, or more or less than a man of the world, any more than his shame of his own shame makes him brutal, though in the inevitable flux and reflux of feeling and habit and pleasure he is always seeming on the verge of touching one or other of these extremes. How admirably, too, the conclusion is managed with that dramatic breaking of day, and the effect that it gives to the chilling of enthusiasm and remorse, which it half produces and is half typical of; coming after the grand passage about lust that brings to a climax the musings over so much beauty and so many good things apparently thrown away causelessly.

ALGERNON CHARLES SWINBURNE

ON 'THE BLESSED DAMOZEL' and 'JENNY'

This paradisal poem [*The Blessed Damozel*], 'sweeter than honey or the honeycomb', has found a somewhat further echo than any of its early fellows, and is perhaps known where little

else is known of its author's. The sweet intense impression of it must rest for life upon all spirits that ever once received it into their depths, and hold it yet as a thing too dear and fair for praise or price. Itself the flower of a splendid youth, it has the special charm for youth of fresh first work and opening love; 'the dew of its birth is of the womb of the morning'; it has the odour and colour of cloudless air, the splendour of an hour without spot. The divine admixtures of earth which humanize its heavenly passion have the flavour and bloom upon them of a maiden beauty, the fine force of a pure first sunrise. No poem shows more plainly the strength and wealth of the workman's lavish yet studious hand. One sample in witness of this wealth, and in evidence of the power of choice and persistent search after perfection which enhance its price, may be cited; though no petal should be plucked out of this mystic rose for proof of its fragrance. The two final lines of the stanza describing the secret shrine of God have been reformed; and the form first given to the world is too fair to be wholly forgotten:—

> 'Whose lamps tremble continually
> With prayer sent up to God,
> *And where each need, revealed, expects*
> *Its patient period.'*

Wonderful though the beauty may be of the new imagination, that the spirits standing there at length will see their 'old prayers, granted, melt each like a little cloud', there is so sweet a force in the cancelled phrase that some students might grudge the loss, and feel that, though a diamond may have supplanted it, a ruby has been plucked out of the golden ring. Nevertheless, the complete circlet shines now with a more solid and flawless excellence of jewels and of setting. The sweetness and pathos and gracious radiance of the poem have been praised by those who have not known or noted all the noble care spent on it in rejection and rearrangement of whatever was crude or lax in the first cast; but the breadth and sublimity which ennoble its brightness and beauty of fancies are yet worthier of note than these. What higher imagination can be found in modern verse than this?

'From the fixed place of heaven she saw
 Time like a pulse shake fierce
 Through all the worlds.'

This grandeur of scale and sweep of spirit give greatness of
style to poetry, as well as sweetness and brightness. These
qualities, together with the charm of fluent force and facile
power, are apparent in all Mr Rossetti's work; but its height
of pitch and width of scope give them weight and price beyond
their own. . . .

Above them all in reach and scope of power stands the poem
of 'Jenny'; great among the few greatest works of the artist.
Its plain truth and masculine tenderness are invested with a
natural array of thought and imagination which doubles their
worth and force. Without a taint on it of anything coarse or
trivial, without shadow or suspicion of any facile or vulgar aim
at pathetic effect of a tragical or moral kind, it cleaves to
absolute fact and reality closer than any common preacher or
realist could come; no side of the study is thrown out or thrown
back into false light or furtive shadow; but the purity and
nobility of its high and ardent pathos are qualities of a moral
weight and beauty beyond reach of any rivalry. A divine pity
fills it, or a pity something better than divine; the more just
and deeper compassion of human fellowship and fleshly
brotherhood. Here is nothing of sickly fiction or theatrical
violence of tone. No spiritual station of command is assumed,
no vantage-ground of outlook from hills of holiness or heights
of moral indifference or barriers of hard contempt; no unction
of facile tears is poured out upon this fallen golden head of a
common woman; no loose-tongued effusion of slippery sym-
pathy, to wash out shame with sentiment. And therefore is 'the
pity of it' a noble pity, and worth the paying; a genuine sin-
offering for intercession, pleading with fate for mercy without
thought or purpose of pleading. The man whose thought is thus
gloriously done into words is as other men are, only with a
better brain and heart than the common, with more of mind
and compassion, with better eye to see and quicker pulse to
beat, with a more generous intellect and a finer taste of things;
and his chance companion of a night is no ruined angel or self-

immolated sacrifice, but a girl who plies her trade like any
other trade, without show or sense of reluctance or repulsion;
there is no hint that she was first made to fit better into a
smoother groove of life, to run more easily on a higher line of
being; that anything seen in prospect or retrospect rebukes or
recalls her fancy into any fairer field than she may reach by her
present road. All the open sources of pathetic effusion to which
a common shepherd of souls would have led the flock of his
readers to drink and weep and be refreshed, and leave the
medicinal wellspring of sentiment warmer and fuller from
their easy tears, are here dried up. This poor hireling of the
streets and casinos is professionally pitiable; the world's
contempt of her fellow tradeswomen is not in itself groundless
or unrighteous; there is no need to raise any mirage about her
as of a fallen star, a glorious wreck; but not in that bitterest cry
of Othello's own agony—'a sufferance panging as soul and
body's severing'—was there a more divine heat of burning
compassion than the high heart of a man may naturally lavish,
as in this poem, upon such an one as she is. Iago indeed could
not share it, nor Roderigo; the naked understanding cannot
feel this, nor the mere fool of flesh apprehend it; but only in
one or the other of these can all sense be dead of 'the pity of it'.

Every touch of real detail and minute colour in the study
serves to heighten and complete the finished picture which
remains burnt in upon the eyes of our memory when the work
is done. The clock ticking, the bird waking, the scratched pier-
glass, the shaded lamp, give new relief as of very light and
present sound to the spiritual side of the poem. How great and
profound is the scope and power of the work on that side, I can
offer no better proof than a reference to the whole; for no
sample of this can be torn off or cut out. Of the might of handi-
work and simple sovereignty of manner which make it so
triumphant a witness of what English speech can do, this one
excerpt may stand in evidence:—

> 'Except when there may rise unsought
> Haply at times a passing thought
> Of the old days which seem to be
> Much older than any history

That is written in any book;
When she would lie in fields and look
Along the ground through the blown grass,
And wonder where the city was,
Far out of sight, whose broil and bale
They told her then for a child's tale.

> 'Jenny, you know the city now.
> A child can tell the tale there, how
> Some things, which are not yet enrolled
> In market-lists, are bought and sold
> Even till the early Sunday light,
> When Saturday night is market-night
> Everywhere, be it dry or wet,
> And market-night in the Haymarket.'

The simple sudden sound of that plain line is as great and rare a thing in the way of verse, as final and superb a proof of absolute poetic power upon words, as any man's work can show. . . .

The whole work is worthy to fill its place for ever as one of the most perfect and memorable poems of an age or generation. It deals with deep and common things; with the present hour, and with all time; with that which is of the instant among us, and that which has a message for all souls of men; with the outward and immediate matter of the day, and with the inner and immutable ground of human nature. Its plainness of speech and subject gives it power to touch the heights and sound the depths of tragic thought without losing the force of its hold and grasp upon the palpable truths which men often seek and cry out for in poetry, without knowing that these are only good when greatly treated.

WILLIAM MICHAEL ROSSETTI

THE DANGERS OF PRE-RAPHAELITISM

The main dangers incidental to Præraphaelitism are three-fold. First, that, in the effort after unadulterated truth, the good of conventional rules should be slighted, as well as their evil avoided. Certainly it is not the first glance at any aspect of nature which will inform the artist of its most essential qualities, and indicate the mode of setting to work which will be calculated to produce the noblest as well as the closest representation possible. Minute study, however, such as the Præraphaelite artists bestow on their renderings from nature, cannot but result in the attainment of one order of truth. Besides this, it is a practical education; an apprenticeship to the more accurate learning of structure, to the more eclectic appreciation of effect; and tends in a more thorough manner to answer the purpose contemplated by the cramming education which they set aside. To the disadvantage under notice the Præraphaelite method of study from nature is liable, as are the executive and manipulative parts of a picture under any system—and for the same reason, that, in all, experience is required for perfect mastery; with this difference in its favour, that it has an absolute value of sincerity and faithfulness.

The second danger is that detail and accessory should be insisted on to a degree detracting from the importance of the chief subject and action. But this does not naturally, much less of necessity, follow from the Præraphaelite principle; which contemplates the rendering of nature as it is,—in other words, as it seems to the artist from his point of view, material and intellectual (for there is no separating the two things), and the principal, therefore, in its supremacy, the subordinate in its subordination. The contrary mistake is one to which only a low estimate, a semi-comprehension, of his own principles, can lead the Præraphaelite. It can scarcely, under any circumstances, be fallen into by a man of original or inventive power.

Thirdly, there remains the danger of an injudicious choice

of model; a danger of whose effect the Præraphaelite pictures offer more than one instance. All artists, indeed, unless they have emancipated themselves into so imaginative an attitude, far from the gross region of fact, as to dispense with models altogether, are exposed to it; for Virgin Maries and Cleopatras are not to be found for the wanting: but he who believes that 'ideal beauty consists partly in a Greek outline of nose, partly in proportions expressible in decimal fractions between the lips and chin, but partly also in that degree of improvement which he is to bestow upon God's works in general',[1] will find the difficulty yielding enough under the influence of idealism by rote. The Præraphaelite dares not 'improve God's works in general'. His creed is truth; which in art means appropriateness in the first place, scrupulous fidelity in the second. If true to himself, he will search diligently for the best attainable model; whom, when obtained, he must render as conformably as possible with his conception, but as truly as possible also to the fact before him. Not that he will copy the pimples or the freckles; but transform, disguise, 'improve', he may not. His work must be individual too—expressive of *me* no less than of *not-me*. He cannot learn off his ideal, and come prepared to be superior to the mere real. It is indeed a singular abuse to call that idealism which is routine and copy; a solecism which cries aloud to common sense for extinction. A young artist cannot enter the lists armed with an ideal prepense, though he may flaunt as his pennant the tracing-paper scored with fac-similes of another man's ideal. If he *will* have one, properly so called, he must work for it; and his own will not be born save through a long and laborious process of comparison, sifting, and meditation. The single-minded artist must, in the early part of his career, work according to his existing taste in actual living beauty, whether or not he means eventually to abide on

[1] As Mr Ruskin phrases it in his pamphlet, *Præraphaelitism*. His main principle, however—that our artists should, and that the Præraphaelites do, 'select nothing'—would in truth, as it appears to us, while it assumes to beg too much in their favour, carry their condemnation in it, could its application to them be verified. This we believe not to be the case; and that, indeed, strict non-selection cannot, in the nature of things, be taken as the rule in a picture of character or incident. But perhaps Mr Ruskin intended his exhortation in a much more limited sense than it bears, thus broadly put.

principle by unidealized fact; and tastes in beauty differ notoriously. The prescription-artist corrects his by Raphael and the Greeks. For the other there is nothing but watchfulness, study, and self-reliance. He is working arduously not to self-expression only, but to development.

THE DEFECT OF MONOTONY: A NOTE ON SWINBURNE
[*Following Morley's attack on Swinburne in the 'Saturday Review' in 1866, W. M. Rossetti, a friend of the poet, published his short booklength defence 'Poems and Ballads: A Criticism'. He did speak, however, of certain weaknesses in the poet's work, among which he located 'a certain degree of monotony'.*]

He does not feel sufficient interest in the multiform phases of human life to write about many different subjects, nor is his mind solicited by many 'occasions' into the frequent inditing of 'occasional poems', such as Göthe and Wordsworth, for instance, were both, in different ways, so prodigal of; and, on the other hand, his habit of potent writing does not undergo very notable modification according as the poetic subject or mood alters. His variations, both in thought and in style, are very mainly artistic variations, not personal. This may explain the consistency of our present remarks with those which have preceded regarding the extraordinary aptitude of Mr Swinburne for reproductive or assimilative work in a number of styles. That aptitude was truly stated, and it necessarily involves a large amount of differing subject-matter and treatment in the volume; and yet, as this impulse is constantly an artistic or literary one, it does not produce a total effect of variety or relief so great as might on first thoughts be supposed. We must not, however, press this charge of monotony too far. The poet who still a decidedly young man, has done a Greek tragedy, three other dramas, and a volume of narrative and lyrical poems marked by several absolute changes of style, and some other not insignificant variations of mood and tint, can only be termed monotonous in a subordinate, though we think it is not an unfair, sense.

A minor form of this monotony is the frequent, and indeed

continual, iteration of certain words, phrases, or images. Curious statistics might be compiled, out of Mr Swinburne's four volumes, of the number of recurrences of the idea of fire, with its correlatives, fiery, flame, flaming, etc.—of kissing, with its correlatives of lips, breasts, breast-flowers, stinging, bruising, biting, etc.—of wine, with spilling, draining, filling, pouring, etc.—of flowers, with flowery, flowering, bud, blossom, etc. (not very frequently the names of *particular* flowers, unless fragrant with some classic reminiscence, or charm of syllables) —of blood, with staining, tingling, bloody, red, crimson, dark, hot, etc.—of the sea, with images and epithets as inexhaustible as itself, and only less noble, for the sea-passion surges through the personal and poetic identity of Mr Swinburne; and several other of these typical or verbal *revenants* might with ease be picked out for enumeration. This is a matter of detail, which, though by no means strictly insignificant as such, would only deserve a passing glance from us, were not that particular detail, as we have intimated, a symptom of the comparative monotony of poetic excitation acting upon our author,—of his being somewhat unduly rapt in his own individual mental world, and not so open in *sympathy* (which lies at the root of most poetic debates) as to be freely and continually receptive, a fresh eye and mind to whatsoever of fresh appeals to either.

We go still further into detail in naming with some degree of blame his great love of alliteration: it is just one more evidence of the specially literary direction of his genius. Nor this alone: it pertains in especial to his powerful rhythmic and lyrical gift. In this connexion, rhythm and rhyme come first; next, assonance, which plays so large a part in Spanish metres; and alliteration is a sort of subordinate assonance, and partly in that character, we have no doubt, natural and dear to Mr Swinburne. It keeps up and reinforces, to his mind and ear, the lyrical flow and sequence of his metres under conditions in which other expedients are not immediately available. But, leaving this more recondite side of the question, alliteration is a device, a refinement, a dillettantism of literature. Writers who are bent upon saying things with the uttermost relief and pungency, with the 'curiousa felicitas' of the pen, can scarcely keep out of alliteration now and then—it comes so naturally

and temptingly, falls so pat, and so tartly reminds both the writer himself and the reader that it is no bungler at the pot-hooks and hangers, but an adept, an expert, who is wielding said pen. An alliteration is a sort of beeswing upon the fluent ink. There is no more thorough, more artistic master of this nicety than Mr Swinburne; but it must be confessed that his use of it runs into abuse, and becomes, if not absolutely a trick, certainly too salient a knack, of style.

Diaries and Autobiographical Writings

[The only difficulty in assembling this section was that of limiting to a few pages so abundant a wealth of material. In so far as the Movement was—as in the days of the P.R.B.—a secret or closed society; or a group of more widely spread individuals—as in its later phases—possessing an esoteric sense of elitism, the thoughts and actions of its members, to themselves or to each other, were matters of the liveliest interest. This feeling of belonging to an artistic aristocracy, such as the Bloomsbury Group possessed, is one which fosters the literature of letter, diary, and memoir-writing; and it is a literature of which the Pre-Raphaelites in their posterity might well be proud.]

WILLIAM MICHAEL ROSSETTI

DEATH OF 'THE GERM' AND ATTACKS ON THE P.R.B.

From 8th April, up to to-day Sunday July 21st [1850], I have neglected the P.R.B. Journal. My excuse is, plenty else to do—the impelling cause, idleness. But I hope henceforth to persevere.

Firstly, *The Gurm* [1] died with its fourth No.—leaving us a legacy of Tupper's bill—£33 odd, of which the greater part, I take it, remains still unpaid. Our last gasp was perhaps the best—containing Orchard's really wonderful *Dialogue*, Gabriel's sonnets on pictures, etc. etc.; with an etching—not

[1] As I have said elsewhere, we had a fancy for mispronounced 'Germ' as 'Gurm'.

very satisfactory in comparison with the standard of our promise—by Deverell. Placards were posted and paraded about daily before the Academy—but to no effect. *The Germ* was doomed, and succumbed to its doom.

Millais's sacred subject, his *Ferdinand and Ariel,* and his *Portrait of Mr Drury and his Grandchild*—Hunt's *Converted British Family sheltering a Christian Missionary from the Persecution of the Druids*—and Collinson's *Answering the Emigrant's Letter*— went to the Academy, where they are still exhibiting; Gabriel having at the last moment elected to send to the National Institution—formerly Free Exhibition. The 'Carpenter's Shop' of Millais, which has now become famous as 'No. 518', sold, the morning before sending in, for £350—Mr Farrer the picture-dealer being the purchaser. Hunt's picture and this are hung half on the line, the portrait on the line, and the *Ferdinand* on the ground; Collinson's, at a height where all its merits are lost. Millais's picture has been the signal for a perfect crusade against the P.R.B. The mystic letters, with their signification, have appeared in all kinds of papers; first, I believe, in a letter, *Town Talk and Table Talk,* in the *Illustrated News,* written by Reach, who must have derived his knowledge, we conjecture, from Munro.[1] But the designation is now so notorious that all concealment is at an end. *The Athenæum* opened with a savage assault [2] on Gabriel, who answered in a letter which the editor did not think it expedient to publish; and a conversation which Millais had with Frank Stone, and in which the latter (speaking of the picture) introduced several of the observations of *The Athenæum,* coupled with some other circumstances, make it tolerably evident that *he* was the author of that and subsequent critiques. In noticing Hunt and Millais, nearly a whole page was devoted to a systematic discussion of (assumed) P.R.B. principles—which F. S. rather overthrew and demolished than otherwise. In all the papers—*The Times, The Examiner, The Daily News,* even to Dickens's *Household Words,* where a leader was devoted to the P.R.B., and devoted them to the infernal gods—the attack on Millais has been most

[1] Angus B. Reach, a popular light writer of those days, and Alexander Munro the sculptor.
[2] An assault, but hardly a savage one.

virulent and audacious; in none more than in *A Glance at the Exhibition*, published by Cundall, and bearing manifold traces of a German source.[1] Indeed, the P.R.B. has unquestionably been one of the topics of the season. The 'notoriety' of Millais's picture may be evidenced by the fact, received from undoubted authority, of the Queen's having sent to have it brought to her from the walls of the R.A., which her recent accouchement had prevented her from visiting—Hunt's picture, Gabriel's, and Collinson's, remain unsold.

Not long after the opening of the Exhibitions the Brotherhood had the misfortune to lose one of its members—Collinson, who announced his resolution thus, in a letter addressed to Gabriel:—'Whit Monday.—Dear Gabriel, I feel that, as a sincere Catholic, I can no longer allow myself to be called a P.R.B. in the brotherhood sense of the term, or to be connected in any way with the magazine. Perhaps this determination to withdraw myself from the Brotherhood is altogether a matter of feeling. I am uneasy about it. I love and reverence God's faith, and I love His holy Saints; and I cannot bear any longer the self-accusation that, to gratify a little vanity, I am helping to dishonour them, and lower their merits, if not absolutely to bring their sanctity into ridicule. I cannot blame any one but myself. Whatever may be my thoughts with regard to their works, I am sure that all the P.R.B.'s have both written and painted conscientiously; it was for me to have judged beforehand whether I could conscientiously, as a Catholic, assist in spreading the artistic opinions of those who are not. I reverence—indeed almost idolize—what I have seen of the Pre-Raphael painters; [and this] chiefly because [they fill] [2] my cousin of Hannay's [3] who had been sitting for the head of Valentine. This week has been signalized by Woolner's taking a medallion of Carlyle, who gave him sittings the four first days of the week, and who of course furnishes material for any number of "nights' entertainments". . . .'

[1] It was written, I think, by Dr Waagen.
[2] The words in brackets indicate some flaw in the letter.
[3] Mr James Lennox Hannay, for many years a Police-magistrate, now retired.

FORD MADOX BROWN

LOOKING FOR LANDSCAPES

21st [Aug. 1855].—Looked out for landscapes this evening; but, although all around one is lovely, how little of it will work up into a picture! that is, without great additions and alterations, which is a work of too much time to suit my purpose just now. I want little subjects that will paint off at once. How despairing it is to view the loveliness of nature towards sunset, and know the impossibility of imitating it!—at least in a satisfactory manner, as one could do, would it only remain so long enough. Then one feels the want of a life's study, such as Turner devoted to landscape; and even then what a botch is any attempt to render it! What wonderful effects I have seen this evening in the hayfields! the warmth of the uncut grass, the greeny greyness of the unmade hay in furrows or tufts with lovely violet shadows, and long shades of the trees thrown athwart all, and melting away one tint into another imperceptibly; and one moment more a cloud passes and all the magic is gone. Begin tomorrow morning, all is changed; the hay and the reapers are gone most likely, the sun too, or if not it is in quite the opposite quarter, and all that *was* loveliest is all that is tamest now, alas! It is better to be a poet; still better a mere lover of Nature, one who never dreams of possession. . . .

26th.—Garden—and then to pay the visit to Seddon and his new wife. She is very sweet and beautiful, and he a lucky dog. . . .

27th.—Saw in twilight what appeared a very lovely bit of scenery, with the full moon behind it just risen; determined to paint it.

28th.—Garden all the morning: then prepared my traps to go and do the landscape. Got there by five, and found it looking dreadfully prosaic. However, began it,[1] and worked till half-past eight. . . .

[1] I suppose this is the picture called *The Hayfield*. [*Note by the editor William Michael Rossetti.*]

30th.— . . . Painted the sky of my little moon-piece. . . .

3rd August.— . . . To work about twelve, at the hand, from my own in the glass, out in back yard: quite spoilt. Too disgusted to go out to moon-piece. . . .

WILLIAM ALLINGHAM

DANTE GABRIEL AND FANNY CORNFORTH

Sunday, June 26 [1864].—To Warwick Crescent; Pen Browning, then enter the great Robert, who greets me warmly, and gives me 'Dramatis Personæ'. He commended *Bloomfield* with reservation—'Not so poetical as some of your things—but O so clever.' We talk of Tennyson, etc.

Down to Chelsea and find D. G. Rossetti painting a very large young woman, almost a giantess, as 'Venus Verticordia'. I stay for dinner and we talk about the old P. R. Bs. Enter Fanny, who says something of W. B. Scott which amuses us. Scott was a dark hairy man, but after an illness has reappeared quite bald. Fanny exclaimed, 'O my, Mr Scott *is* changed! He ain't got a hye-brow or a hye-lash—not a 'air on his 'ead!' Rossetti laughed immoderately at this, so that poor Fanny, good-humoured as she is, pouted at last—'Well, I know I don't say it right', and I hushed him up.

Monday, June 27.—Got down to Chelsea by half-past eight to D. G. R.'s. Breakfasted in a small lofty room on first floor with window looking on the garden. Fanny in white. Then we went into the garden and lay on the grass, eating strawberries and looking at the peacock. F. went to look at the 'chicking', her plural of chicken. Then Swinburne came in, and soon began to recite—a parody on Browning was one thing; and after him Whistler, who talked about his own pictures—Royal Academy—the Chinese painter-girl, Millais, etc. I went off to Ned Jones's, found Mrs. Ned and Pip, and F. Burton; talked of Christianity, Dante, Tennyson and Browning, etc. Enter Miss Hill and another lady, and Val Prinsep.

DANTE GABRIEL: HIS TASTES AND MANNERISMS

Thursday, September 19 [1867].—R. [D. G. Rossetti] and I look round the furniture brokers, he buys an old mirror and several other things 'for a song', but they will have to be done up, 'otherwise you fill your house with dinginess'. Then a walk. R. walks very characteristically, with a peculiar lounging gait, often trailing the point of his umbrella on the ground, but still obstinately pushing on and making way, he humming the while with closed teeth, in the intervals of talk, not a tune or anything like one but what sounds like a *sotto voce* note of defiance to the Universe. Then suddenly he will fling himself down somewhere and refuse to stir an inch further. His favourite attitude—on his back, one knee raised, hands behind head. On a sofa he often, too, curls himself up like a cat. He very seldom takes particular notice of anything as he goes, and cares nothing about natural history, or science in any form or degree. It is plain that the simple, the natural, the naïve are merely insipid in his mouth; he must have strong savours, in art, in literature and in life. Colours, forms, sensations are required to be pungent, mordant. In poetry he desires spasmodic passion, and emphatic, partly archaic, diction. He cannot endure Wordsworth, any more than I can S. He sees nothing in Lovelace's 'Tell me not, Sweet, I am unkind'. In foreign poetry, he is drawn to Dante by inheritance (Milton, by the way, he dislikes); in France he is interested by Villon and some others of the old lyric writers, in Germany by nobody. To Greek Literature he seems to owe nothing, nor to Greek Art, directly. In Latin poetry he has turned to one or two things of Catullus for sake of the subjects. English imaginative literature—Poems and Tales, here lies his pabulum: Shakespeare, the old Ballads, Blake, Keats, Shelley, Browning, Mrs Browning, Tennyson, Poe being first favourites, and now Swinburne. *Wuthering Heights* is a Koh-i-noor among novels, *Sidonia the Sorceress* 'a stunner'. *Any* writing that with the least competency assumes an imaginative form, or any criticism on the like, attracts his attention more or less; and he has discovered in obscurity, and in some cases helped to rescue from it, at least in his own circle, various unlucky books; those, for

example, of Ebenezer Jones and Wells, authors of *Joseph and His Brethren* and *Stories after Nature*. About these and other matters Rossetti is chivalrously bold in announcing and defending his opinions, and he has the valuable quality of knowing what he likes and sticking to it. In Painting the Early Italians with their quaintness and strong rich colouring have magnetised him. In Sculpture he only cares for picturesque and grotesque qualities, and of Architecture as such takes, I think, no notice at all.

WILLIAM BELL SCOTT

'THE MYSTERIOUS LETTERS P.R.B.'
[*In Chapter XXI of his Autobiographical Notes, Bell Scott speaks of his first encounter with the Brotherhood*]

The very first years of my acquaintance with the poet D. G. R., and the set of young innovating artists to which he belonged, I had a visit from his brother William. In the summer of 1848 he appeared in Newcastle, and it was only by seeing the mysterious letters P.R.B. on the address of his letters that I became aware of the existence of the bond of union which rose to be so celebrated in a year or two, much to their own surprise. 'It's only a sort of club some of Gabriel's and Hunt's friends and other young fellows have planned out, and I, the youngest of the set, but no artist, am to be secretary. It is only friendly, we are making a start on a new line,' he continued. I thought no more about it till he was leaving, when he suggested that the brotherhood was going to print something I might hear of. He wanted to keep it to himself at that moment, so I said no more; but I found afterwards that the combination was extremely limited and heterogeneous, and it was only the name of Millais, the favourite of the Academy and miracle of precocity, and the singularity of their cognomen, that gave them immediate notoriety. One year, or perhaps two, after my first visit to Hunt and Rossetti, I was in Millais's studio, when

I observed a print hanging there framed. It was an Italian engraving, inscribed 'From Nature', by Agostino Lauro at Turin, dated 1845, and called 'Meditacione', representing a girl seated among shrubs and trees. Every leaf of every plant, nay, the two halves of every leaf, radiating from the centre fibre even of those in shade, were elaborated, and the pattern on the dress of the girl was in every part exactly made out. I was arrested by this print when Millais quitted his easel and approached. 'Ha! you've observed that, have you; that's P.R.B. enough, is it not? We haven't come up to that yet. But,' he went on, 'I for one won't try; it's all nonsense; of course nature's nature, and art's art, isn't it? One could not live doing that!' So soon had the principal executive tenet of the bond fallen off from the ablest expert of the three painters who were giving the new school its renown.

D. G. ROSSETTI AND HOLMAN HUNT AT WORK
[*from Chapter XIX of the author's 'Autobiographical Notes'*]

[1849] I found Gabriel (who was never called by any other name than Gabriel by his relatives and intimate friends) and his fellow-artist, who was no other than Holman Hunt, whose studio it was: a room not very commodious for two, furnished with the then inevitable lay-figure in all its loveliness. They were both working in the quite novel manner of elaboration as yet untalked of, kept secret apparently, but which even next year began to make a noise in the world and to raise a critical clamour, principally through the work of Millais. Unprepared for any peculiar character, I looked upon these two as following their lights and imitating the early manner so well known and much beloved by me in the early performances of the Low Countries I had then lately seen in the Belgian Galleries. Holman Hunt's picture was the 'Oath of Rienzi over the Body of his Brother', designed with every modern advantage in composition and expression. I saw at once he was an educated artist, and a very skilful one; still there was the Flemish elaboration of the primitive days: his lay-figure was mounted on a table, kneeling, and I was made to observe that the chain

mail in his picture was articulated perfectly, and as an armourer would construct it, every ring holding four other rings in its grasp—a miracle of elaboration.

Rossetti, the man I had come to see, was painting a subject wholly in the spirit of the poems which had reached me under a cover inscribed 'Songs of the Art-Catholic'. It was 'The Girlhood of the Virgin'. I thought at the first moment: 'He is an Italian, a Romanist of course, worshipping that young Nazarene, the "mother of the body of Christ", painting her and St Anne from his own sister and mother; and here was St Joseph without any joinery work, he had apparently turned *vigneron*—a prettier trade; and here too was really the third person of the Trinity—not the symbolic dove with outspread wings that we moderns see in Masonic diplomas and what not, but a natural dove, only within a nimbus, sitting on the vine.' The propensity to laugh was strong in a Scotchman who had absorbed in juvenile years the *Philosophical Dictionary*, although he had tried his hand poetically in a semi-mediæval poem, or four poems, called *Four Acts of Saint Cuthbert*. But admiration of this daring performance of a boy turning what was naturally a lyrical subject into a picture, and this his first adventure in painting, was something quite new. I saw at once that he had possibly never before used even a piece of chalk. He was painting in oils with water-colour brushes, as thinly as in water-colour, on canvas which he had primed with white till the surface was as smooth as cardboard, and every tint remained transparent. I saw at once, too, that he was not an orthodox boy, but acting purely from the æsthetic motive: the mixture of genius and dilettanteism of both the men shut me up for the moment, and whetted my curiosity for all the year till I should see them again.

Holman Hunt's picture had no pre-Reformation character in the subject or invention, only in the manner, in the elaborated detail; he had actually introduced a fly, as we see done in some early Flemish portraits, to show how minute the artist's hand could go.[1] These early Flemish portraits were painted

[1] I should like to see this picture again, to make sure that the fly, which was somewhere on the foreground, very near the edge, is still there. If it is not, he has eradicated it by some later impulse.

exactly at the period of the invention and sudden perfection of engraving, when the production of such an example of miniature detail as the 'Knight with Death and the Devil' astounded the northern art-world; and here it was again affecting painting. Every movement has its genesis, as every flower its seed; the seed of the flower of Pre-Raphaelism was photography. The seriousness and honesty of motive, the unerring fatalism of the sun's action, as well as the perfection of the impression on the eye, was what it aspired to. History, genre, mediævalism, or any poetry or literality, were allowable as subject, but the execution was to be like the binocular representations of leaves that the stereoscope was then beginning to show. Such was my conclusion on thinking over that first visit to Hunt's studio—conclusion as to the execution, that is to say.

JAMES SMETHAM

D. G. ROSSETTI, DANTE, BEATRICE

24th March 1860.

A letter from Rossetti. He is coming to see us before long. He has some fine things at the Hogarth Club, to which he gave me a ticket. . . .[Edward Burne-Jones] . . . Rossetti has Dante and Beatrice in Paradise; a glorious thing. The sky is gilt, the name is put on scrolls ('*Hortus Eden*') in the sky, and the names are written near the heads. The background is a rich rose hedge, with birds of Paradise pecking roses, and nestling, and singing birds singing lustily. There is a floor of tall buttercups, hyacinths, and lilies, among which the five figures are treading ankle deep. Coloured calm, 'above all pain, all passion, and all pride', reigns in the atmosphere. There they walk in knowledge, love, and beauty evermore.

'*ABSOLUTE* IMITATION OF NATURE . . . IS IMPOSSIBLE' 1868

About 1849 I read Ruskin, and saw the logical and verbal force of what he said, and determined to put it to the proof, painting several pictures in the severely imitation style, and deriving much of both profit and pleasure from it. After a fair trial I saw that words and pigments are not at all the same things. As he, after fifteen years close study of painting, found his eyes opened to the Venetians, who upset half his former theories, so I by sheer experiment saw that truth for the nineteenth century art lay between Holman Hunt's work and Titian's work; that *absolute* imitation of nature with twelve pigments is simply impossible, that there was a flaw in the logic about 'resemblance to nature', that the true basis of a painting may be defined thus: 'the expression of the feeling of an individual man about nature, needing some good amount of culture on the part of the observer to understand his language', must therefore for ever be laid open to endless varieties of opinion, being in fact a Fine (aerial, attenuated, subtle, imponderable) Art. Then with much thankfulness to John Ruskin for his great services in so eloquently calling the attention of the British public to the subject, and for many wonderful fruits of his own observations of nature and pictures, I retired once again into my own lines of operation, conscious of my position, and disabused of many early dreams of perfectibility and public recognition of Art.

Parody and Repercussion

[This last section provides a natural tail-piece to the book. In it, the criticism of the Pre-Raphaelites is shown to have come full circle. Praise, awe and wonder (the notes of many critics during its hey-day) have given way to that sense of the ridiculous with which the Movement was welcomed at its inception. But, now, instead of sharp hostility, the critics' sense of the ridiculous is informed by tempered humour even if—as with Robert Ross's words on Holman Hunt—the tone is not invariably sympathetic.]

ALGERNON CHARLES SWINBURNE

SONNET FOR A PICTURE

That nose is out of drawing. With a gasp,
 She pants upon the passionate lips that ache
 With the red drain of her own mouth, and make
A monochord of colour. Like an asp,
One lithe lock wriggles in his rutilant grasp.
 Her bosom is an oven of myrrh, to bake
 Love's white-warm shewbread to a browner cake.
The lock his fingers clench has burst its hasp.

The legs are absolutely abominable.
 Ah! what keen overgust of wild-eyed woes
 Flags in that bosom, flushes in that nose?

Nay! Death sets riddles for desire to spell,
 Responsive. What red hem earth's passion sews,
But may be ravenously unripped in hell?

'ALGERNON CHARLES SIN-BURN'
(ARTHUR CLEMENT HILTON)

'OCTOPUS': A NEW VIEW OF SWINBURNE'S 'DOLORES'

Strange beauty, eight-limbed and eight-handed,
 Whence camest to dazzle our eyes?
With thy bosom bespangled and banded
 With the hues of the seas and the skies;
Is thy home European or Asian,
 O mystical monster marine?
Part molluscous and partly crustacean,
 Betwixt and between.

Wast thou born to the sound of sea trumpets?
 Hast thou eaten and drunk to excess
Of the sponges—thy muffins and crumpets,
 Of the seaweeds—thy mustard and cress?
Wast thou nurtured in caverns of coral,
 Remote from reproof or restraint?
Art thou innocent, art thou immoral,
 Sinburnian or Saint?

Lithe limbs, curling free, as a creeper
 That creeps in a desolate place,
To enrol and envelop the sleeper
 In a silent and stealthy embrace;
Cruel beak craning forward to bite us,
 Our juices to drain and to drink,
Or to whelm us in waves of Cocytus,
 Indelible ink!

Oh breast, that 'twere rapture to writhe on!
 Oh arms 'twere delicious to feel
Clinging close with the crush of the Python,
 When she maketh her murderous meal!
In thy eight-fold embraces enfolden,
 Let our empty existence escape;
Give us death that is glorious and golden,
 Crushed all out of shape!

Ah thy red lips, lascivious and luscious,
 With death in their amorous kiss!
Cling round us, and clasp us, and crush us,
 With bitings of agonized bliss;
We are sick with the poison of pleasure,
 Dispense us the potion of pain;
Ope thy mouth to its uttermost measure,
 And bite us again!

 Written at the Crystal Palace Aquarium.

ROBERT ROSS

'PIETISTIC EJACULATIONS'—A LATE WORD ON HOLMAN HUNT

For the essence of beauty there is nothing of Mr Holman Hunt's to compare with Rossetti's 'Beloved' or the 'Blue Bower'; and you could name twenty of the poet's water-colours which, for design, invention, devious symbolism, and religious impulse, surpass the finest of Mr Hunt's most elaborate works. Even in the painter's own special field—the symbolised illustration of Holy Writ—he is overwhelmed by Millais with the superb 'Carpenter's Shop'. [1] . . . In Mr Holman Hunt we lost another Archdeacon Farrar. Then, in the sublimation of uglitude, Madox-Brown, step-father of the

[1] See plates.

Pre-Raphaelites (my information is derived from a P.R.B. aunt), was an infinitely greater conjurer. Look at the radiant painting of 'Washing of the Feet' in the Tate Gallery; is there anything to equal that masterpiece from the brush of Mr Holman Hunt? The 'Hireling Shepherd' [1] comes nearest, but the preacher, following his own sheep, has strayed into alien corn, and on the cliffs from which is ebbing a tide of nonconformist conscience. Like his own hireling shepherd, too, he has mistaken a phenomenon of nature for a sermon.

One of the great little pictures, 'Claudio and Isabella', proves, however, that *once* he determined to be a painter. In the 'Lady of Shalott' he showed himself a designer with unusual powers akin to those of William Blake. Still, examined at a distance or close at hand, among his canvases do we find a single piece of decoration or a picture in the ordinary sense of the word? My definition of a religious picture is a painted object in two dimensions destined or suitable for the decoration of an altar or other site in a church, or room devoted to religious purposes; if it fails to satisfy the required conditions, it fails as a work of art. Where is the work of this so-called religious painter which would satisfy the not exacting conditions of a nonconformist or Anglican place of worship? You are not surprised to learn that Keble College mistook the 'Light of the World' for a patent fuel, or that the background of the 'Innocents' was painted in 'the Philistine plain'. . . . What are they if we cannot place them in the category of pictures? They are pietistic ejaculations—ticked-up maxims in pigment of extraordinary durability—counsels of perfection in colour and conduct. Of all the Pre-Raphaelites, Mr Hunt will remain the most popular. He is artistically the scapegoat of that great movement which gave a new impulse to English art, a scapegoat sent out to wander by the dead seas of popularity. . . . Yes, he has a message for every one. . . . He is a missing link between art and popularity. He symbolises the evangelical attitude of those who would go to German Reed's and the Egyptian Hall, but would not attend a theatre. . . . When modern art, the brilliant art of the 'sixties, was strictly

[1] See plates.

excluded from English homes except in black and white magazines, engravings from the 'Finding of Christ in the Temple' and the 'Light of the World' were allowed to grace the parlour along with 'Bolton Abbey', the 'Stag at Bay', and 'Blücher meeting Wellington'.

Biographical and Critical Notes

WILLIAM ALLINGHAM (1824–89): Born in Ireland, but finally installed in literary London, Allingham's output of poetry was large, his *Collected Poems* appearing in six volumes between 1883 and 1893. His most ambitious work in verse, a narrative entitled 'Laurence Bloomfield in Ireland' (1864), was admired by Turgenev. Gladstone quoted from it in the House, and granted him a Civil List pension of £60 per annum. Today, apart from a handful of poems, he lives through the selection from his diaries and notes published by his wife, the water-colourist Helen Paterson, and Dolly Radford in 1907; a repository of anecdotes and reminiscences concerning eminent nineteenth-century figures in art and literature cultivated by him. Holman Hunt speaks of him as 'well known in our circle', and his accounts of D. G. Rossetti are some of the most vivid we possess.

Of Protestant and Plantation stock, Allingham considered Ireland 'an ungrateful soil for the cultivation of the higher belles lettres'. There is something ironical about this statement, since—through *The Fairies* and such-like pieces—he can be regarded as something of a link between the Pre-Raphaelites and the Celtic Twilight writers of the '90s. He is also a regional poet of not a little importance and charm; and Yeats declared that 'he sang Ballyshannon not Ireland', remarking that to 'feel the entire fascination of his poetry, it is perhaps necessary to have spent one's childhood . . . in one of those little sea-board Connaught towns' (*Poets and Poetry of the Century*, ed. Alfred H. Miles, 1892).

Birbeck Hill edited D. G. Rossetti's letters to Allingham in 1897, and there is a good all-round essay on him entitled 'Down a Rushy Glen' in Geoffrey Grigson's volume *Poems and*

Poets (1969). Allingham wrote about himself in certain passages of his pseudonymous work *Rambles in England and Ireland* by Patricia Walker (1873). *Letters from W. Allingham to E. B. Browning* (1914) should also be consulted.

FORD MADOX BROWN (1821–93): Brown has been described as probably the most important single influence in the Pre-Raphaelite movement (Raymond Watkinson: *Pre-Raphaelite Art and Design*, 1870) even though he was never a member of the R.P.B. After many years studying painting in Europe he returned to England in 1845, and in 1848 D. G. Rossetti asked him to give him lessons. Just how far the master was influenced by Rossetti and the doctrine of his P.R.B. friends can be seen from a study of Brown's painting after this date, as well as by numerous passages from his Journals edited by W. M. Rossetti and included in the latter's *Pre-Raphaelite Letters and Diaries* (1900). Briefly, the Pre-Raphaelite influence on Brown may be said to have furthered his own conscientious industry, particularly in the painting of detail, and his own innate poetic imagination—one which, unlike that of D. G. Rossetti and Burne-Jones, was controlled by a vigorous reality-principle.

He contributed a sonnet *The Love of Beauty* to *The Germ* as well as an essay *On the Mechanism of a Historical Picture* which remained unfinished because of that magazine's demise. James D. Merritt's anthology *The Pre-Raphaelite Poem* (N.Y. 1966) contains a further sonnet *For the Picture,* '*The Last of England*'.

The fullest records of him are to be found in F. M. Hueffer's *Ford Madox Brown: A Research of His Life and Work* (1896) and Mary Bennett's catalogue *Ford Madox Brown 1821–1893* of a loan exhibition organized by the Walker Art Gallery, Liverpool, 1964.

OLIVER MADOX BROWN (1855–74): Son of the painter Ford Madox Brown. 'The wonderful precocity of his genius', as Richard Garnett termed it, manifested itself almost in his boyhood—a factor no doubt encouraged by the number of talented people often to be found in his father's company. In his teens he was exhibiting pictures of marked originality at

the Royal Academy, and in the winter of 1871–2 he wrote the opening chapters of a novel dealing with illicit love. Under a publisher's blandishments, the harsh tale was castrated into tameness and given a conventional ending. In this form it was issued as *Gabriel Denver* by the firm of Smith, Elder & Co. in November 1873. The unmutilated version of the story, under its original title of *The Black Swan,* is to be found in his two-volume *Literary Remains* published posthumously in 1876. This last-mentioned work also contained an unfinished tale *The Dwale Bluth* (the Devonshire name for the deadly nightshade) as well as certain pieces of verse.

D. G. Rossetti, Thomas Gordon Hake, Philip Bourke Marston and Theodore Watts-Dunton all commemorated him in poems, while John Payne described him as 'not one of those whom time effaces'. 'It is quite possible,' wrote Hugh Walker of this young man not spared to complete his twentieth year, 'that more was buried in that early grave than any other except the grave of Chatterton himself' (*The Literature of the Victorian Era,* 1910).

There is a fine portrait of Oliver Madox Brown at the age of five in a picture entitled *The English Boy* by his father Ford Madox Brown. A life of him by John H. Ingram appeared in 1883.

EDWARD BURNE-JONES (1833–98): Abandoning the notion he had entertained at Oxford of founding a semi-monastic brotherhood and taking Holy Orders, Burne-Jones decided with William Morris to devote himself to art. Pre-Raphaelite painting came as a revelation to him, 'Until I saw Rossetti's work and Fra Angelico's I never supposed that I liked painting,' he declared. 'I hated the kind of stuff that was going in them' (*Memorials*). In terms of draughtsmanship Burne-Jones classicizes the Romantic anatomy of Rossetti's figures while extending the mystical mediaeval mood of one aspect of Pre-Raphaelitism. 'I mean by a picture,' he once stated, 'a beautiful romantic dream of something that never was, never will be.'

For some twenty years, he was a resolute opponent of the Royal Academy, yet had little difficulty in becoming a popular

painter. George Moore reports in his *Modern Painting* (1893) how 'Mr Agnew gave him a commission of fifteen thousand pounds—the largest, I believe, ever given—to paint four pictures, the 'Briar Rose' series', and how he was then elected an Associate of the R.A., resigning this distinction seven years later.

He contributed a story *The Cousins* and an essay on Thackeray's *The Newcomes* to *The Oxford and Cambridge Magazine*, married the altogether charming Georgina Macdonald (who later compiled his *Memorials*) in 1860, and was created a baronet in 1897.

There is an attractive account of his life and art in Lord David Cecil's Andrew Mellon Lectures *Visionary and Dreamer*, 1969, while severe and humorous criticism of his painting is made by Quentin Bell in *Victorian Artists*, 1967. There is an excellent portrait of Burne-Jones painted when the subject was thirty-seven by G. F. Watts. The first full critical study of him was Malcolm Bell's *Sir Edward Burne-Jones: A Record and Review*, 1898. *Drawings of Burne-Jones* with an introduction by T. Martin Wood was published in 1906.

ROBERT WILLIAMS BUCHANAN—'THOMAS MAIT-LAND' (1841–1901): Buchanan journeyed to London from Glasgow with the Scots poet David Gray to embark on a literary career. It was his later loyal staunchness to the memory of this friend which was to heighten, if it did not spark off, the war between Buchanan and the Pre-Raphaelites. Swinburne had spoken in derogatory fashion of Gray; and in an unsigned article in *The Athenaeum* Buchanan had reviewed *Poems and Ballads* (1866) accusing him of being 'unclean for the sake of uncleanness'. William Michael Rossetti then waded in on Swinburne's side, speaking of Buchanan as a 'poor and pretentious poetaster' (*Swinburne's Poems and Ballads: A Criticism*, 1866). Other authors became involved, and in 1871 Buchanan launched his broadside in an article in the *Contemporary Review* entitled *The Fleshly School of Poetry* (under the pseudonym of Thomas Maitland). Other names and issues were drawn into the fray, and finally, in a legal action in 1876 between Buchanan and Swinburne, the former was awarded

£150 damages. But with this victory he earned the scorn of the whole Pre-Raphaelite group as well as of the critics of the time. Buchanan's own admission in a letter that he was 'guilty to one instinct of recrimination' and that he was resolved 'to have no mercy' robs his criticism of such integrity as he might have claimed for it.

Controversy was not the only string to Buchanan's bow. Acclaimed in his day for his novels and plays, he hoped to obtain the Laureateship left vacant at Tennyson's death, but Alfred Austin, a rival candidate, happened to know Lord Salisbury, the Premier, better.

There is a witty dismissive essay on him by Arthur Symons in *Studies in Prose and Verse* (1904) and a biography *Robert Buchanan* by Harriett Jay (1903) whom the poet had adopted when she was young.

RICHARD WATSON DIXON (1833–1900) : Dixon, later an honorary Canon of Carlisle Cathedral, first associated with Morris, Burne-Jones and others of the Pre-Raphaelite Group as an Oxford undergraduate. Besides contributing much information and many reminiscences on the lives of his friends Burne-Jones and Morris, he published seven volumes of verse together with his six-volume life-work *History of the Church of England* from the Abolition of the Roman Jurisdiction (1878–1902). He met Gerard Manley Hopkins when the latter was a pupil at Highgate School where he was then teaching, and they corresponded in later years on poetic and prosodic matters, their letters being published in 1935.

Writing to his cousin Maria Choyce in 1855, Burne-Jones pictures his friend Dixon as 'a most interesting man . . . dark-haired and pale-faced, with a beautiful brow and a deep, melancholy voice'. Mary Coleridge thought his *Song* ('The feathers of the willow') one of the great lyrics of the nineteenth century, and John Heath-Stubbs has noticed in his poem on Mary Magdalene 'the same detailed pictorial quality' as discovered in the Pre-Raphaelite painters.

There is a memoir contributed by Robert Bridges to the posthumous *Poems of the late Rev. Dr. Richard Watson Dixon*, 1909.

SEBASTIAN EVANS (1830–1909): Evans held a number of different posts, including those of manager of the art department of a glass-works near Birmingham (where he designed glass windows for churches) and of editor of the Birmingham *Daily Gazette*. In 1868 he was elected to Parliament, and in 1878 helped to found the Conservative weekly *The People*, acting as its editor until 1881. At the same time, he maintained a creative output in art, exhibiting at the Royal Academy, and working in wood-carving, engraving and bookbinding. A small Cambridge collection of verses was followed by three more books of poetry, as well as a translation of *The High History of the Holy Grail* (1898–1903, 1910) and an original study of the Grail story—*In Quest of the Holy Grail* (1898).

The mediæval and the mystical, as well as considerable arts-and-crafts interests, align Evans with the Pre-Raphaelites, especially its Anglo-Catholic wing. George MacBeth has called the title-poem of Evans's volume *Brother Fabian's Manuscript and other Poems* (1865) 'the most important forgotten masterpiece of the Victorian period' (*The Penguin Book of Victorian Verse*, 1969).

WALTER HAMILTON (1844–99): A miscellaneous writer, Hamilton produced such widely varied works as *A History of National Anthems and Patriotic Songs*, *French Book-plates* and *An odd vol. for smokers: poems in praise of tobacco*. His useful little primer *The Aesthetic Movement in England* (1882) enjoyed a deserved success, since in popular journalistic terms it connected the Pre-Raphaelite Movement with the new vogue of Aestheticism, commenting on these later manifestations when they were very much in the news.

The six volumes of *Parodies of English and American Authors* collected and annotated by him between 1884 and 1889 contain many amusing travesties of the leading writers of the day, including Tennyson, Swinburne and Wilde.

ARTHUR CLEMENT HILTON (1851–77): A largely neglected Victorian, who died young. Hilton is known to students of the period for the clever parodies of contemporary poets contributed to the two issues of *The Light Green*, a magazine

edited and predominantly written by himself just before and after his obtaining a degree at Cambridge. He can be rated with such other better-known parodists as C. S. Calverley and James and Horace Smith.

The Works of Arthur Clement Hilton: together with his Life and Letters was edited by Sir Robert P. Edgcumbe in 1904.

WILLIAM HOLMAN HUNT (1827–1910): Holman Hunt's father, a warehouse manager, opposed his son adopting an artistic career. At length, however, he relented, and in 1844 Hunt met Millais and Rossetti who, like him, were then attending the Royal Academy Schools. With these and four others, in 1850, he helped to found the Pre-Raphaelite Brotherhood, among whose members he was sometimes referred to as 'the maniac', an epithet bestowed on him, not without esteem, presumably on account of his unrelenting hard work, tenacity and some small fanatic streak.

He travelled much in Egypt and the Holy Land painting Biblical scenes with accurate local setting and types. His brand of allegorical naturalism—as represented by such pictures as *The Hireling Shepherd* (1851) [1] and *The Awakening Conscience* (1852)—was often misunderstood but wide attention was paid to it. Perhaps the most 'English' of the Pre-Raphaelite painters, there was something of William Hogarth in him—a largely humourless Hogarth, it is true, but with the eighteenth-century artist's hard moral temper and desire to instruct.

Hunt is the most important painter of the realistic wing of Pre-Raphaelitism, and he could claim, with much show of justice, in his massive two-volume work *Pre-Raphaelitism and the Pre-Raphaelite Brotherhood* (1905), that he was the only adherent of the group to remain faithful to P.R.B. principles.

There is an early self-portrait by him (1845) in the City Museum and Art Gallery, Birmingham, and a later one (1868) in the Uffizi, Florence.

VERNON LUSHINGTON (1832–1912): Lushington became a Queen's Counsel and finally County Court Judge for Surrey

[1] See plates.

and Berkshire, 1877–1900. He was keen on works of social philanthropy and embraced Auguste Comte's religion of humanity. A member of the Council of the Working Men's College (founded by F. D. Maurice) in Great Ormond Street, London, he was instrumental in introducing Burne-Jones to D. G. Rossetti whom the former had worshipped from afar ('and big results it brought into my life', Burne-Jones declared). His contribution to *The Oxford and Cambridge Magazine, Two Pictures* (by Ford Madox Brown and D. G. Rossetti), compares very favourably with Burne-Jones's account of some Rossetti illustrations to William Allingham's *Day and Night Songs* inserted in his essay *The Newcomes* also published in that journal.

A forwarder and patron of things Pre-Raphaelite, Lushington was a member of the Hogarth Club, a loose association of artists, friends and sympathizers, founded by Ford Madox Brown and D. G. Rossetti, who met in premises in Waterloo Place used both as a social and exhibiting centre. He features as a recipient of many letters from D. G. Rossetti.

PHILIP BOURKE MARSTON (1850–87): It was from his father's literary intimates and acquaintances that Marston may be said to have gained his education; and at the age of fourteen when he first met Swinburne, he could recite the whole of that author's *Poems and Ballads (First Series)* by heart.

Fortunate as he was in literary connections, it has well been said that his life was a 'series of losses'. First, of his sight when only four years old; then of a cherished sister; then of a promised bride. He also lost, by death, his close friend Oliver Madox Brown, with whom he had shared and discussed his literary schemes. Another tribulation befell him in the June of 1882 when alcoholic homeless James Thompson (author of *The City of Dreadful Night*) burst a blood-vessel while visiting him and lay dying beyond Bourke Marston's care.

He was, however, supported by the encouragement of Swinburne, Watts-Dunton and D. G. Rossetti who declared that his mantle had descended on the younger poet and wrote a fine sonnet *To Philip Bourke Marston: Inciting Me to Poetic Work*. He was also commemorated in another sonnet by Swinburne.

'Mournful and musical' are the epithets commonly 'applied to his verse. The novelist and critic Coulson Kernahan wrote of him that 'In lyric loveliness and grace, some of the blind poet's work is not unworthy of Rossetti, but we miss in Marston's lines the deep-mouthed volume of sound, the rhythmic splendour and sonority which are rarely absent from the Pre-Raphaelites.' (*The Poets & Poetry of the Nineteenth Century: Robert Bridges and Contemporary Poets*, ed. Alfred H. Miles, 1906.)

There is a good Memoir of him by William Sharp introducing the little volume of selections *Song-Tide* published by Walter Scott in 1888.

JOHN MORLEY (1838–1923): After a career as editor and journalist, Morley was elected Liberal M.P. for Newcastle in 1883 and became Gladstone's right-hand man. When he attacked Swinburne he was only twenty-eight and more than a year younger than the poet, to whose political and religious heterodoxy he was sympathetic. This did not stop him branding Swinburne as 'the libidinous laureate of a pack of satyrs'. The full history of Morley's attack and Swinburne's energetic defence is told by Clyde Kenneth Hyder in his *Swinburne's Literary Career and Fame* (1933).

Morley's Recollections were published in 1917.

WILLIAM MORRIS (1834–96): Abandoning his intention of reading for Holy Orders, and becoming a co-founder and proprietor of *The Oxford and Cambridge Magazine* (January–December 1856), Morris soon demonstrated his versatility as a poet, storyist, descriptive writer and critic; and in 1859 he married the beautiful Jane Burden. Articled as an architect, he next became a painter; and by 1882 was described by Walter Hamilton as 'a designer of art decorations, wall-paper, carpets and such like ornamental household necessaries, in which kind of business the new styles inaugurated and encouraged by the Aesthetes have created quite a revolution' (*The Aesthetic Movement in England*). Not only did Morris extend the principles of Pre-Raphaelitism to the fine arts: side by side with the firm he founded, he worked to set the arts and crafts in a Socialist

context. For him, it was part of a unified vision to found the Society for the Protection of Ancient Buildings in 1877 and The Socialist League in 1884.

Writing of him as a poet, John Heath-Stubbs remarks that 'his poetry is really less mediaeval than pagan', and that the ideal society he envisaged in his prose-work *News from Nowhere* (1891) is 'a mediaeval dream-world, very unlike the actual Middle Ages' (*The Darkling Plain*, 1950).

Morris was a man who crammed six men's work into one lifetime. He wrote narrative poems on classical themes, translated the *Aeneid* (1875) and the *Odyssey* (1887), travelled to Iceland and composed the vast sugar-loaf-like poem *Sigurd the Volsung* (1876). In 1890 he founded the Kelmscott Press, that 'final Pre-Raphaelite masterpiece', the Kelmscott Chaucer, being put into his hands just four months before he died in 1896.

There is a fine painting of Morris by G. F. Watts in the National Portrait Gallery; and a brilliant caricature of Morris and Burne-Jones entitled *Topsy and Ned Jones, settled on the settle in Red Lion Square* by Max Beerbohm is included in his volume *Rossetti and his Circle* (1922). The standard life of Morris (1899) is by J. W. Mackail.

FREDERICK WILLIAM HENRY MYERS (1843–1907): Co-founder of the Society for Psychical Research, Myers was also permanent Inspector of Schools, contributing essays on classical and literary subjects to the journals of his day. His essay *Rossetti and the Religion of Beauty* published in 1883 is of importance on two counts: first, in that it serves to repudiate the charges of sensualism made by Robert Buchanan in his article *The Fleshly School of Poetry* (1871), and, secondly, in that it testifies to the interest of a practised examiner of the psychic in D. G. Rossetti's own half-mystic eroticism. Coming in the year after the poet-painter's death, it helped to set the seal of Victorian 'high seriousness' and scholarly academic approval on the posthumous exhibition of Rossetti's pictures at Burlington House: 'the visible sign of the admission of a new strain of thought and emotion within the pale of our artistic orthodoxy'.

Fragments of Prose and Poetry, edited by his wife Eveleen

Myers (1904) contains a short autobiography by Myers entitled *Fragments of Inner Life*, and there is autobiographical material in his *Collected Poems* (1921).

ARTHUR WILLIAM EDGAR O'SHAUGHNESSY (1844–1881): O'Shaughnessy moved in Pre-Raphaelite circles, and was included by Walter Hamilton (*The Aesthetic Movement in England*, 1882) among the six writers treated as Pre-Raphaelite poets. Richard Garnett, who describes certain of his poems as 'miracles of melody', says that 'Few were so well versed in modern French literature' as O'Shaughnessy (see the section 'Translations from the Contemporary French Poets' in his posthumous volume *Songs of a Worker* (1881)).

Some time before his death, he took up the study of ancient sculpture, an enthusiastic interest reflected in 'Thoughts in Marble', a series published in *Songs of a Worker*. In these poems O'Shaughnessy can be seen to represent the Aesthetic rather than the Idealist aspect of Pre-Raphaelitism, as his words on them testify. 'My artistic object is gained if, in them, I have kept strictly within the lines assigned to the sculptor's art, an art in which I have as yet failed to perceive either morality or immorality. They are essentially thoughts in marble, or poems of form, and it would therefore be unjustifiable to look in them for a sense which is not inherent in the purest Parian' (see the Preface by A. W. Newport Deacon to *Songs of a Worker*).

A life of the poet by the American author Louise C. Moulton was published in 1894.

JOHN PAYNE (1842–1916): In 1866 John Payne formed a friendship with two other young men of Pre-Raphaelite persuasion: the poet Arthur O'Shaughnessy and the painter John Trivett Nettleship. These inseparable three became known as 'The Triumvirate' and had the *entrée* to the homes of Ford Madox Brown and Burne-Jones. Besides writing original poems, Payne early showed linguistic gifts of considerable order and admired particularly Gautier and Balzac. This was a passion he shared with the curious woman Mrs Helen Snee who was to become his Eugenia, though it was only twenty-five years after her death that his best poems commemorating

her (in the volume *Carol and Cadence*, 1908) were written. She was described as 'one of the loveliest and most gifted women of her age'; but seems to have also been a neurotic and affected person.

Payne was a prolific poet, but his original work is not up to the standard of the translations which he made from Villon (1878, 1881-92), Hafiz (1901), Heine (1911) and others. He also translated *The Thousand and One Nights* (1882-4), *The Decameron* (1886) and *The Novels of Matteo Bandetto* (1890). Contemporary French poets held an honoured place in his pantheon.

There is a balanced critical account of his work by B. Ifor Evans in his *English Poetry in the Later Nineteenth Century* (1933).

CHRISTINA GEORGINA ROSSETTI (1830-94) : Sister to Dante Gabriel and William Michael, Christina lived in London all her life. She never married, her strong commitment to Anglicanism twice coming between her and the object of her affection: once in the case of her relationship with the P.R.B. painter James Collinson and once with Charles Bagot Cayley, author, scholar, and translator of Dante's *Commedia* in the original metre. A recent work (*Christina Rossetti* by Lona Mosk Packer, 1963) suggests the strong possibility of another love relationship, in whatever terms we choose to define it, with the poet-painter William Bell Scott.

Her poems first appeared in a little pamphlet published by her grandfather when she was only sixteen. In 1850 she contributed poems to *The Germ* under the pseudonym of Ellen Alleyn, and in 1862 she made her début proper with *Goblin Market and other Poems* illustrated by Dante Gabriel.

Disappointed love and ill health deepened with melancholy her already considerable pious bent, and from 1881 she published nothing but devotional work. 'Her life,' wrote her brother William Michael, 'had two motive powers—religion and affection—hardly a third.' Her poems are characterized by fine craftsmanship and pathos; and in an excellent essay on her verse Arthur Symons speaks of her 'autumnal muse . . . the muse . . . of an autumn going down towards winter with the

happy light still on it of a past, or but now scarcely passing, summer'.

An early likeness of her is to be found in Dante Gabriel's picture *Ecce Ancilla Domini* (1849–50) [1] where she is featured as the Virgin.

GABRIEL CHARLES DANTE ROSSETTI (1828–82): Gabriel Dante was educated at King's College School, the Royal Academy Schools, and not least by the political and literary conversation which was so constant a factor in the unconventional Rossetti household in Soho. For a while he worked in the studios of Ford Madox Brown and Holman Hunt, but technical inadequacy and independence compelled him to establish his own personal mode of work and style. In 1860 he married Elizabeth Siddal who had been his model and mistress for some years. Her death from an overdose of laudanum in 1862 set him off on a downward path which, with his increasing addiction to chloral and whisky, led to his death at the age of fifty-four.

In both poetry and painting, Rossetti was the dominant personality in the Pre-Raphaelite Movement and his influence was felt far outside the select ranks of the Brotherhood. His vision in verse and paint has been assessed and interpreted diversely. Robert Buchanan, in his article *The Fleshly School of Poetry* (1871), saw it as an expression of sensuality; while F. W. H. Myers viewed it as a spiritual system of platonic love (v. *Rossetti and the Religion of Beauty*, 1883). The resolution of this antinomy probably lies in Walter Pater's statement that 'Like Dante, he knows no region of spirit which shall not be sensuous also, or material' (*Appreciations*, 1889). The French scholar Louis Cazamian puts the same notion in more positive terms, declaring that 'He is a stranger to the hesitations of a divided northern soul, when it comes up against the apparent conflict of the flesh and the spirit' (*A History of English Literature* by Emile Legouis and Louis Cazamian, 1930).

His relationship with Elizabeth Siddal and other women has been well examined by Rosalie Glynn Grylls in her *Portrait of*

[1] See plates.

Rossetti (1964); while Virginia Surtees's *Paintings and Drawings of Dante Gabriel Rossetti* is essential to any study of him as an artist. His *Letters* have been edited in five volumes by O. Doughty and J. R. Wahl, 1965–8; and the City Museum and Art Gallery, Birmingham, possess an excellent portrait of him made by Holman Hunt in 1853 [1] and a more enigmatic self-portrait dated 1861.

WILLIAM MICHAEL ROSSETTI (1829–1919): Younger brother of Dante Gabriel, William Michael Rossetti was critic, biographer and memoirist, as well as an employee of the Inland Revenue Department from 1845 to 1894. The only member of the Pre-Raphaelite Brotherhood not himself engaged in the visual or plastic arts, he was appointed by the group as Editor of their magazine *The Germ* and official keeper of the *P.R.B. Journal*. He can, in fact, be regarded as the archivist and general secretary of the Movement. In 1874 he married Lucy, daughter of Ford Madox Brown. His volume of art criticism *Fine Art, Chiefly Contemporary* (1867) contains interesting examples of then-current reviews of painting slanted according to Pre-Raphaelite standards.

He published a little poetry which was kindly regarded by Swinburne ('my too generous friend') and James Thomson, but it was as a workaday critic that he made his own small respectable name. There are two good portraits of him: one by Ford Madox Brown, painted in 1856 by gaslight; the other by Alphonse Legros done in 1864. His own autobiography *Some Reminiscences of William Michael Rossetti* appeared in two volumes in 1906.

ROBERT BALDWIN ROSS (1869–1913): Literary journalist and art critic, Ross, with regard to his writings on Pre-Raphaelitism (v. *Masques and Phases*, 1909), represents the point of view of a second-generation Aesthete of the nineties looking with kindness, but absence of respect, on the awe-inspiring figures of the sixties and seventies. His essays on Swinburne and Pater (a Pre-Raphaelite sympathizer) are cases

[1] See plates.

in point; but his amused censure of Holman Hunt probably in part arises from the fundamental attitudes of the two men: Ross, a Catholic immoralist; and Hunt, an earnest moral-minded Protestant.

Ross is supposed to have boasted that it was he (as a boy of sixteen) who initiated Oscar Wilde into homosexual practice; and in view of this it is interesting to read his essay on Simeon Solomon, a Jewish homosexual Pre-Raphaelite painter, Swinburne's one-time playmate while living as a tenant of Rossetti in number 16, Cheyne Walk, Chelsea.

Robert Ross: Friend of Friends edited by Margery Ross (1952) offers the fullest account of him.

JOHN RUSKIN (1819–1900): The first volume of Ruskin's great five-volume *Modern Painters* appeared in 1843; and in 1851 he took up himself a qualified defence of the Pre-Raphaelites in the pages of *The Times*. Over the years, his championship of the Movement became fuller, though (much provoked) he quarrelled with D. G. Rossetti.

Ruskin defended both wings—the realistic and the romantic—of the Pre-Raphaelite Movement, and his first two lectures on D. G. Rossetti and Holman Hunt, and Burne-Jones and G. F. Watts in *The Art of England and the Pleasures of England* given at Oxford, 1883–5, should be noted. His other chief writings on the Movement are the pamphlet *Pre-Raphaelitism* (1851) and the fourth chapter and addenda in *Lectures on Architecture and Painting* (1854). By his early stress on natural detail (and his own considerable studies in botany and geology), he advanced the naturalistic and realistic aspect of Pre-Raphaelite painting; and by his financial patronage of D. G. Rossetti as a water-colour painter, he furthered the romantic side of the Movement which, first and foremost, derived from this artist.

The first portrait of Ruskin is the full-length study of him at Glenfinlas in 1853 by the young Millais. His autobiography *Praeterita* was published 1885–9.

WILLIAM BELL SCOTT (1811–90): Although Bell-Scott's early poetry was influenced by the Spasmodics, a growing

acquaintance with D. G. Rossetti and his circle brought a Pre-Raphaelite suggestion into some of his poems and pictures. The young Dante Gabriel conceived such a respect for him that he sent *The Blessed Damozel* for Bell Scott to revise. Before long, however, the roles of master and disciple were reversed, and Rossetti was praising and encouraging Bell Scott. 'That last splendid ballad' was how he referred to Bell Scott's poem *Lady Janet Mary Jean*, urging him to place it in the front of his forthcoming *Poems* (1875), a hint which the poet duly took. His connection with the Pre-Raphaelites was strengthened by a relationship of sorts with Christina Rossetti; though as an agnostic he can hardly have been the most likely choice of that orthodox and melancholy lady.

On retiring from the Government School of Design, he bought an Adam house in Chelsea, not far from Rossetti. This, of course, increased his own knowledge of affairs and things Pre-Raphaelite, and it is his intimacy with this circle which makes his posthumous *Autobiographical Notes* (1892), edited by W. Minto, chiefly of interest. A certain grudging note is heard when he writes about the P.R.B., but pale passing flickers of affection for D. G. Rossetti are sometimes to be discovered. One Pre-Raphaelite trait in Bell Scott is the conjunction of poetic and painterly gifts, brought together at least in one work. *Poems* (1875) is 'a rich decorative volume with etchings by Alma Tadema and Bell Scott himself' (B. Ifor Evans).

The greater mass of Bell Scott's poetry lacks distinction, but a handful of lyrics and ballads such as *Kriemhild's Tryst* show him writing with quickened and melodious diction. 'No external or adventitious merits, nor even purely intellectual qualities, can altogether determine the value of poetry. It must affect us like music or wine,' he wrote in the preface to *Poems*. Like James Hogg's verse-tale of 'Bonnie Kilmeny', Bell Scott's finest poem *The Witches' Ballad* may be said to affect us in this manner.

There are two sad and disappointed-looking self-portraits of Bell Scott which serve as frontispieces to the two volumes of his *Autobiographical Notes*.

ELIZABETH ELEANOR SIDDAL (1883–62): The arche-

typal Pre-Raphaelite beauty, Elizabeth Siddal was spotted by
the poet William Allingham while working in a milliner's shop
near Leicester Square in London. Allingham duly reported her
presence to the painter Walter Deverell who featured her as
Viola in his picture *The Duke with Viola listening to the court
minstrel* which was shown at the Academy Exhibition of 1850.
She modelled for Holman Hunt, Millais and D. G. Rossetti, the
last of whom claimed her for his own. In 1860 this 'stunner and
no mistake' (Ford Madox Brown) was married to Rossetti, and,
following a miscarriage, died from an overdose of drugs almost
certainly self-administered.

How the grief-stricken husband had his poems buried with
her in her hair, only to have her body exhumed and the poems
removed for publication seven years afterwards is part of the
exotic Pre-Raphaelite legend. Though beautiful, Elizabeth
was a physically sick woman; and she passed on to the morbid
Rossetti her own unhealthy dependence on drugs. Painted
endlessly by Dante Gabriel, 'The Sid', 'Lizzie' or 'Guggums'
(as she was called) echoed in her own poems and paintings
something of Rossetti's weird world of mysterious yearning.
(Ruskin described her as 'beautiful as the reflection of a
golden mountain in a crystal lake', shrewdly adding, 'which
is what she is to him'.)

W. M. Rossetti published her poems in three of his family
compilations: *Ruskin: Rossetti: Pre-Raphaelitism* (1899), *Dante
Gabriel Rossetti: His Family Letters* (1895), and *Some Reminiscences* (1906), in the last of which he gives some account of her.
There are water-colours by her in the Victoria and Albert
Museum and the Fitzwilliam Museum, Cambridge, as well as
portfolios of her sketches at Wightwick Manor, Wolverhampton (National Trust).

JAMES SMETHAM (1821–89): Smetham was a teacher of
drawing at the Normal College, Westminster, a Wesleyan
foundation for the training of teachers. In 1854 he met Ruskin
(who confessed himself 'amazed, almost awed, by the amount
of talent and industry and thoughtfulness shown in these
[drawing] books of yours') and became something of a protégé
of him and Rossetti. The latter invited him to work once a

week in his studio at Chelsea, and when his *Hymn of the Last Supper* was exhibited there in 1869 the artist Watts pronounced it 'a great picture though it is a small one'.

A distinction of Smetham is that of being the only Methodist Pre-Raphaelite of note. His theory and practice as an artist, however, point to a qualified Pre-Raphaelite attitude; and his letters bear witness to the mixture of fascination and fear with which he regarded these strange personalities as if he stood in danger of losing his own artistic identity.

Apart from a few poems, his only publications were four articles contributed to the *London Quarterly Review* between 1861 and 1868. One of these—his essay on William Blake—was in great part reprinted as an addendum to the second edition of Gilchrist's *Life of Blake* edited by D. G. Rossetti, who considered that Smetham's piece contained the best, most penetrative review of the life and character of Blake that had up to that time been published. These four essays are published together in *The Literary Works of James Smetham*, ed. William Davis, 1893. The same editor—who, with the painter's widow, edited the *Letters of James Smetham*, 1891—spoke rightly of 'their lightness of touch, airiness and sportiveness of character . . . their quick and visual modes of thought, and their disposition to discern a comic element in the most serious moods and on the darkest occasions'. There are many references in these letters—or 'ventillations' as he chose to call them—to Pre-Raphaelite works and personalities.

FREDERICK GEORGE STEPHENS—'JOHN SEWARD' (1828–1907): Stephens, though a founder member of the Pre-Raphaelite Brotherhood, was better known as a critic than a painter. In 1861 he became the art critic of *The Athenaeum* and wrote a pamphlet, published anonymously in 1860, on the life and work of Hunt to coincide with the exhibition of that painter's *The Finding of the Saviour in the Temple*.

His 'attractive person and face', as W. M. Rossetti put it, is featured as Ferdinand by Millais in his picture *Ferdinand and Ariel* and he appears as Christ in Ford Madox-Brown's *Christ Washing Peter's Feet*. The fullest account of him is to be found in *F. G. Stephens and the Pre-Raphaelite Brotherhood* (ed. Manson,

1920). There is a good early portrait of him (1847) by Holman
Hunt in the Tate Gallery.

ALGERNON CHARLES SWINBURNE (1837–1909):
Swinburne's connections with the Pre-Raphaelites from the
time when Rossetti visited Oxford in 1857 were of the strongest,
and he lived for a while in Cheyne Row, Chelsea, sharing with
D. G. Rossetti a house whose other inhabitants were, at one
time, the painter Simeon Solomon and the poet-novelist
George Meredith. *Poems and Ballads* (First Series, 1866) was
dedicated 'To my friend Edward Burne Jones', and other Pre-
Raphaelite names are similarly honoured in other books by
him. The last thirty years of his life were spent under the super-
vision of his 'best friend' Theodore Watts-Dunton, a literary
lawyer who rescued him from ruinous dissipation by carrying
him off to reside with him at his villa, no. 2, The Pines, Putney.

More than D. G. Rossetti, Swinburne was the real offender
against the puritanical canon of much Victorian criticism, a
charge he answered in a scathing pamphlet *Under the Micro-
scope* (1872). Swinburne, as a poet, can be thought of as com-
bining Pre-Raphaelite influence with those of Gautier and
Baudelaire to create the Aestheticism which was to have such
an effect on English writers of the eighties and nineties. There
is a deal of interesting and rhapsodic art and literary criticism
of the Pre-Raphaelites in his books of essays. *Notes on the Royal
Academy Exhibition* (1868) written in conjunction with W. M.
Rossetti should be consulted.

His letters have been edited by Edmund Gosse and Thomas
James Wise, in two volumes (1928), and more recently in six
volumes by Cecil V. Lang. There is a superb early portrait of
him by G. F. Watts in the National Portrait Gallery, London,
and a strange likeness by William Bell Scott at Balliol College,
Oxford.

THEODORE WATTS-DUNTON (1832–1914): As a solici-
tor in London, Watts-Dunton grew to be an intimate of the
Pre-Raphaelites. From 1879, to all intents and purposes, he
acted as Swinburne's friendly custodian, restraining him from
drink and dissipation. A humorous account of the household

they shared is given by Max Beerbohm in his essay *No. 2, The Pines* (1914)—a reference to Watts-Dunton's villa at the foot of Putney Hill.

Poet, critic and novelist, his work is mostly of interest today through his association with more eminent men. His gypsy novel *Aylwin* (1898) met with enormous success. In it he has painted a superb portrait of Rossetti in his latter phase as 'Haroun-al-Raschid the Painter'. His verse collection *The Coming of Love* (1897) contains poems on Christina Rossetti and Oliver Madox-Brown; and his essays *Old Familiar Faces* (1915) include recollections of Morris and Rossetti.

The Putney *ménage* shared by Swinburne and Watts-Dunton has been vividly described by Mollie Panter-Downes in *At the Pines* (1971).

Everyman
A selection of titles

*indicates volumes available in paperback

Complete lists of Everyman's Library and Everyman Paperbacks are available from the Sales Department, J.M. Dent and Sons Ltd, Aldine House,33 Welbeck Street, London WIM 8LX.

BIOGRAPHY

Bligh, William. *A Book of the 'Bounty'*
Boswell, James. *The Life of Samuel Johnson*
Byron, Lord. *Letters*
Cibber, Colley. *An Apology for the Life of Colley Cibber*
*De Quincey, Thomas. *Confessions of an English Opium-Eater*
Forster, John. *Life of Charles Dickens* (2 vols)
*Gaskell, Elizabeth. *The Life of Charlotte Brontë*
*Gilchrist, Alexander. *The Life of William Blake*
Houghton, Lord. *The Life and Letters of John Keats*
*Johnson, Samuel. *Lives of the English Poets: a selection*
Pepys, Samuel. *Diary* (3 vols)
Thomas, Dylan
 Adventures in the Skin Trade
 Portrait of the Artist as a Young Dog
Tolstoy. *Childhood, Boyhood and Youth*
*Vasari, Giorgio. *Lives of the Painters, Sculptors, and Architects*
 (4 vols)

ESSAYS AND CRITICISM

Arnold, Matthew. *On the Study of Celtic Literature*
*Bacon, Francis. *Essays*
Coleridge, Samuel Taylor
 Biographia Literaria
 Shakespearean Criticism (2 vols)
Dryden, John. *Of Dramatic Poesy and other critical essays*
 (2 vols)

*Lawrence, D.H. *Stories, Essays and Poems*
*Milton, John. *Prose Writings*
Montaigne, Michel Eyquem de. *Essays* (3 vols)
Paine, Thomas. *The Rights of Man*
Pater, Walter. *Essays on Literature and Art*
Spencer, Herbert. *Essays on Education and Kindred Subjects*

FICTION

*American Short Stories of the Nineteenth Century
Austen, Jane
 **Emma*
 **Mansfield Park*
 **Northanger Abbey*
 **Persuasion*
 **Pride and Prejudice*
 **Sense and Sensibility*
*Bennett, Arnold. *The Old Wives' Tale*
Boccaccio, Giovanni. *The Decameron*
Brontë, Anne
 **Agnes Grey*
 **The Tenant of Wildfell Hall*
Brontë, Charlotte
 **Jane Eyre*
 **The Professor* and *Emma* (a fragment)
 **Shirley*
 **Villette*
Brontë, Emily. *Wuthering Heights* and *Poems*
*Bunyan, John. *Pilgrim's Progress*
Butler, Samuel.
 Erewhon and *Erewhon Revisited*
 The Way of All Flesh
Collins, Wilkie
 **The Moonstone*
 **The Woman in White*
Conrad, Joseph
 **The Nigger of the 'Narcissus', Typhoon, Falk and other stories*
 **Nostromo*

*Grossmith, George and Weedon. *Diary of a Nobody*
*Hardy, Thomas. *Stories and Poems*
Hawthorne, Nathaniel.
 The House of the Seven Gables
 The Scarlet Letter
James, Henry
 Selected Tales
 The Turn of the Screw
*Jefferies, Richard. *Bevis: The Story of a Boy*
*Lawrence, D.H. *Short Stories*
*Maupassant, Guy de. *Short Stories*
*Melville, Herman. *Moby Dick*
*Modern Short Stories
*Modern Short Stories 2 (1940–1980)
*Peacock, Thomas Love. *Headlong Hall* and *Nightmare Abbey*
*Poe, Edgar Allan. *Tales of Mystery and Imagination*
*Pushkin, Alexander. *The Captain's Daughter and other stories*
Richardson, Samuel
 Clarissa (4 vols)
 Pamela (2 vols)
*Russian Short Stories
*Saki. *Short Stories*
Scott, Walter
 The Antiquary
 The Bride of Lammermoor
 Heart of Midlothian
 Ivanhoe
 Redgauntlet
 Rob Roy
 The Talisman
 Waverley
*Shelley, Mary Wollstonecraft. *Frankenstein*
*Smollett, Tobias. *Roderick Random*
*Somerville, E. and Ross, M. *Some Experiences of an Irish R.M.*
 and *Further Experiences of an Irish R.M.*
Stern, Lawrence
 *A Sentimental Journey through France and Italy; Journal to
 Eliza; Letters to Eliza*
 Tristram Shandy

*Stowe, Harriet Beecher. *Uncle Tom's Cabin*
Stevenson, R.L.
 Dr Jekyll and Mr Hyde, The Merry Men and other tales
 Kidnapped
 The Master of Ballantrae and *Weir of Hermiston*
 Treasure Island
Swift, Jonathan
 Gulliver's Travels
 A Tale of a Tub and other satires
Thackeray, W.M.
 Henry Esmond
 Vanity Fair
Thomas, Dylan
 Miscellany 1
 Miscellany 2
 Miscellany 3
*Tolstoy, Leo. *Master and Man and other parables and tales*
Trollope, Anthony
 The Warden
 Barchester Towers
 Dr Thorne
 Framley Parsonage
 Small House at Allington
 Last Chronicle of Barset
*Voltaire, *Candide and other tales*
*Wilde, Oscar. *The Picture of Dorian Gray*
Woolf, Virginia. *To the Lighthouse*

HISTORY

*The Anglo-Saxon Chronicle
Burnet, Gilbert. *History of His Own Time*
*Crèvecoeur. *Letters from an American Farmer*
Gibbon, Edward. *The Decline and Fall of the Roman Empire*
 (6 vols)
Macaulay, T.B. *The History of England* (4 vols)
Machiavelli, Niccolò. *Florentine History*
Prescott, W.H. *History of the Conquest of Mexico*

LEGENDS AND SAGAS

*Beowulf and Its Analogues
*Chrétien de Troyes. *Arthurian Romances*
 Egils Saga
 Holinshed, Raphael. *Chronicle*
*Layamon and Wace. *Arthurian Chronicles*
*The Mabinogion
*The Saga of Gisli
*The Saga of Grettir the Strong
 Snorri Sturluson. *Heimskringla* (3 vols)
*The Story of Burnt Njal

POETRY AND DRAMA

*Anglo-Saxon Poetry
*American Verse of the Nineteenth Century
*Arnold, Matthew. *Selected Poems and Prose*
*Blake, William. *Selected Poems*
*Browning, Robert. *Men and Women and other poems*
 Chaucer, Geoffrey
 Canterbury Tales
 Troilus and Criseyde
*Clare, John. *Selected Poems*
*Coleridge, Samuel Taylor. *Poems*
*Elizabethan Sonnets
*English Moral Interludes
*Everyman and Medieval Miracle Plays
*Everyman's Book of Evergreen Verse
*Gay, John. *The Beggar's Opera and other eighteenth-century
 plays*
*The Golden Treasury of Longer Poems
 Goldsmith, Oliver. *Poems and Plays*
*Hardy, Thomas. *Selected Poems*
*Herbert, George. *The English Poems*
*Hopkins, Gerard Manley. *The Major Poems*
 Ibsen, Henrik
 A Doll's House; The Wild Dick; The Lady from the Sea
 Hedda Gabler; The Master Builder; John Gabriel Borkman

*Keats, John. *Poems*
*Langland, William. *The Vision of Piers Plowman*
 Marlowe, Christopher. *Complete Plays and Poems*
*Milton, John. *Complete Poems*
*Middleton, Thomas. *Three Plays*
*Palgrave's Golden Treasury
*Pearl, Patience, Cleanness, and Sir Gawain and the Green Knight
*Pope, Alexander. *Collected Poems*
*Restoration Plays
*The Rubáiyát of Omar Khayyám and other Persian poems
*Shelley, Percy Bysshe. *Selected Poems*
*Six Middle English Romances
*Spenser, Edmund. *The Faerie Queene: a selection*
 The Stuffed Owl
*Synge, J.M. *Plays, Poems and Prose*
*Tennyson, Alfred. *In Memoriam, Maud and other poems*
 Thomas, Dylan
 Collected Poems, 1934–1952
 Under Milk Wood
*Wilde, Oscar. *Plays, Prose Writings and Poems*
*Wordsworth, William. *Selected Poems*

RELIGION AND PHILOSOPHY

 Aristotle. *Metaphysics*
*Bacon, Francis. *The Advancement of Learning*
*Berkeley, George. *Philosophical Works including the works on vision*
*The Buddha's Philosophy of Man
*Chinese Philosophy in Classical Times
*Descartes, René. *A Discourse on Method*
*Hindu Scriptures
 Hume, David. *A Treatise of Human Nature*
*Kant, Immanuel. *A Critique of Pure Reason*
*The Koran
*Leibniz, Gottfried Wilhelm. *Philosophical Writings*
*Locke, John. *An Essay Concerning Human Understanding (abridgment)*
*Moore, Thomas. *Utopia*

Pascal, Blaise. *Pensées*
Plato. *The Trial and Death of Socrates*
*The Ramayana and Mahábhárata

SCIENCES: POLITICAL AND GENERAL

Aristotle. *Ethics*
*Castiglione, Baldassare. *The Book of the Courtier*
*Coleridge, Samuel Taylor. *On the Constitution of the Church and State*
*Darwin, Charles. *The Origin of Species*
George, Henry. *Progress and Poverty*
Harvey, William. *The Circulation of the Blood and other writings*
*Hobbes, Thomas. *Leviathan*
*Locke, John. *Two Treatises of Government*
*Machiavelli, Niccolò. *The Prince and other political writings*
Marx, Karl. *Capital. Volume I*
*Mill, J.S. *Utilitarianism; On Liberty; Representative Government*
Owen, Robert. *A New View of Society and other writings*
*Plato. *The Republic*
*Ricardo, David. *The Principles of Political Economy and Taxation*
Rousseau, J.-J.
 Emile
 The Social Contract and Discourses
Smith, Adam. *The Wealth of Nations*
*Wollstonecraft, Mary. *A Vindication of the Rights of Woman*

TRAVEL AND TOPOGRAPHY

Boswell, James. *The Journal of a Tour to the Hebrides*
*Darwin, Charles. *The Voyage of the 'Beagle'*
Giraldus Cambrensis. *Itinerary through Wales* and *Description of Wales*
Stevenson, R.L. *An Inland Voyage; Travels with a Donkey; The Silverado Squatters*
Stow, John. *The Survey of London*
*White, Gilbert. *The Natural History of Selborne*